Australia
Exposed

A foreword by Jack Thompson

When I left my home in Sydney in 1955, I exchanged an urban life by the glistening waters of the Pacific for the life of a station-hand in the arid heartland of the Northern Territory. A landscape largely untouched by the mark of man and as omnipresent as time itself. The ochre-red dust of these apparently endless plains seemed to cover almost everything.

Australia is geologically, the oldest of the continental landmasses and her ancient lineage is nowhere more apparent than in the very texture of the land itself. It seems to permeate all things, even those who live in it. I fell in love with this gaunt beauty, a love that remains to this day.

When I first saw Jason Kimberley's photographs I knew that he too had fallen in love with this, "beauty burnished by the sun." Australia Exposed is more than a photographic essay, it is a loving and often laconic song of praise to the land and it's people, a celebration of our heritage. It is a tribute to our common muse - "the bush."

Jack Thompson A.M

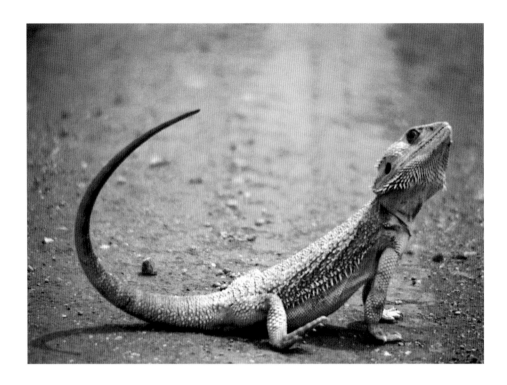

Australia Exposed

Published in 2003

By Sunburnt Country Photos
 32 Clyde street St Kilda, 3182 Victoria, Australia
 phone +61 3 9534 1898 www.sunburntcountry.net
 ABN 86 100 879 150

 National Library of Australia Cataloguing-in-Publication Data:
 Kimberley, Jason, 1967- .
 Australia Exposed

 ISBN 0-9750772-1-X

 1. Australia - Description and travel. I. Title.
 919.4

All images in this book are available through Sunburnt Country Photos.

Designed by Paul Johnstone and Jason Kimberley

Pre-press by Colorwize Studio, Adelaide, South Australia
Printed in Hong Kong by Bookbuilders on 157gsm Matt Art

above: bearded dragon, silverton, NSW
right: cloud, nullarbor plain, WA
following page: sisal bush, eyre peninsula, SA
back cover: making notes, tully inlet, NT
back cover photo by: Caroline Kimberley

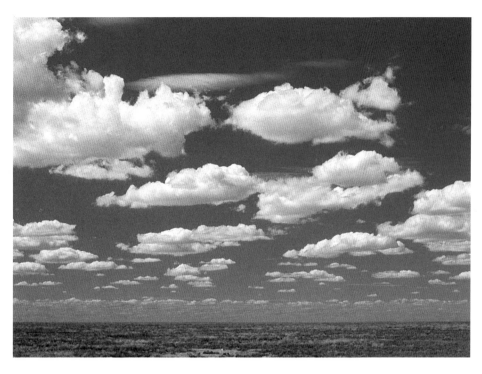

Contents

On the road 1
Signs of life 24
Rodeo 40
Death and decay 56
Shifting sands 94
Rusty barrels 108
Dry lakes 118
Streaky bay races 130
Eye in the sky 140
Waterholes 150
Birdsville 160
Land meets sea 178
On the road again 202
Behind the scenes 219

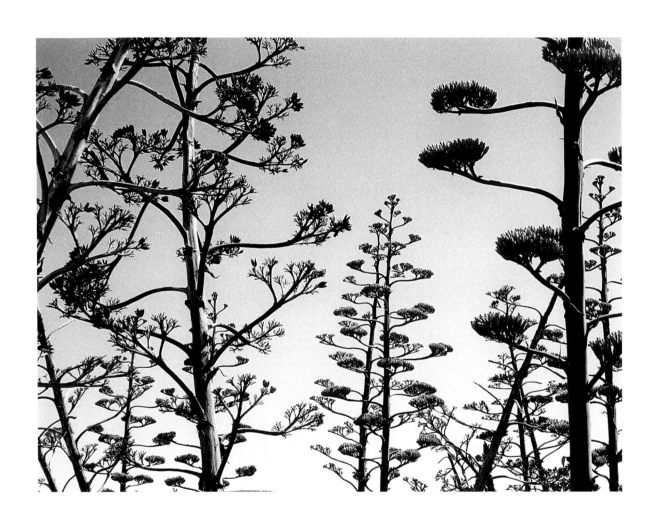

It's all about the journey

My interest in the Australian interior was inspired by a book given to me on my fourth birthday. The book was hard-covered and skinny not more than forty pages. It had wonderfully detailed coloured drawings of men setting off to cross the continent with their horses and camels. They were full of ambition, hopes and dreams. As the journey wore on one mishap followed another. The men and their beasts visibly deteriorated to the point where the men were in rags, the horses and camels died. Soon the men started to die. What type of country could be this difficult, so harsh? I had to see for myself. My wait would not be long.The book was 'Bourke and Wills.' The seed had been planted.

In 1976 my parents decided to take my younger sister and I on an outback adventure to experience the country. This further fuelled my fascination with the interior. We flew into Alice Springs. From here we joined a twenty-two seat, four-wheel drive bus complete with driver, cook, eighteen strangers and twelve awkward canvas tents. The journey would take us from Alice to Broome to Darwin. I was nine years old.

Our first night camping was preceded by an all day drive. 'Are we there yet?' took on a whole new meaning for my little sister. When we finally stopped to camp it was dark. The steady rain had intensified to heavy, then torrential. We were on the Tanami Track, the camp was named 'The Granites', an abandoned mine since reopened. In ankle deep red mud our group of novice campers struggled to set up their tents for the first time in the dark.

My father let fly with a flurry of exclamations that began with 'fancy paying some bugger for the privilege of doing this...' and ended with a series of words that I knew young people were never meant to hear. I was sure that this was to be my first and last 'outback adventure'.

The rains finally cleared and the darkness lifted. The country was revealed. It was almost impossible to take everything in. The light. The colours. The vastness. The changing of the land. The wonder. I was overwhelmed. Never before had I experienced a holiday where the destination diminished in importance to the getting there. The journey took on the greater significance. The seed was germinating.

Since then I have been able to take several six to twelve week Australian road trips. I had always dreamed of taking a year off to see Australia. My interests had now spread from the interior to the remote coasts and back to the deserts again. There is something strange about the desert. It is unique. The desert is silent. The desert is clean.

So how to pack up your life for a year and fulfil your dreams? I was fortunate to be a part-owner in a successful pub, and my business partner managed it in my absence. The house contents were placed in storage. In November 1999 my wife Caroline and I set off on the journey of a lifetime. Our only plan was to have no plan.

The result of this trip is **Australia Exposed**

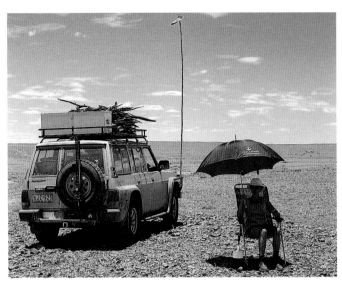

lunch, dalhousie, SA

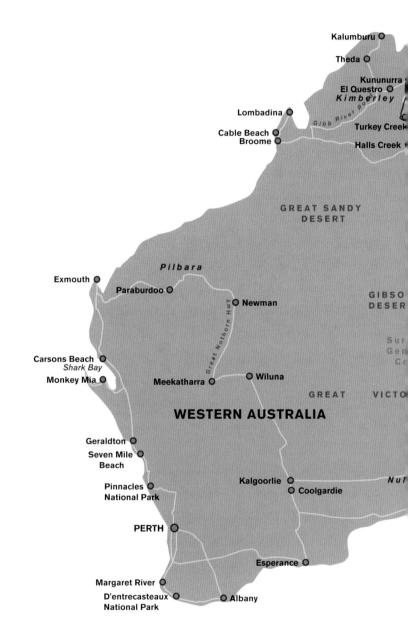

Kalumburu

Theda

Kununurra
El Questro
Kimberley

Lombadina

Gibb River Road

Turkey Creek

Cable Beach
Broome

Halls Creek

GREAT SANDY
DESERT

Pilbara

Exmouth
Paraburdoo

O Newman

GIBSO
DESER

Great Northern Hwy

Sur
Gem
Co

Carsons Beach
Shark Bay
Monkey Mia

Meekatharra

O Wiluna

GREAT VICTO

WESTERN AUSTRALIA

Geraldton
Seven Mile
Beach

Kalgoorlie
Coolgardie

Nul

Pinnacles
National Park

PERTH

Esperance

Margaret River
D'entrecasteaux
National Park

O Albany

Travel map

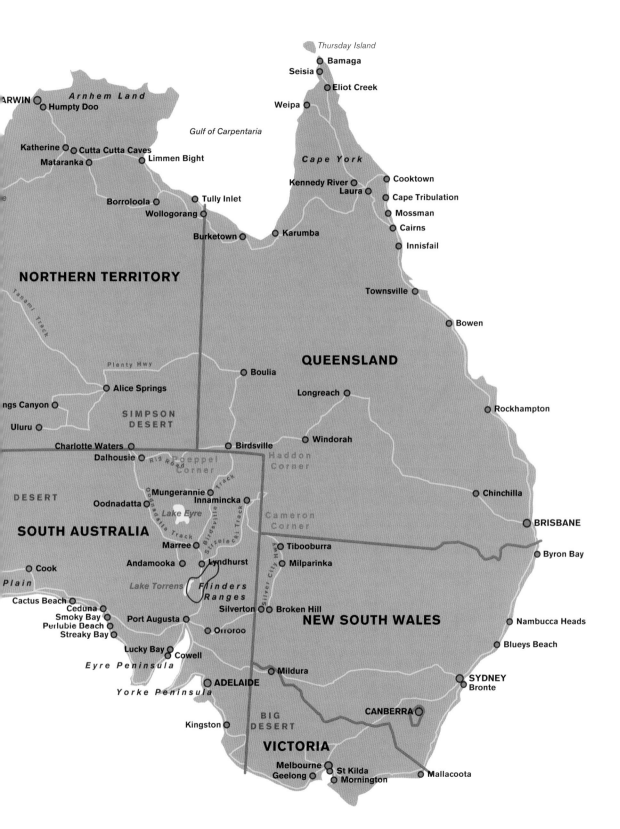

Thursday Island

Bamaga
Seisia
Eliot Creek
Weipa

Gulf of Carpentaria

DARWIN
Humpty Doo

Arnhem Land

Cape York

Katherine
Cutta Cutta Caves
Mataranka
Limmen Bight

Kennedy River
Laura
Cooktown
Cape Tribulation
Mossman
Cairns
Innisfail

Borroloola
Tully Inlet
Wollogorang
Burketown
Karumba

NORTHERN TERRITORY

Tanami Track

Townsville

Bowen

Plenty Hwy

QUEENSLAND

Boulia

Alice Springs

SIMPSON DESERT

Longreach

Rockhampton

ngs Canyon

Uluru

Charlotte Waters
Dalhousie

Rig Road

Poeppel Corner

Haddon Corner

Birdsville

Windorah

DESERT

Mungerannie
Innamincka
Oodnadatta

Lake Eyre

Oodnadatta Track

Birdsville Track

Cameron Corner

Strzelecki Track

Chinchilla

SOUTH AUSTRALIA

Marree

Andamooka
Lyndhurst

Silver City Hwy

BRISBANE

Byron Bay

Cook

Tibooburra
Milparinka

Lake Torrens

Flinders Ranges

Plain

Cactus Beach
Ceduna
Smoky Bay
Perlubie Beach
Streaky Bay

Silverton
Broken Hill

NEW SOUTH WALES

Nambucca Heads

Port Augusta

Orroroo

Blueys Beach

Lucky Bay
Cowell

Eyre Peninsula

Mildura

SYDNEY
Bronte

ADELAIDE

Yorke Peninsula

CANBERRA

Kingston

BIG DESERT

Mallacoota

VICTORIA

Melbourne
Geelong
St Kilda
Mornington

Map Key

Travel by Road

Travel by Air

TASMANIA

HOBART

On the road

The road is a calling, a place to lose yourself in the journey, forget about the destination. Just being on the road moving is a joy. The Australian road is everything, the link to all places, it becomes a part of you, gets under your skin, in your hair, nails and mouth. The road becomes your best friend, playing with you, talking to you, giving signals of what may lie ahead.

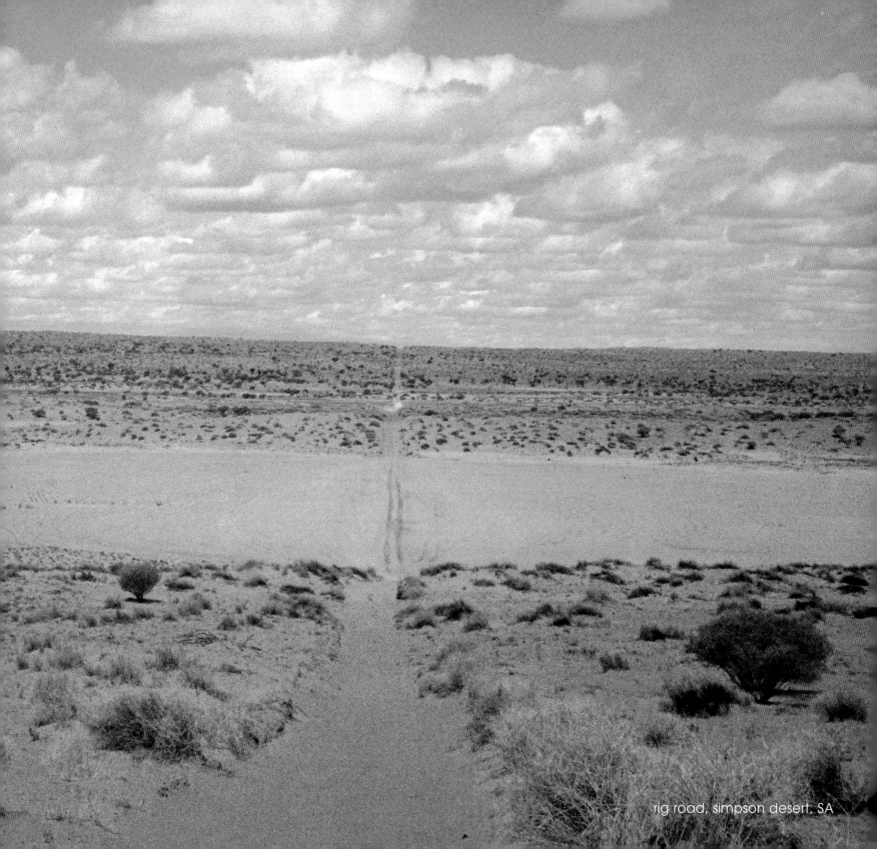

rig road, simpson desert, SA

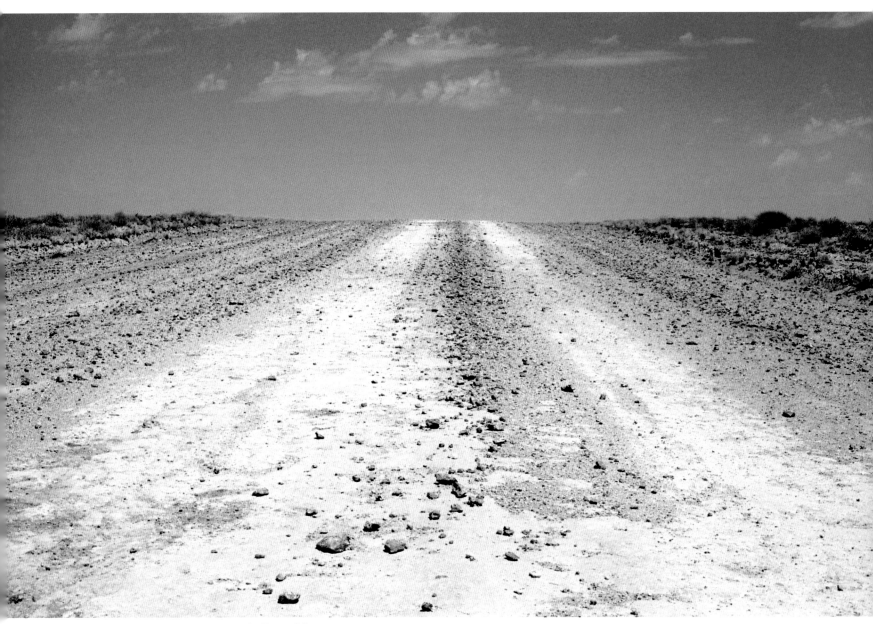

road to nowhere, kalamurina station, SA

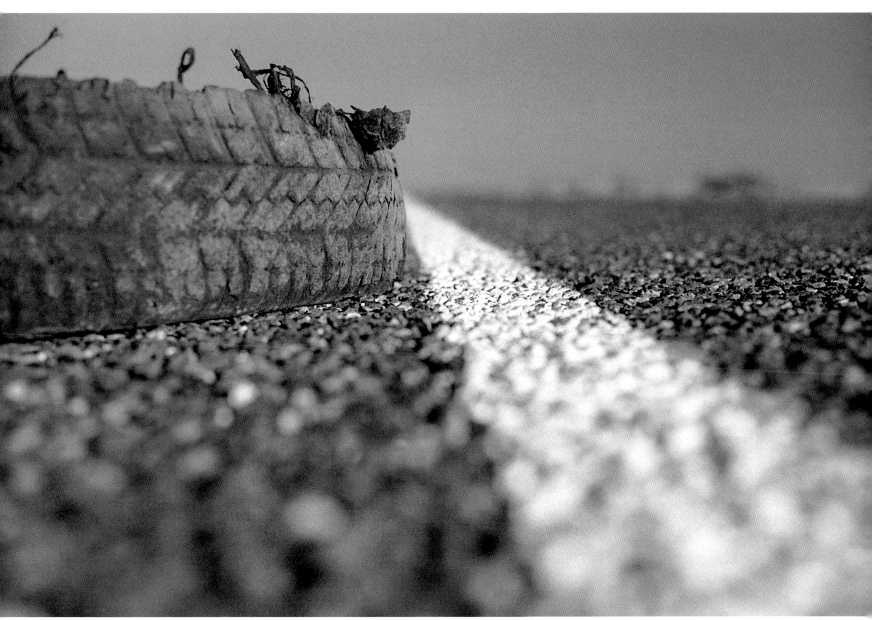

blowout #1, eyre highway, WA

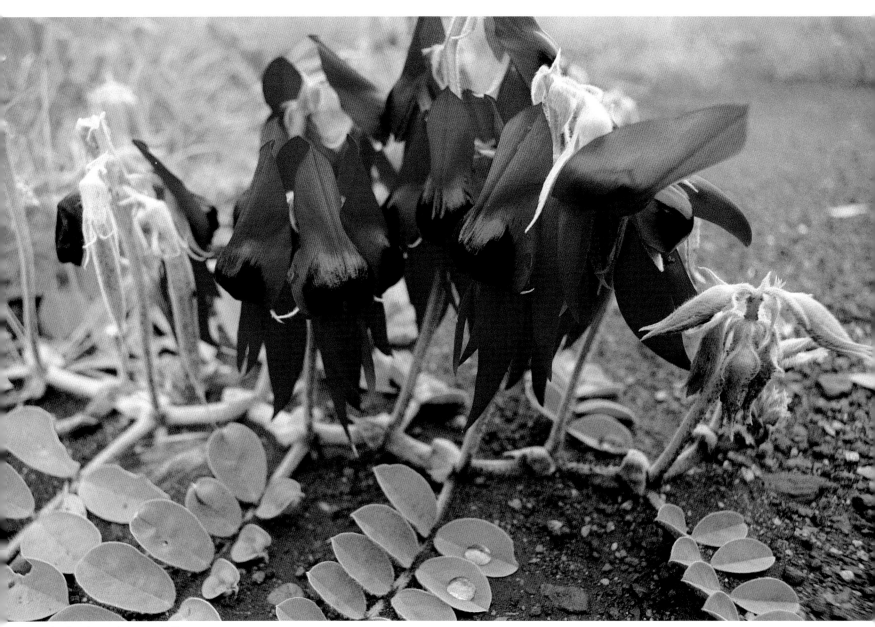

sturts desert pea, WA

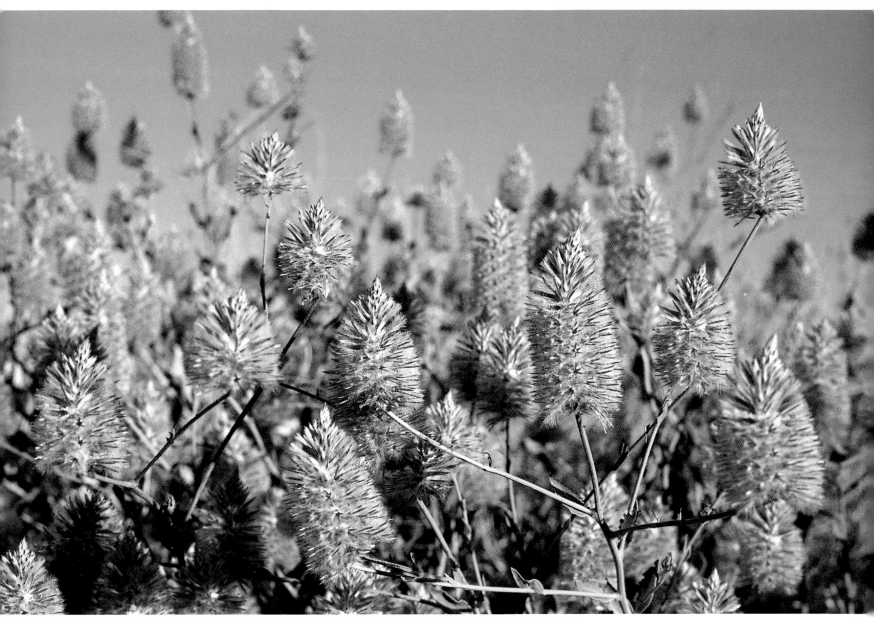

turkey bush, NT

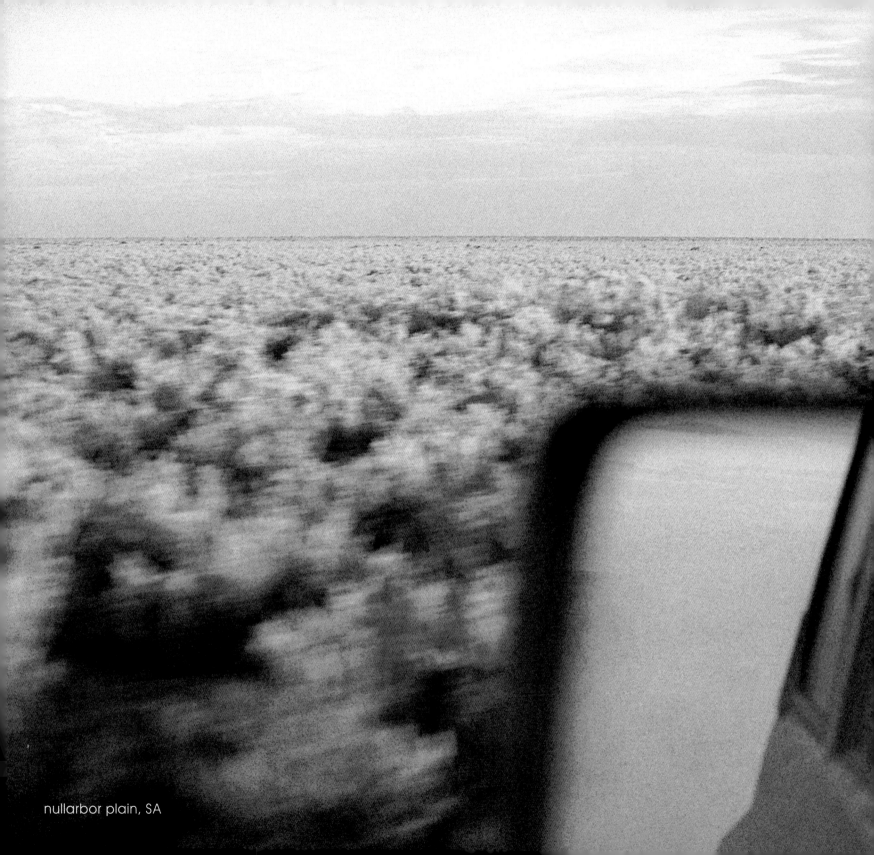

nullarbor plain, SA

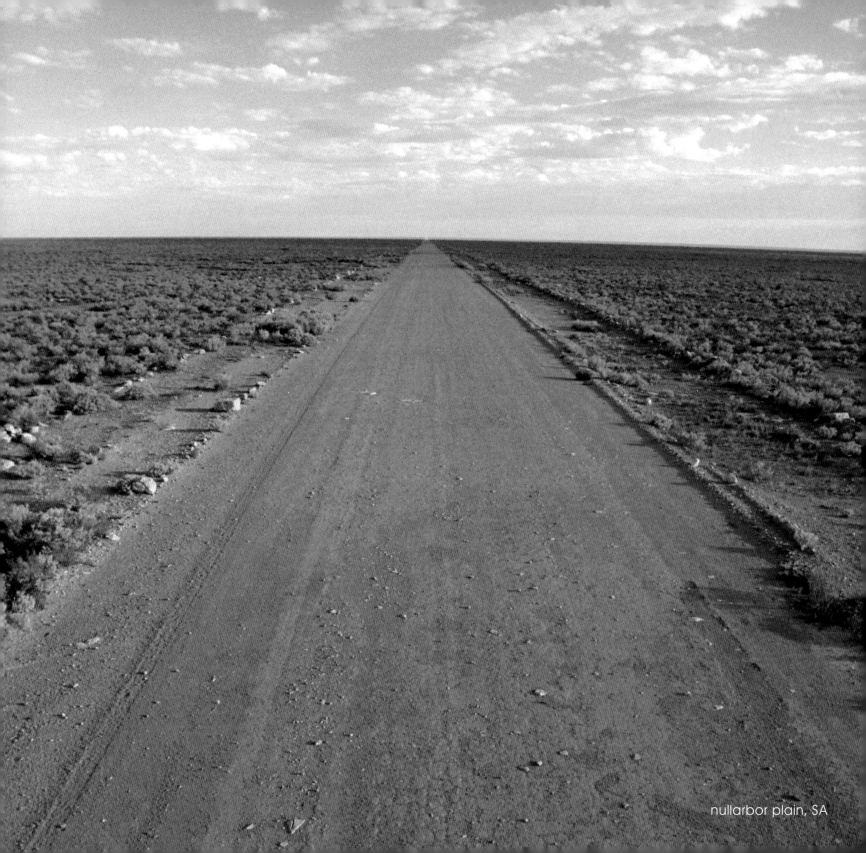

nullarbor plain, SA

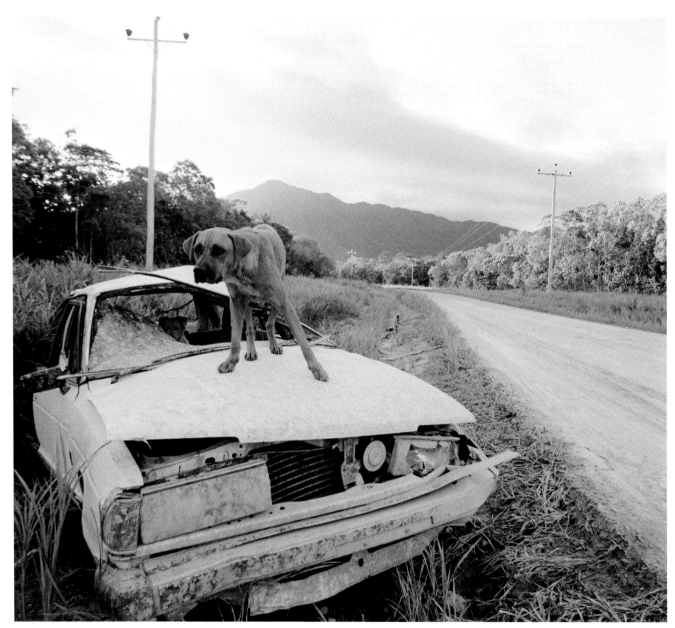

stray dogs, cape tribulation, QLD

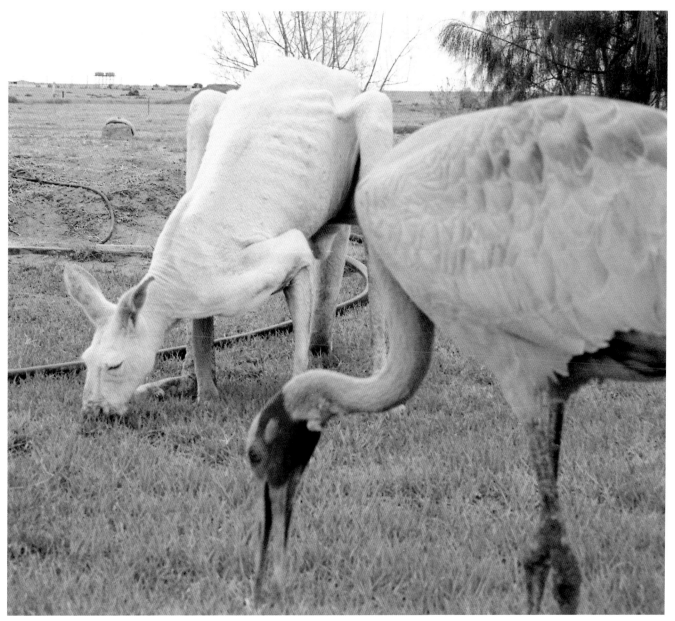

albino kangaroo and brolga, marree, SA

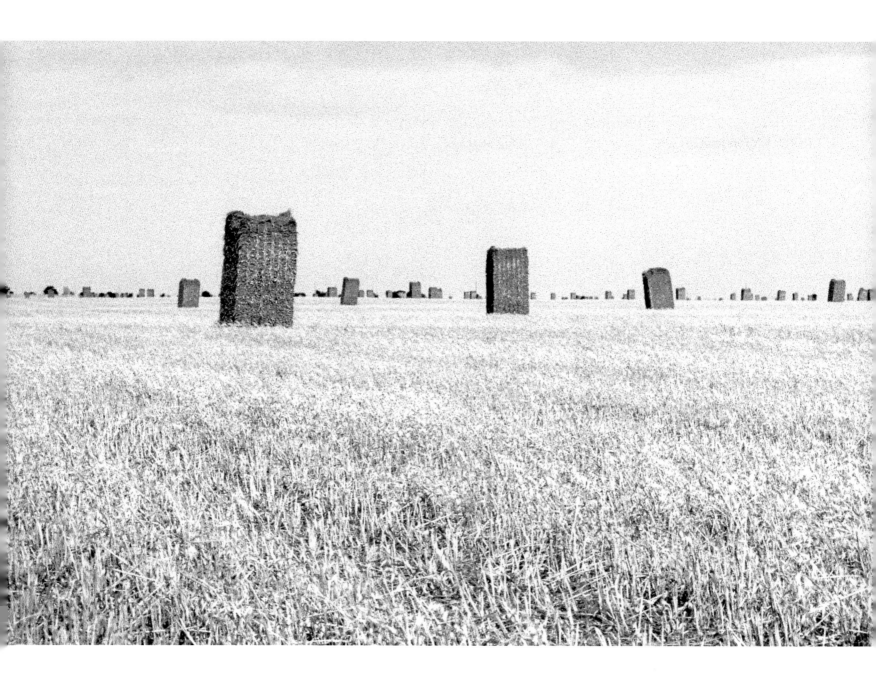

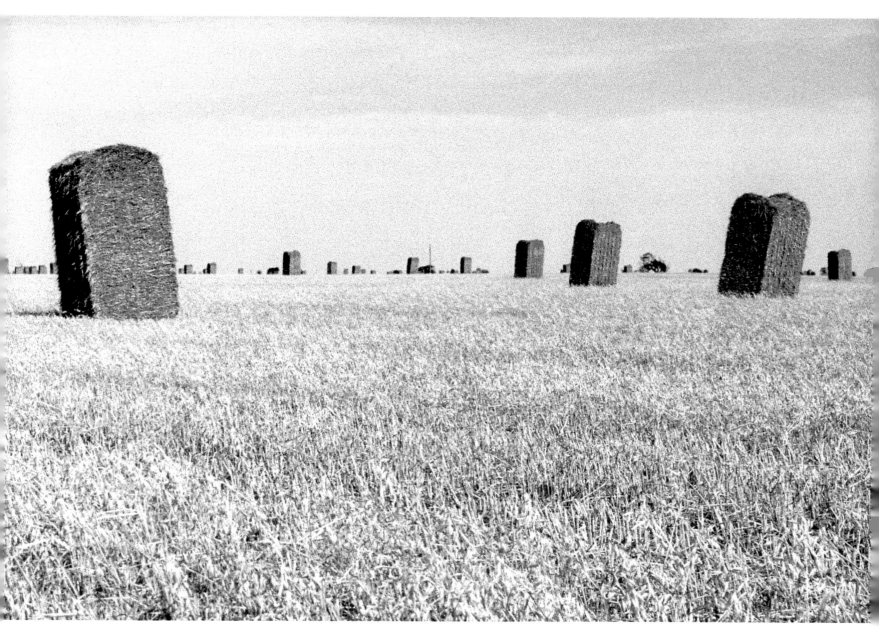

hay bale, yorke peninsula, SA

13

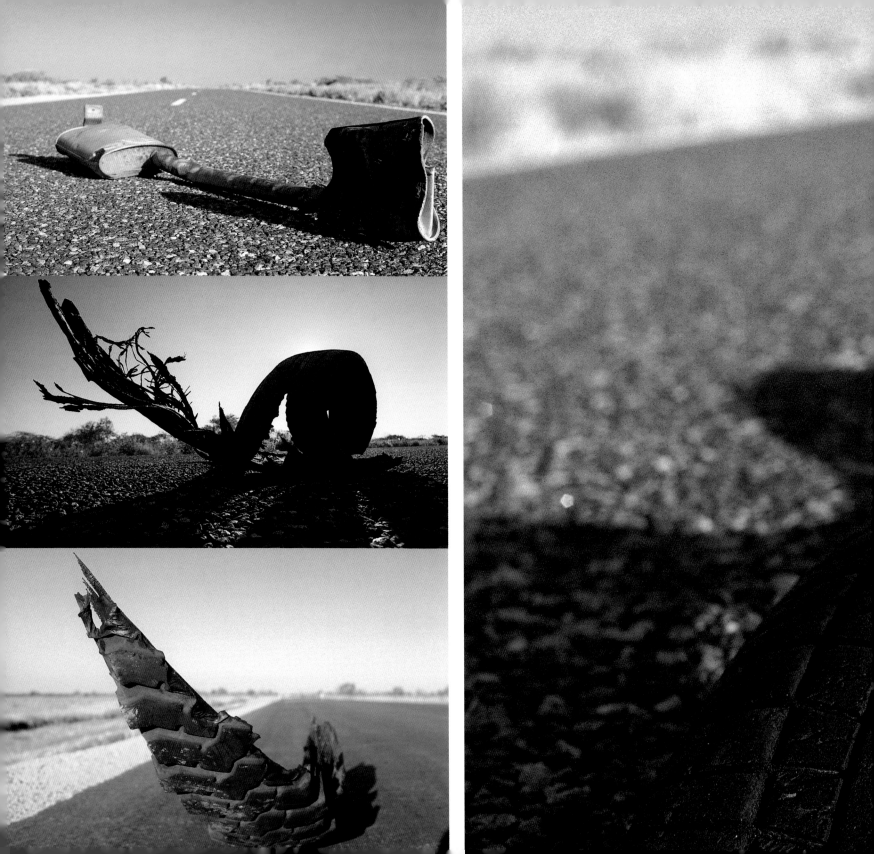

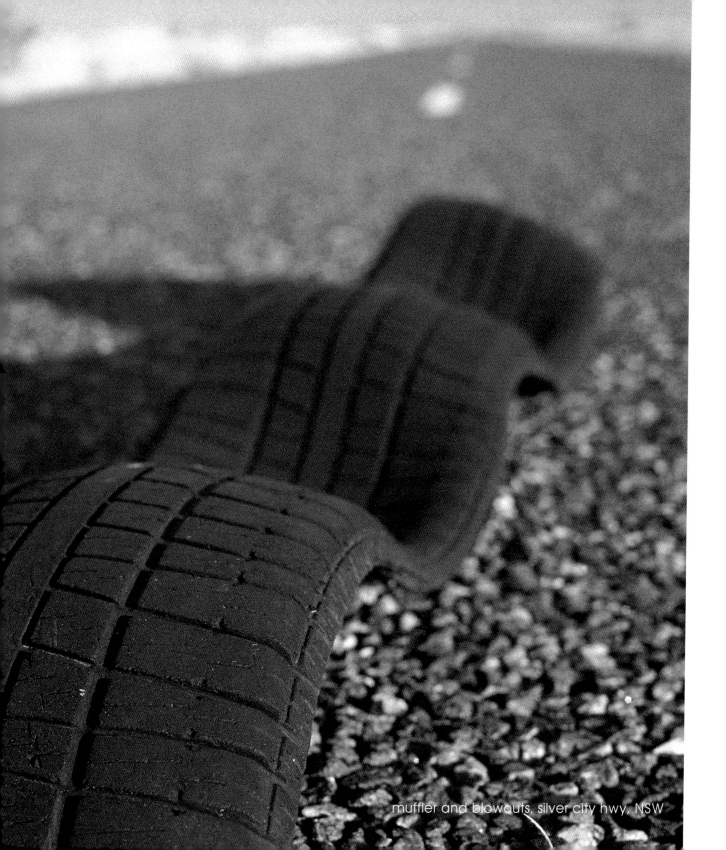

muffler and blowouts, silver city hwy, NSW

larry the lobster, kingston, SA

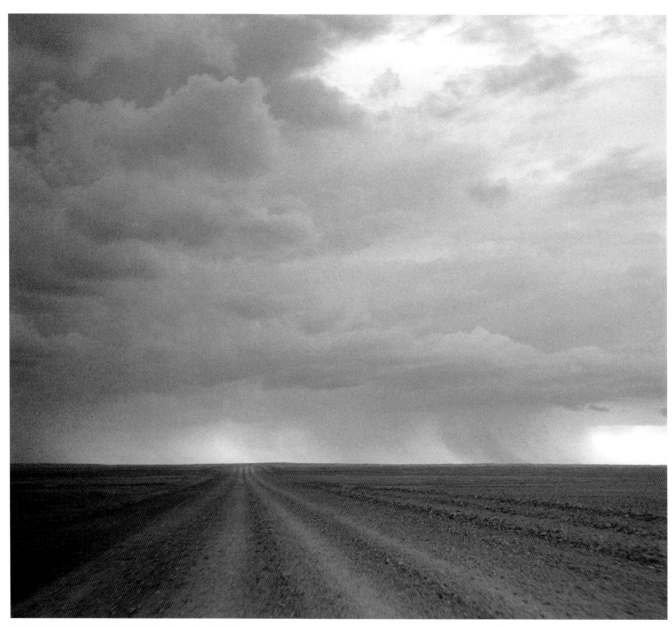

passing storm, birdsville track, QLD

sunset, strzelecki track, SA

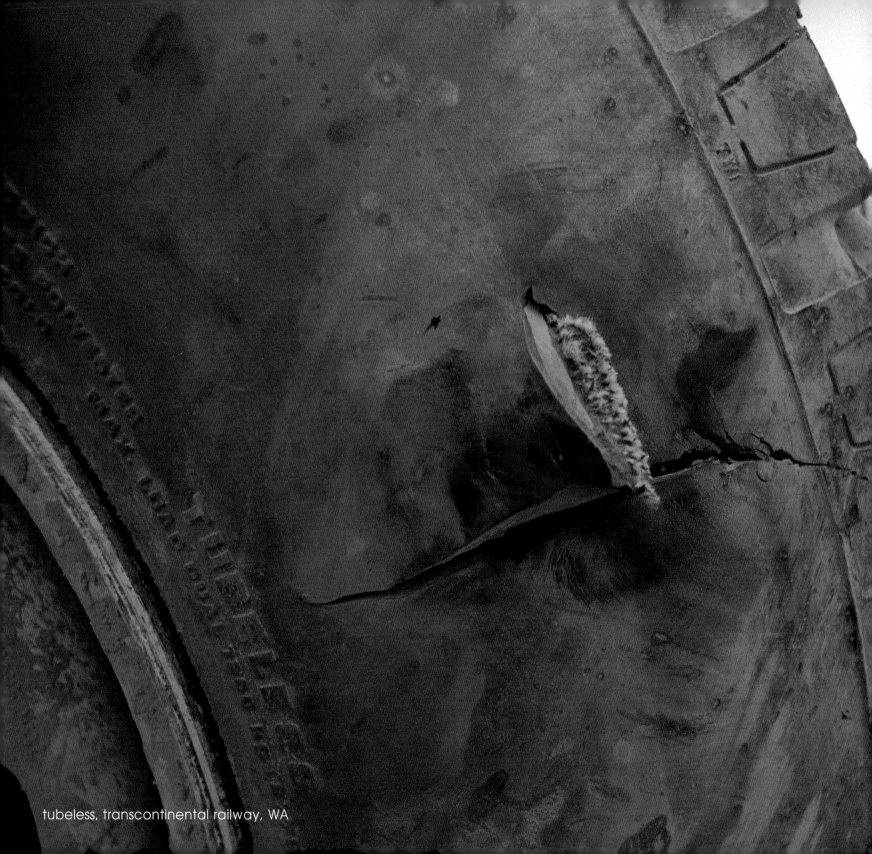

tubeless, transcontinental railway, WA

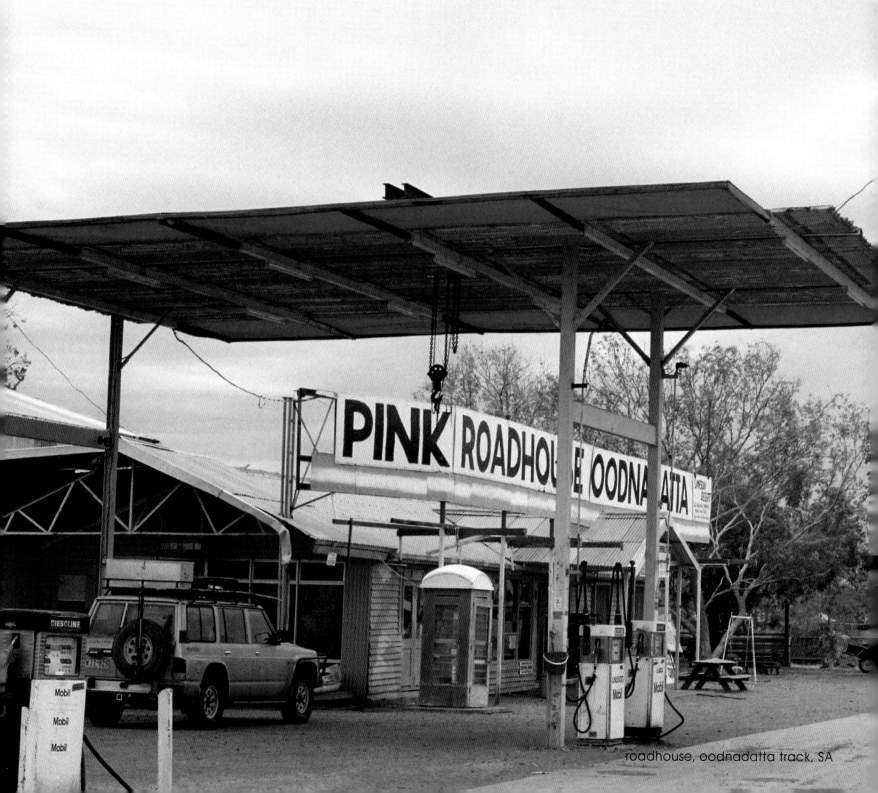

roadhouse, oodnadatta track, SA

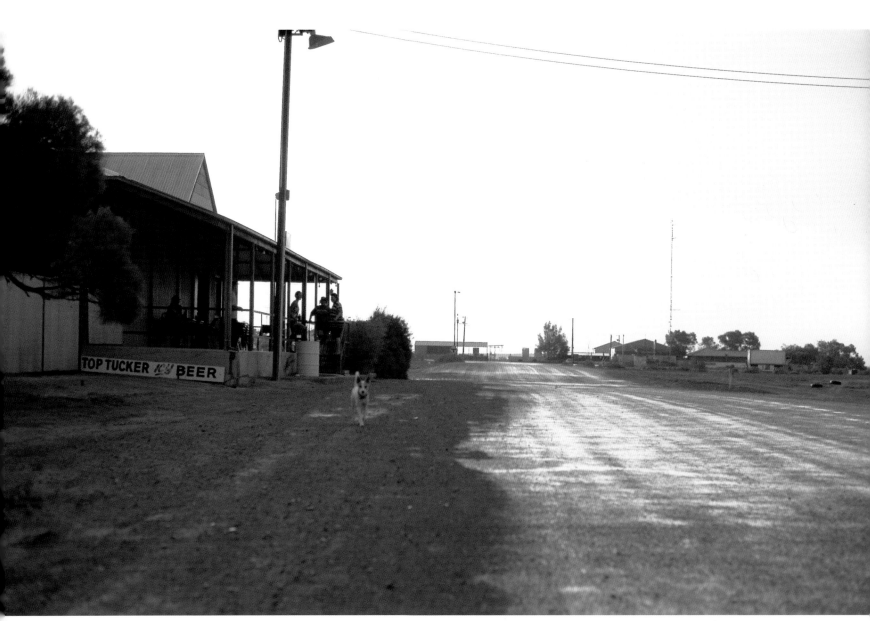

afternoon shower, lyndhurst, SA

Signs of life

Signs give direction, offer assistance, tell us what to do. Often they are just plain funny, absurd, wrong, dramatic, home made...entertaining.

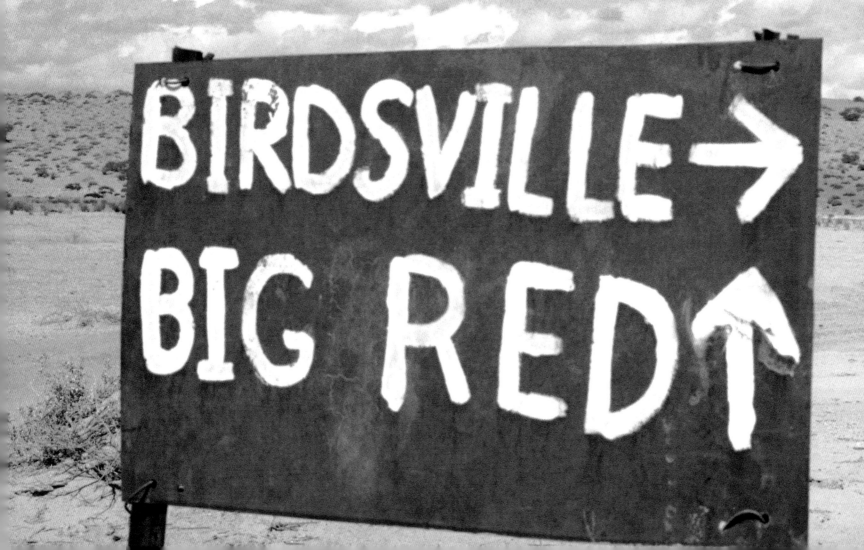

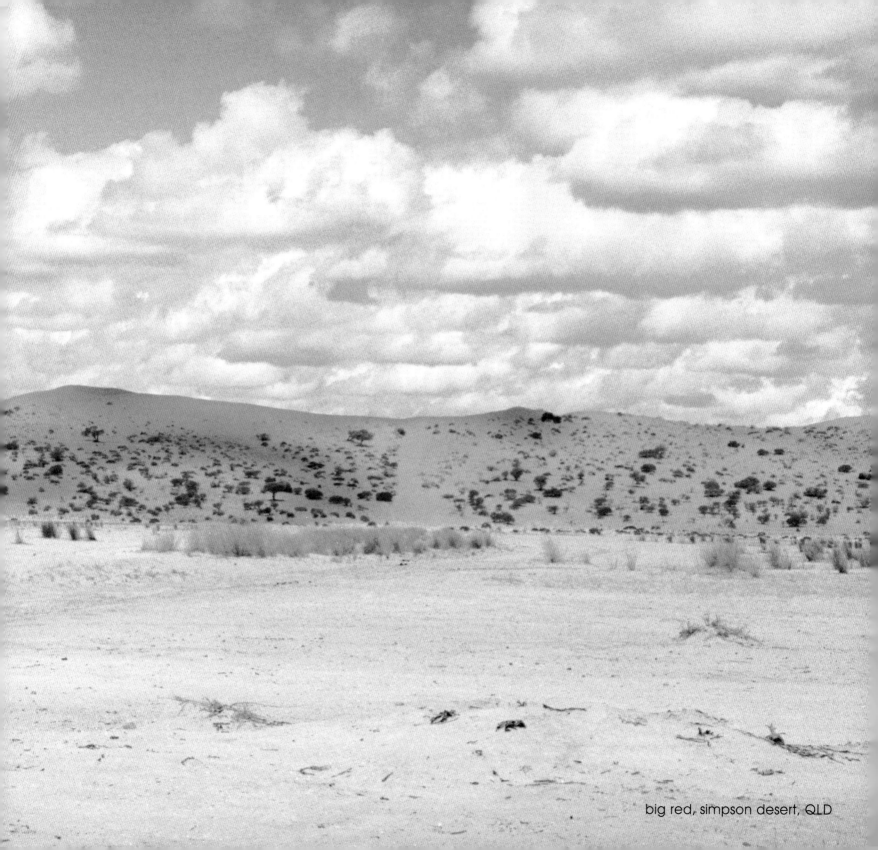

big red, simpson desert, QLD

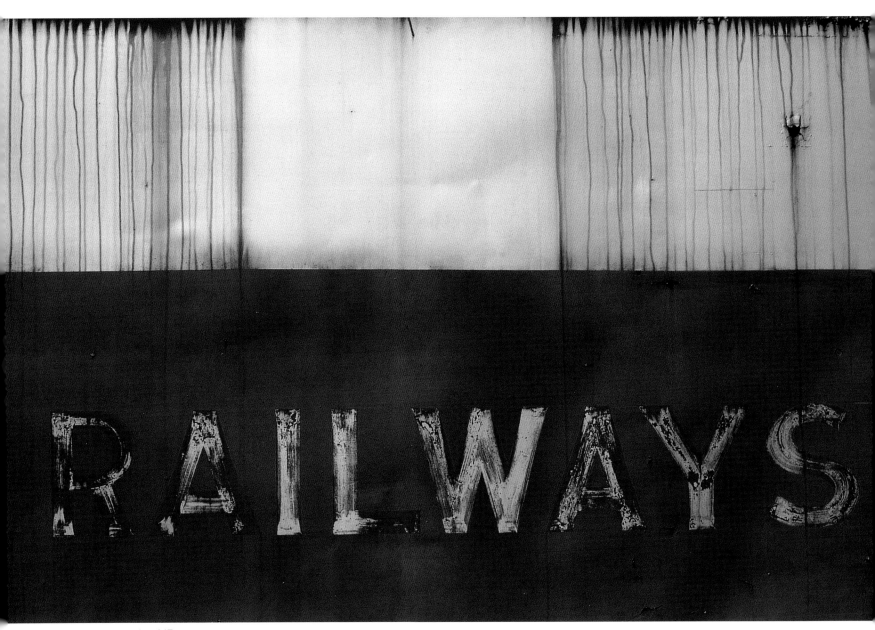

railways, darwin, NT

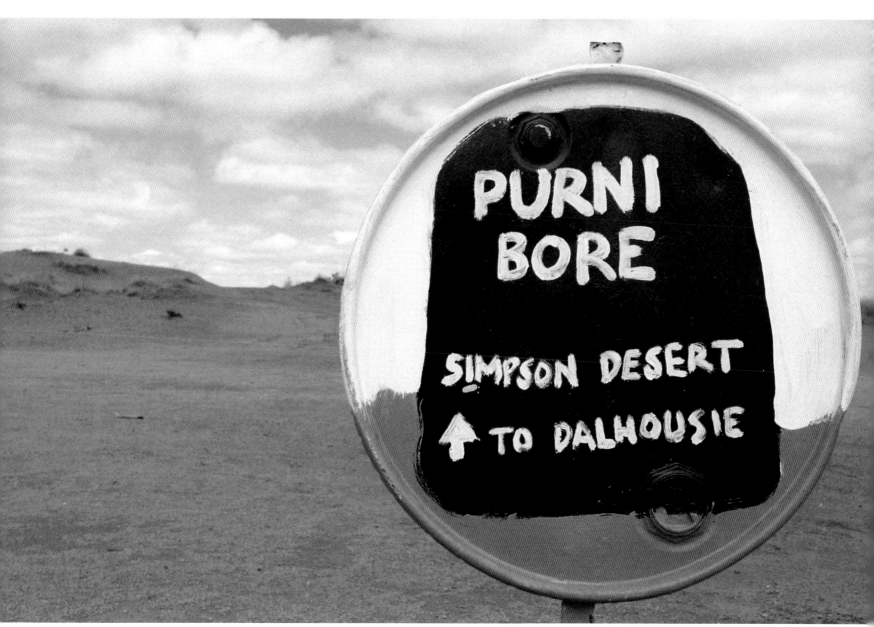

purni bore, simpson desert, QLD

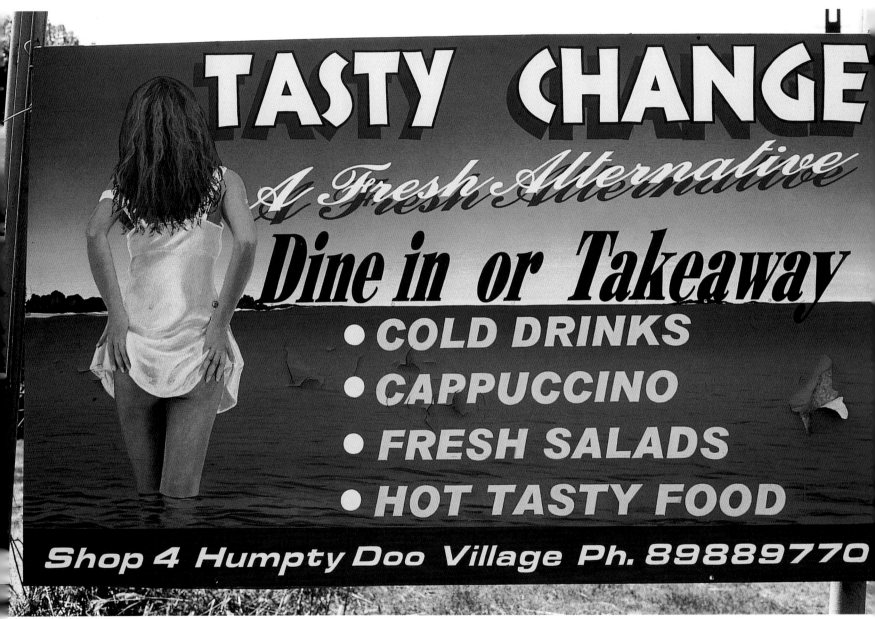

a fresh alternative, humpty doo, NT

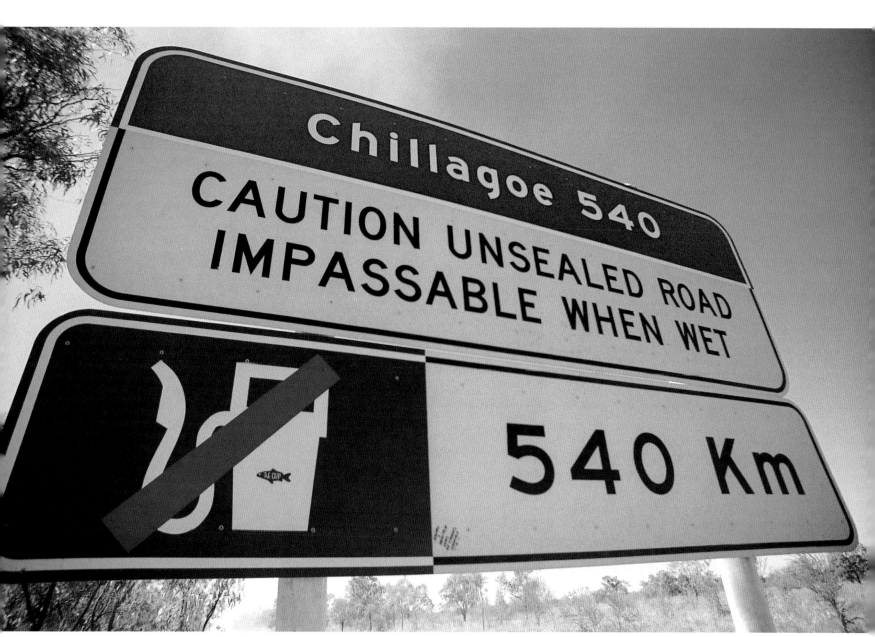

last fuel, normanton, QLD

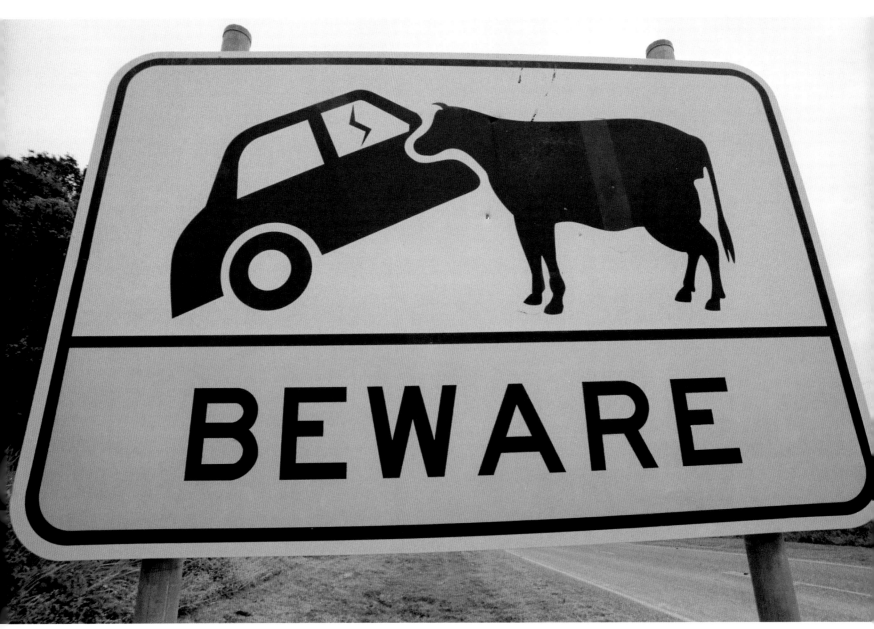

beware, innisfail, QLD

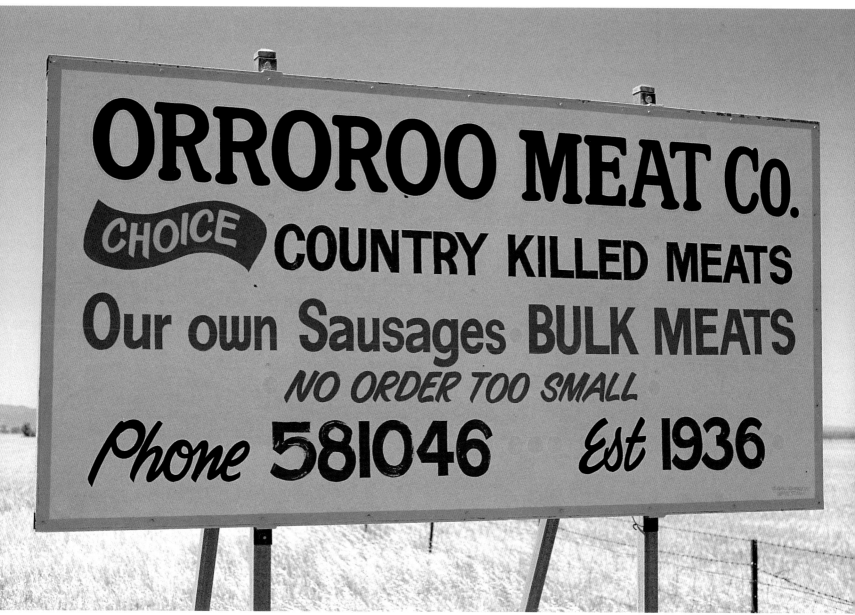

no order too small, ororoo, SA

men, halls creek, WA

- NO GROG
- NO GUNS
- NO WEAPONS
- NO DRUNKS

NO FRED

no fred, tanami track, NT

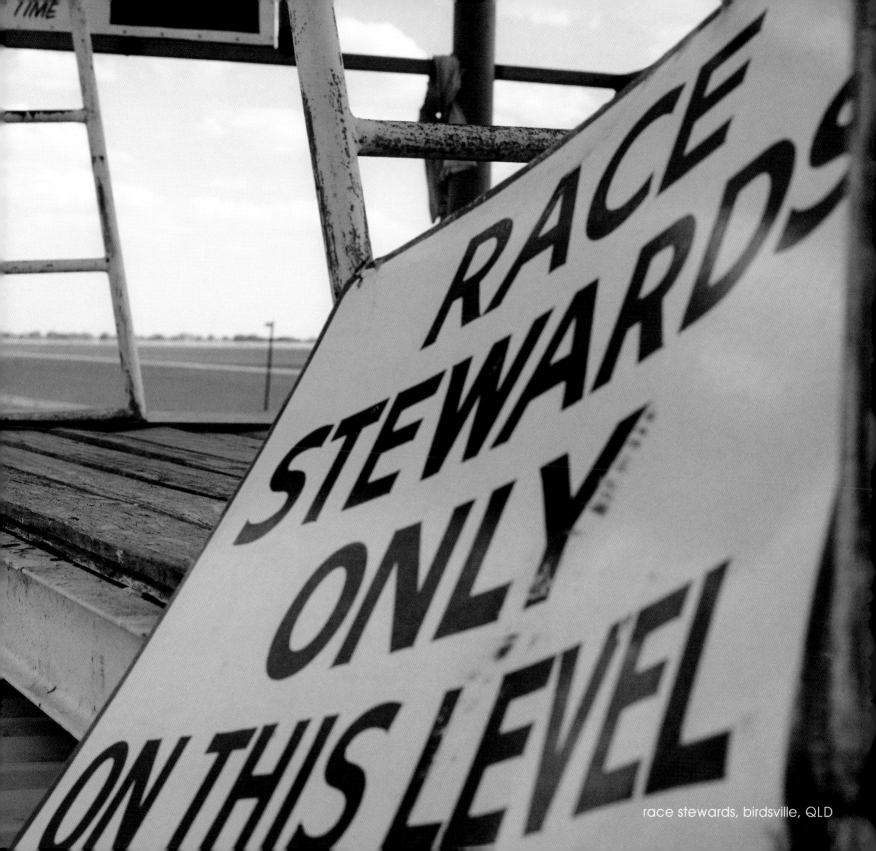

TIME

RACE STEWARDS ONLY ON THIS LEVEL

race stewards, birdsville, QLD

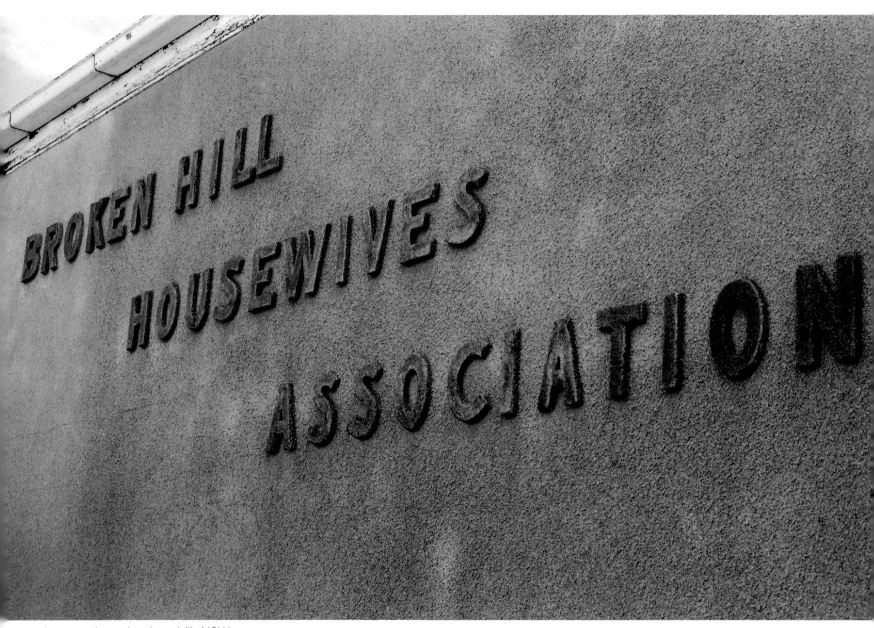

housewives, broken hill, NSW

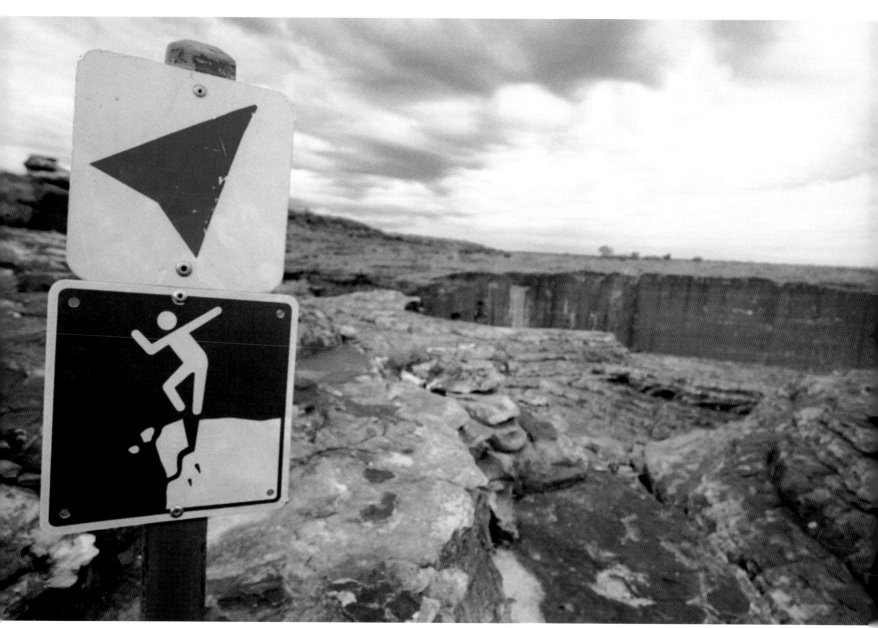

falling man, kings canyon, NT

WELCOME TO PARABURDOO
A K.A.B.C. 5 STAR TIDY TOWN

ENCOURAGEMENT AWARD 1988
2nd CATEGORY D 1989
1st CATEGORY D 1990
1st OVERALL STATE 1991

PLEASE USE BINS PROVIDED

TIDY TOWNS WINNER

2ND CATEGORY "E"
1ST CATEGORY "E" 1992
OVERALL STATE WINNER 1993
95 "2nd" CATEGORY "E"
96 "1st" CATEGORY "E"

tidy town, paraburdoo, WA

Rodeo

Laura is set in rugged scrub country approximately three hundred kilometres North West of Cairns. The Laura rodeo produces unmerciful beasts and the most brave riders. There is a great sense of community as the old hands encourage and assist a new generation of riders during their rights of passage to manhood. The youngest settle for the mechanical bull.

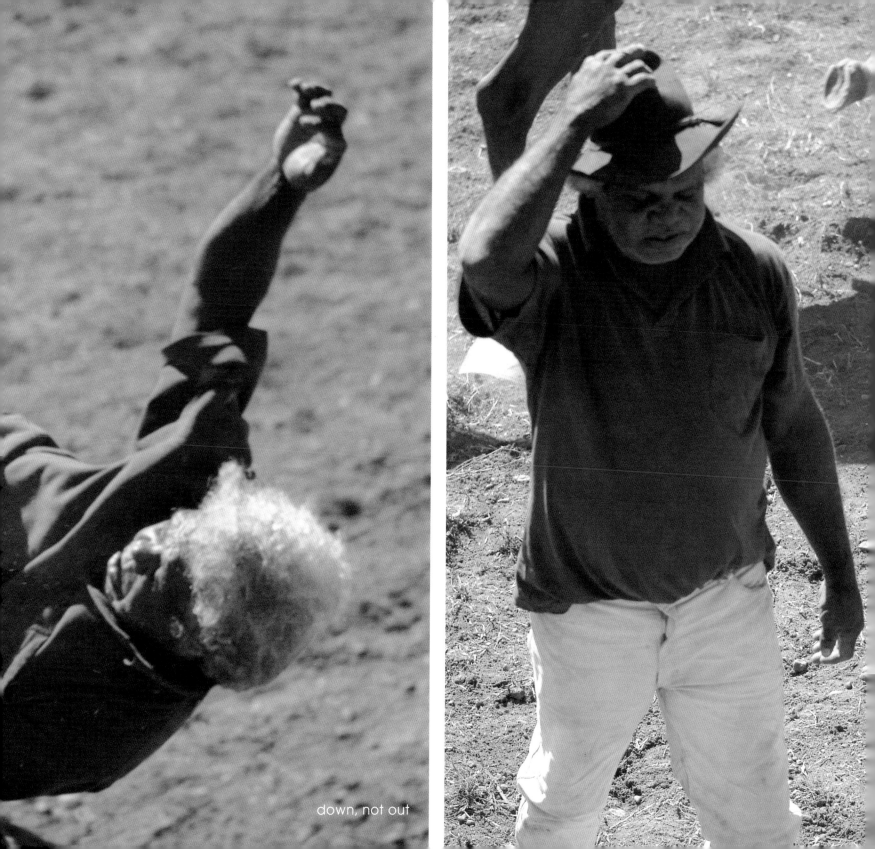

down, not out

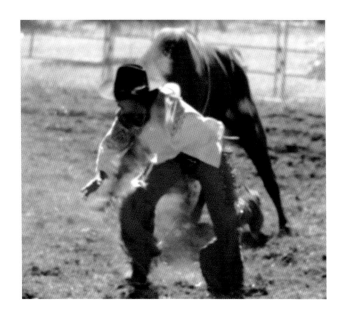
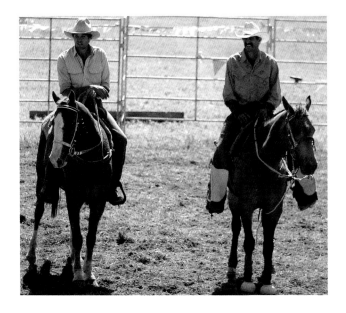
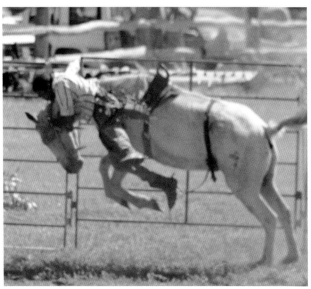
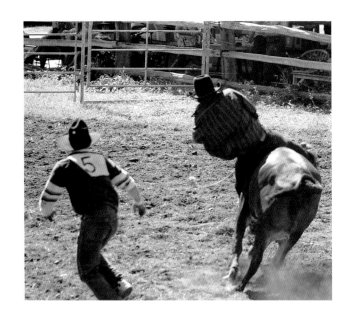

rough riders

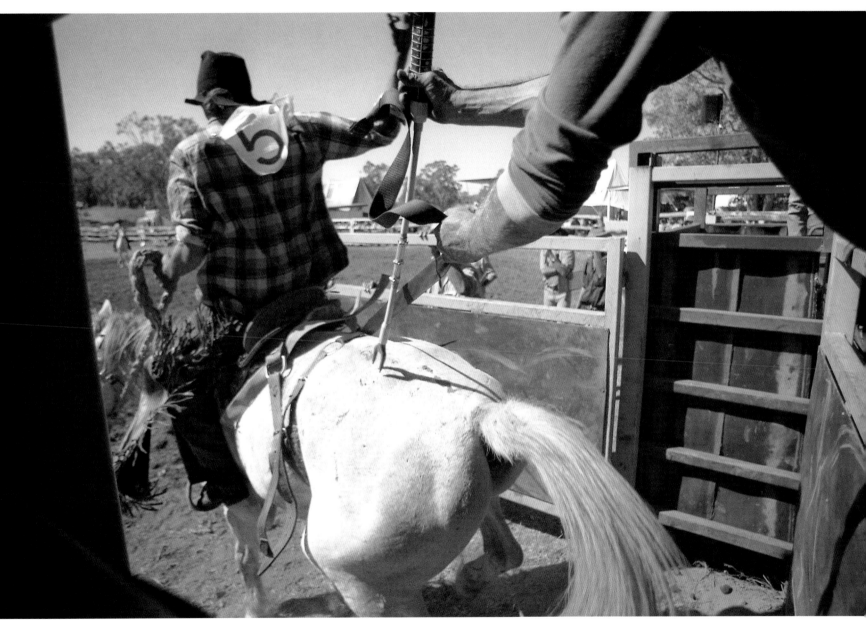

leaving the chute

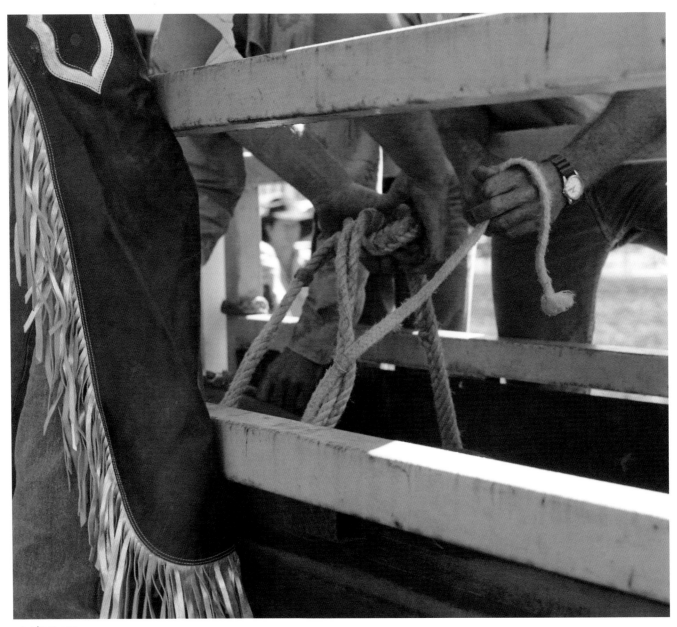

roping up

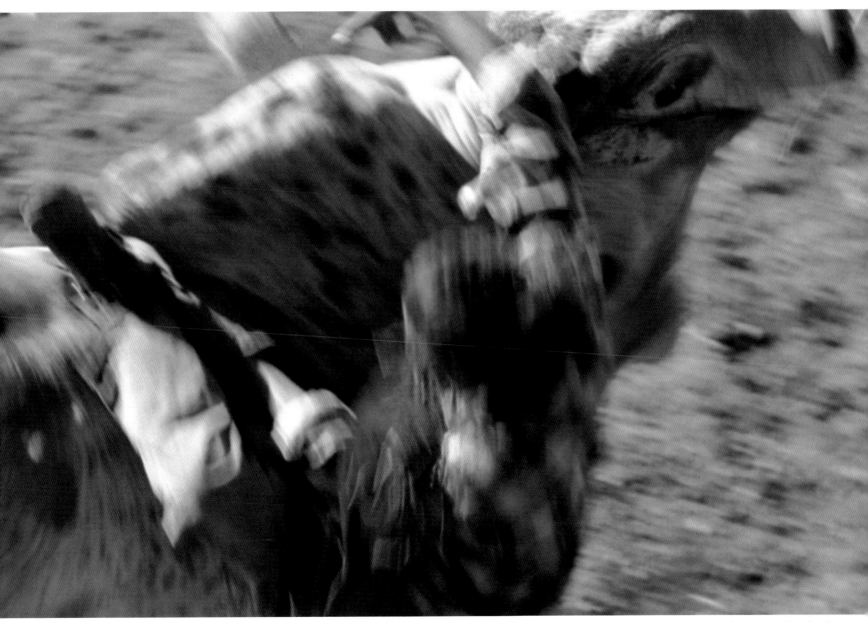

leaving the bull

in the yards

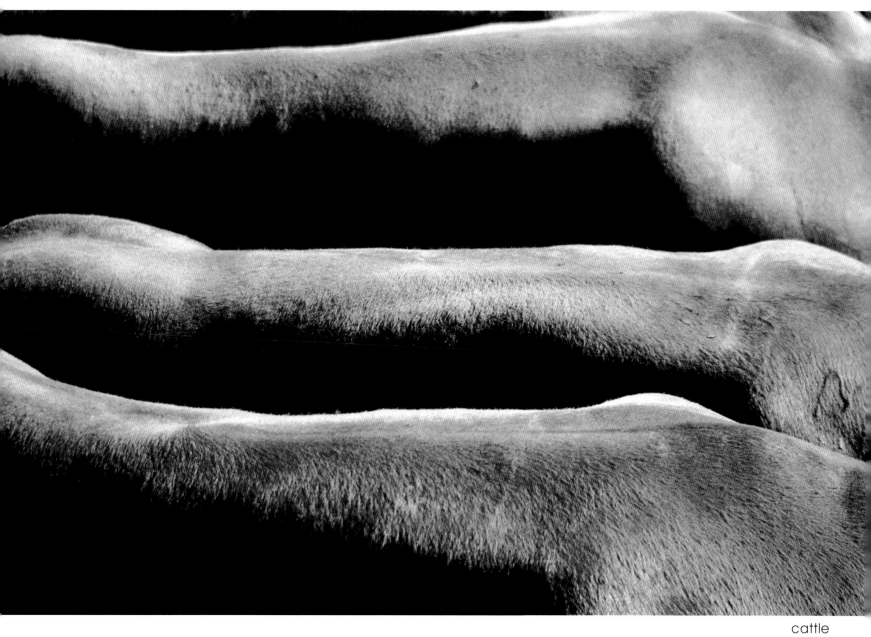

cattle

eye on the spur

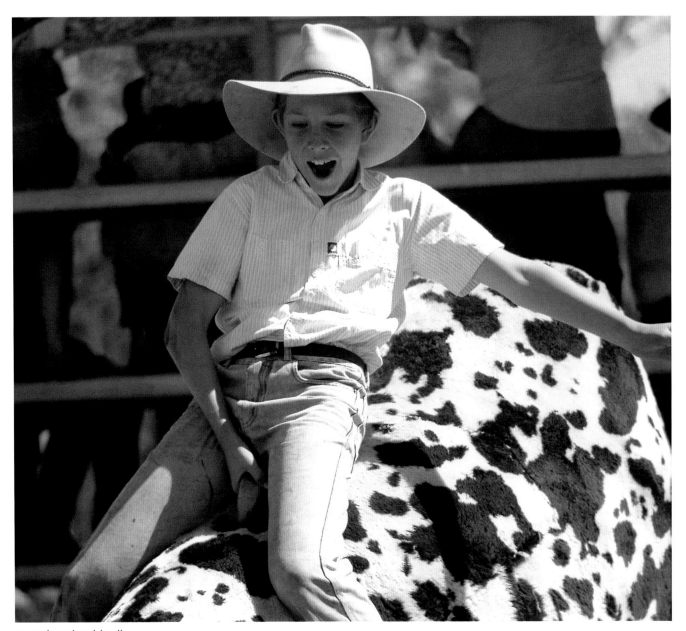

mechanical bull

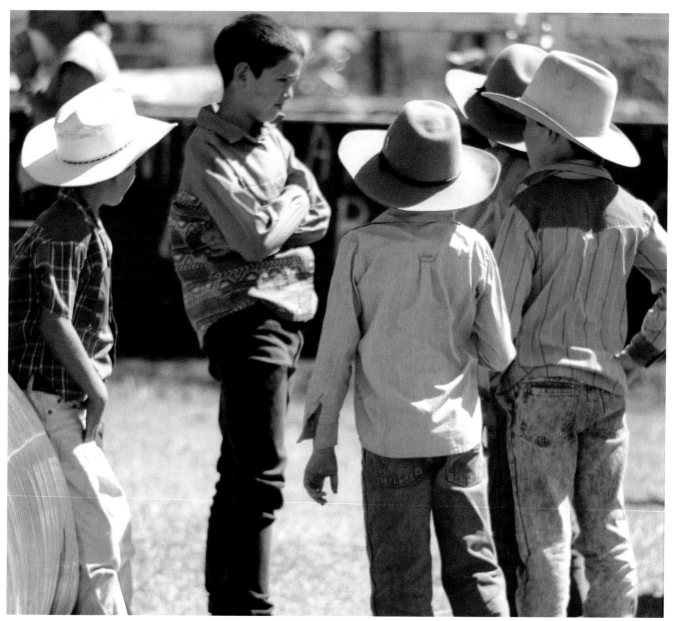

the gang

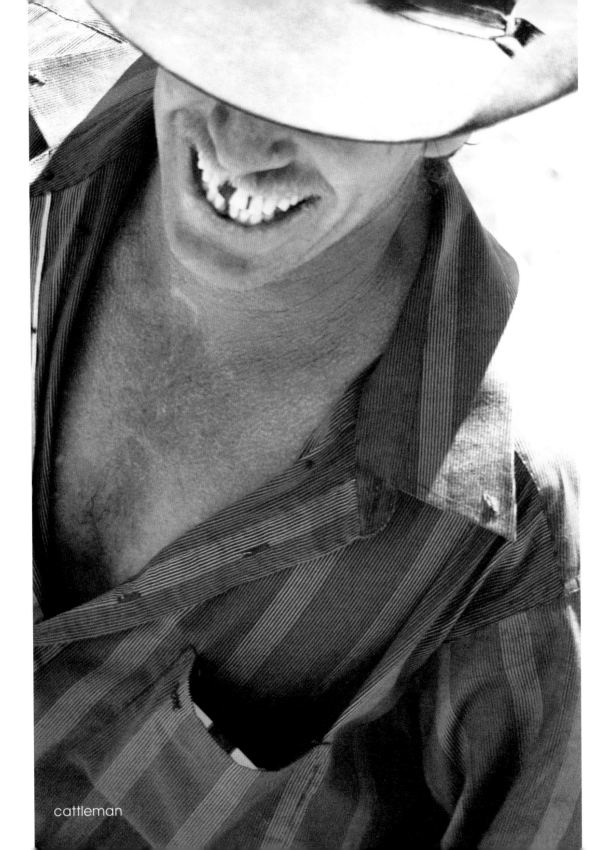

cattleman

chaps

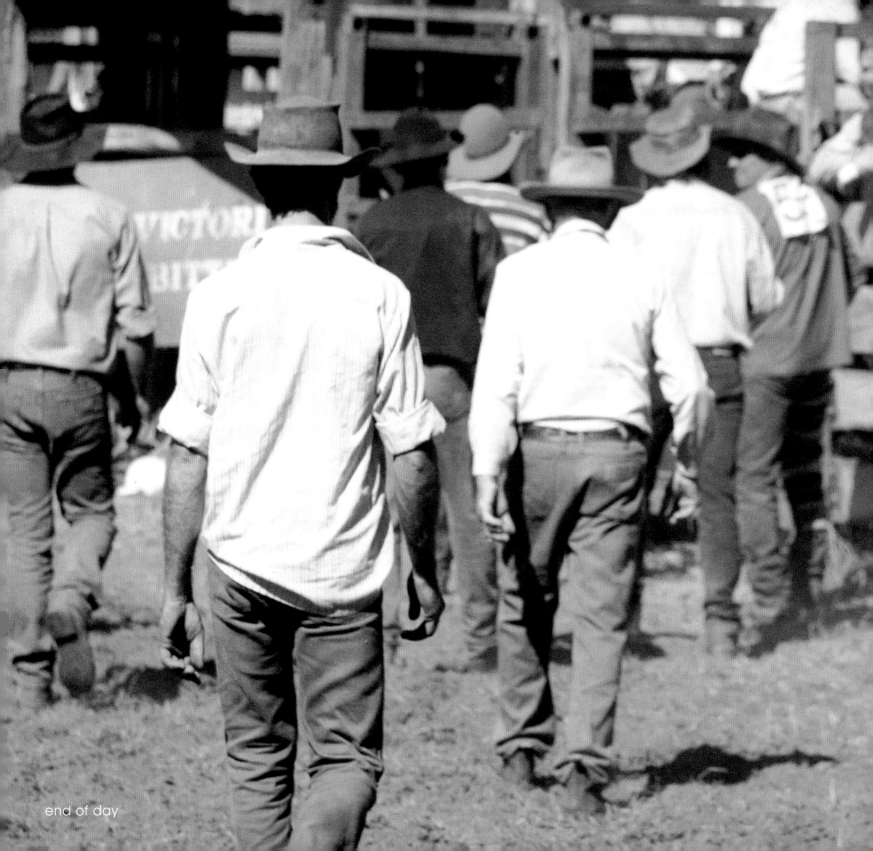

end of day

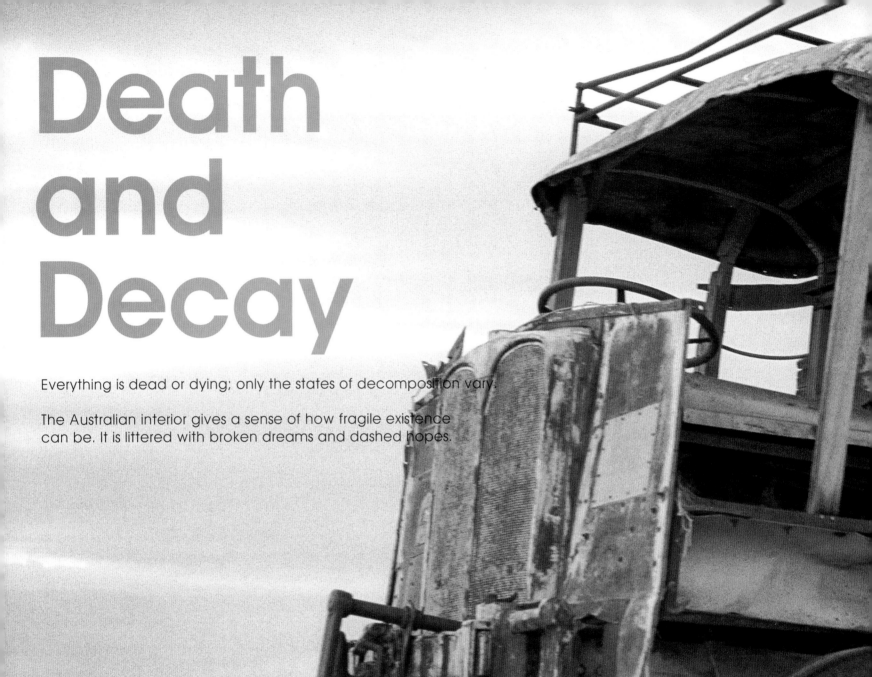

Death
and
Decay

Everything is dead or dying; only the states of decomposition vary.

The Australian interior gives a sense of how fragile existence
can be. It is littered with broken dreams and dashed hopes.

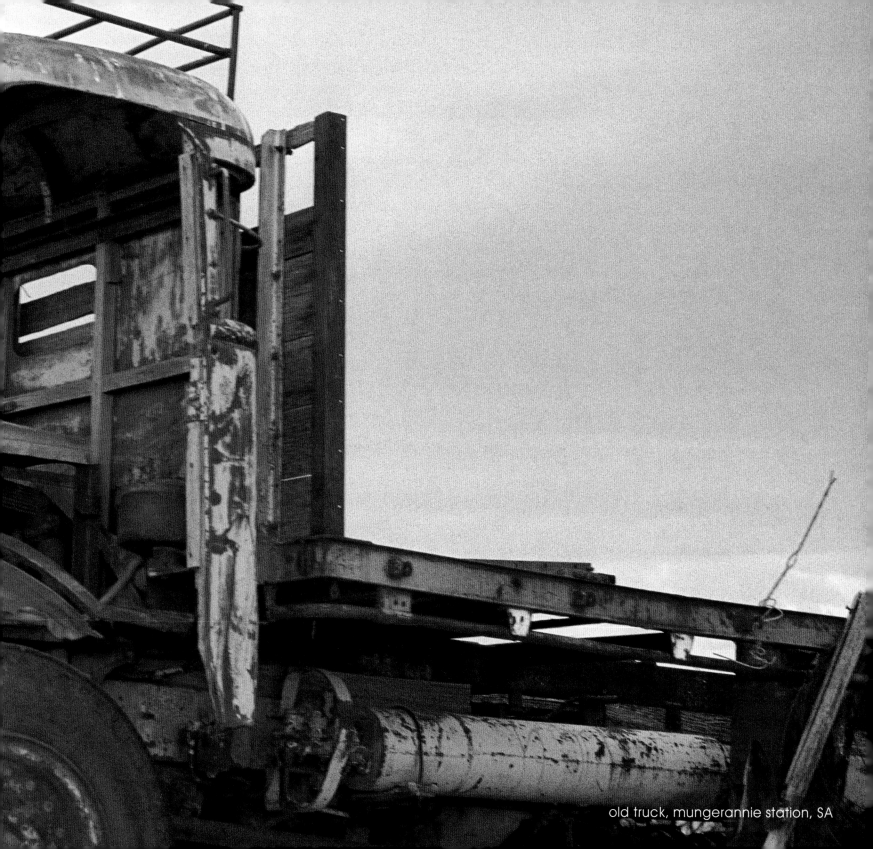

old truck, mungerannie station, SA

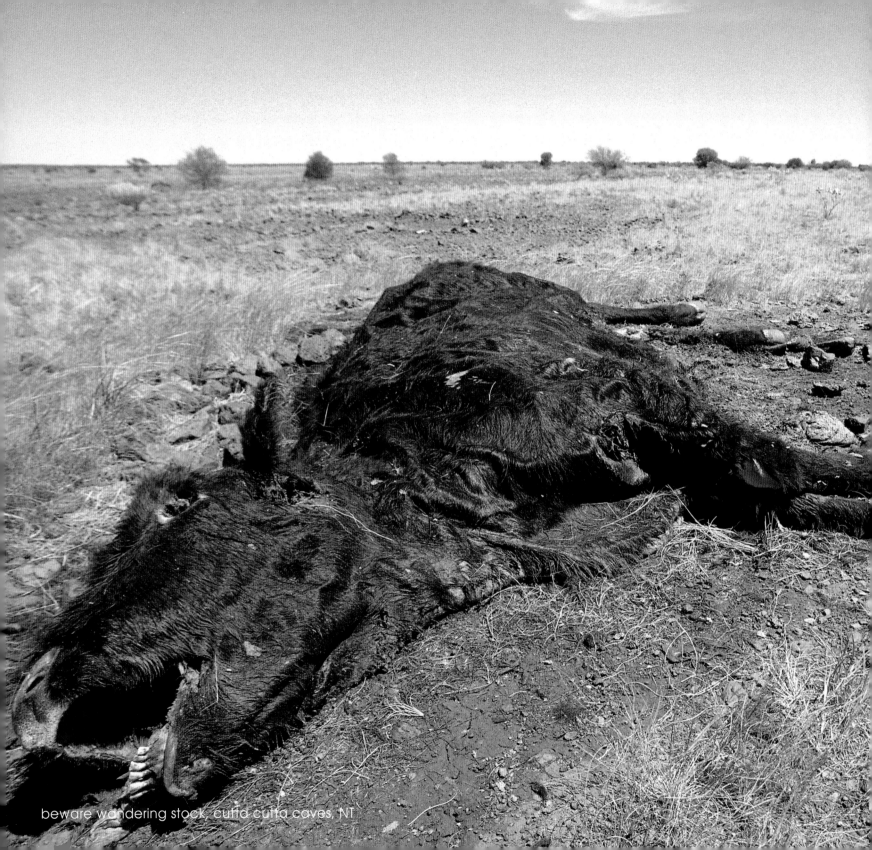

beware wandering stock, cutta cutta caves, NT

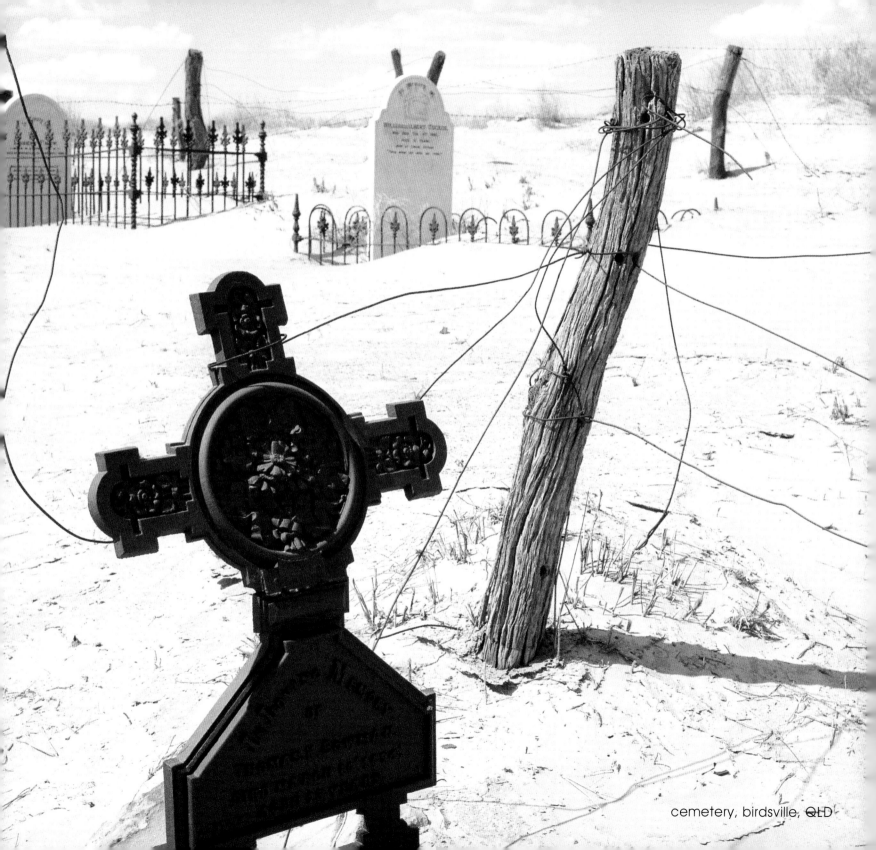

cemetery, birdsville, QLD

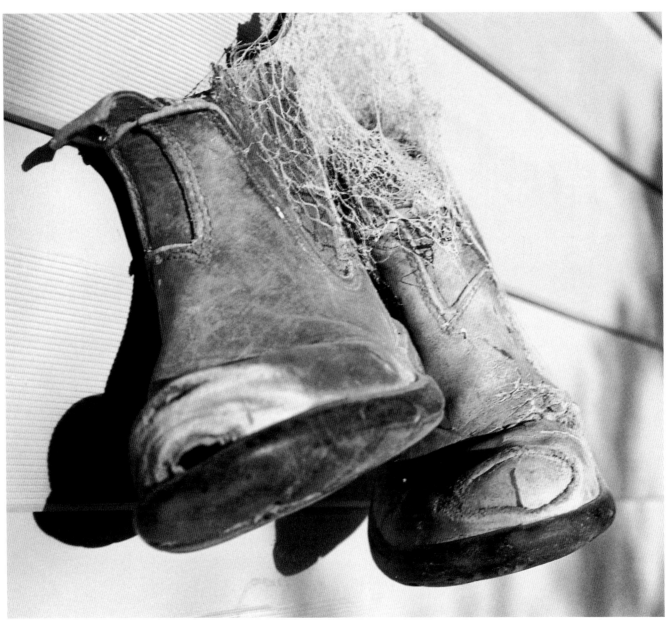

boots, mungerannie station, SA

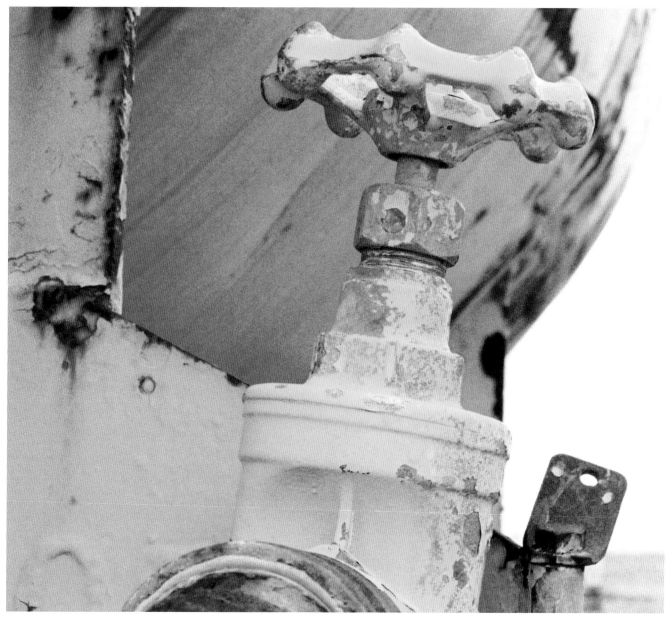

tap, weipa, QLD

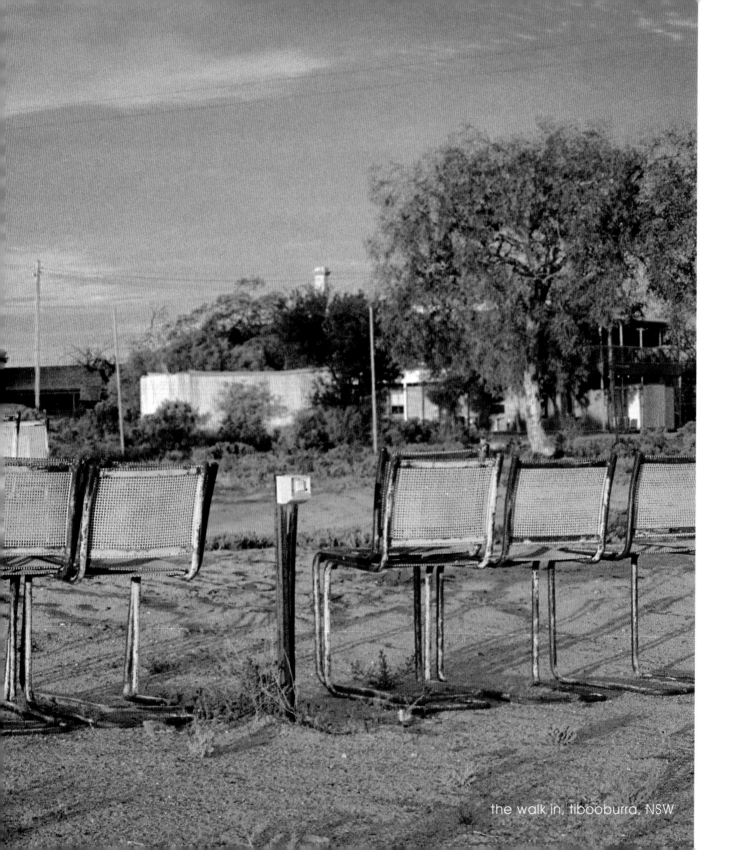

the walk in, tibooburra, NSW

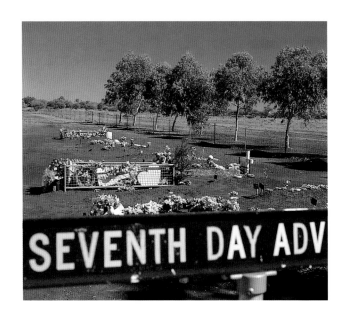
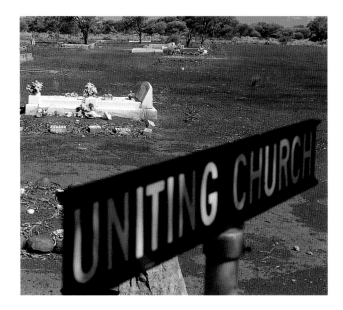
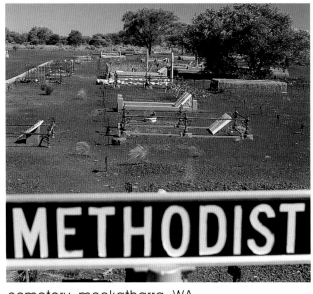
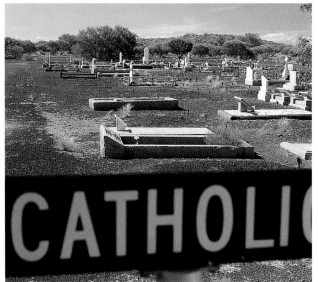

cemetery, meekatharra, WA

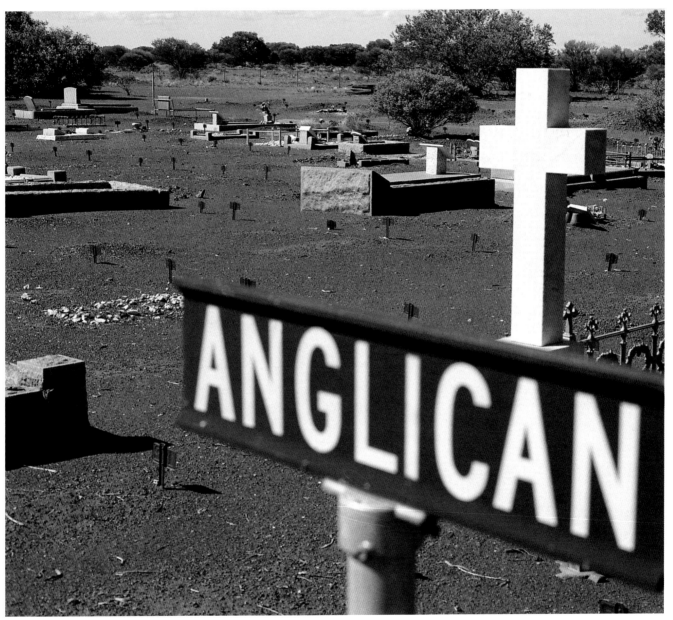

cemetery, meekatharra, WA

farm house, big desert, VIC

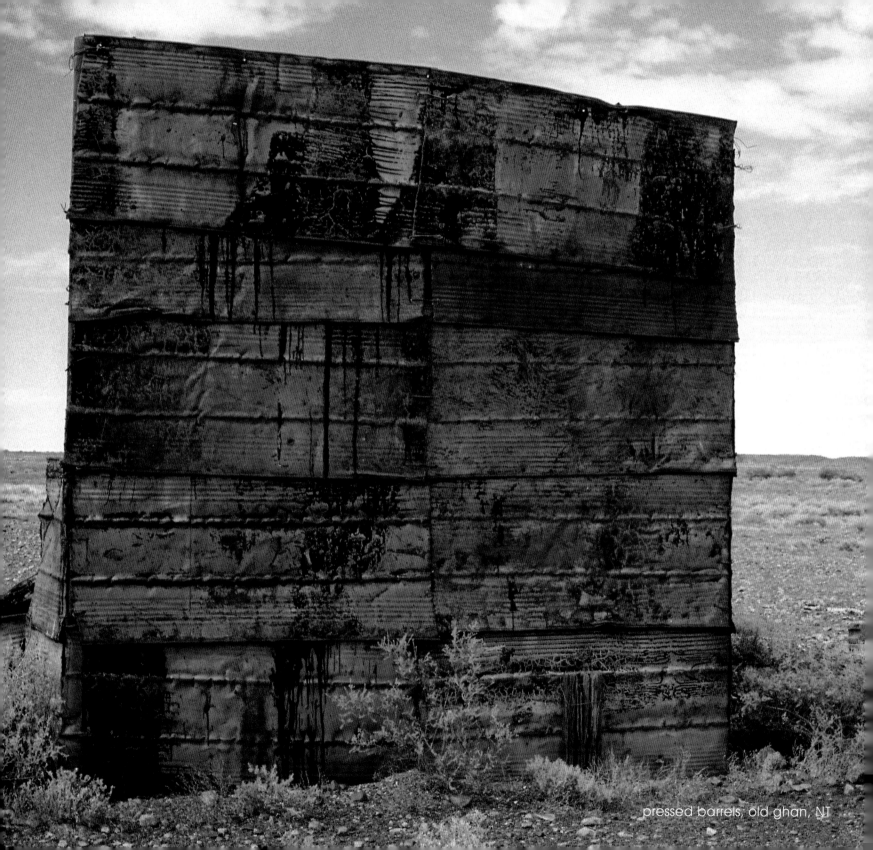

pressed barrels, old ghan, NT

shorts, broken hill, NSW

abandoned homestead, the kimberley, WA

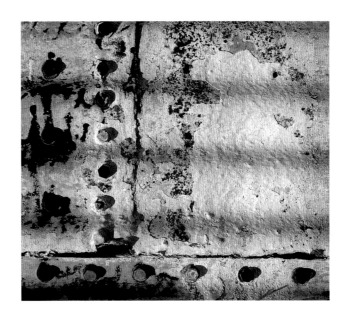

abandoned homestead, the kimberley, WA

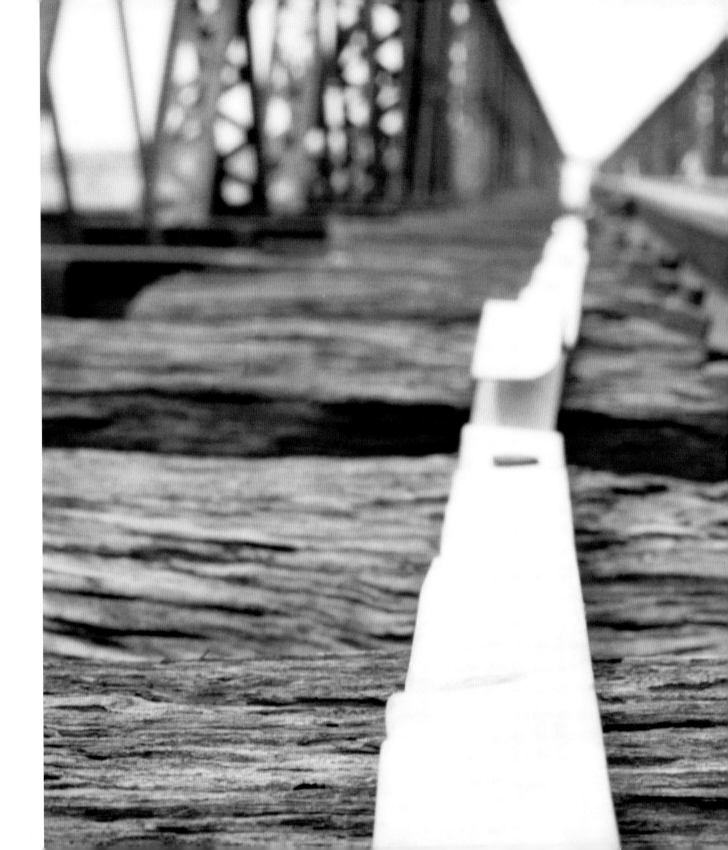

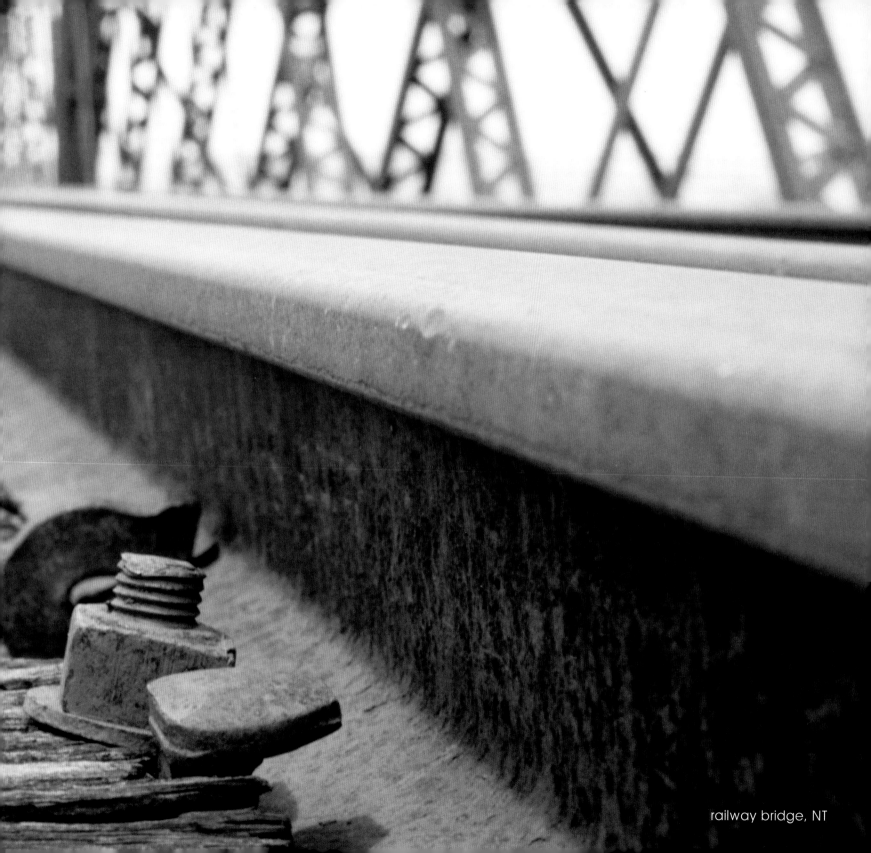

railway bridge, NT

corrugated fence, kalgoorlie, WA

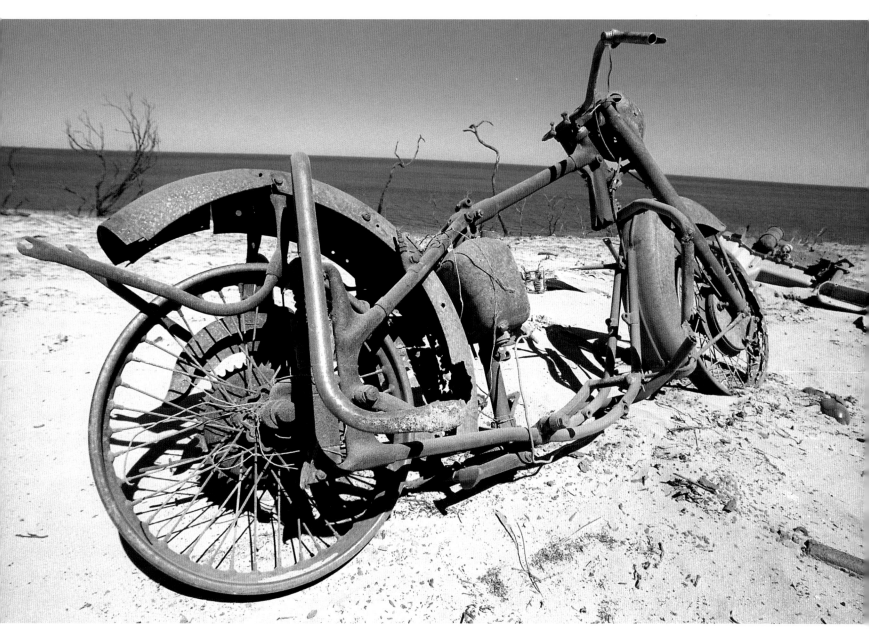

motor bike, seven mile beach, WA

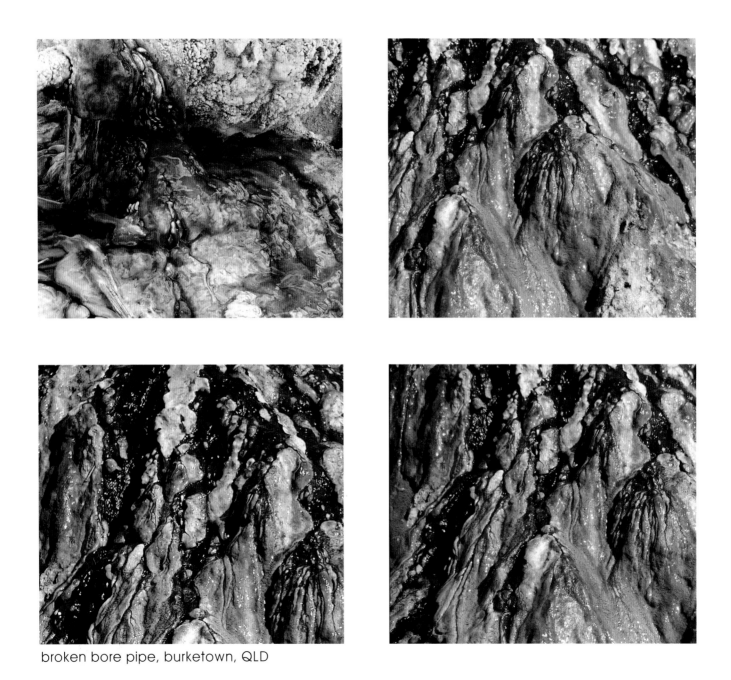

broken bore pipe, burketown, QLD

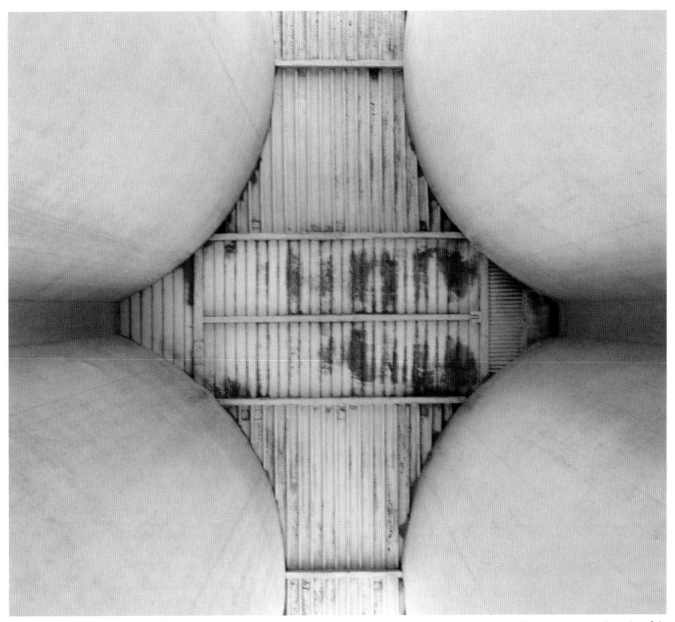

silo, eyre peninsula, SA

kangaroo, boulia, QLD

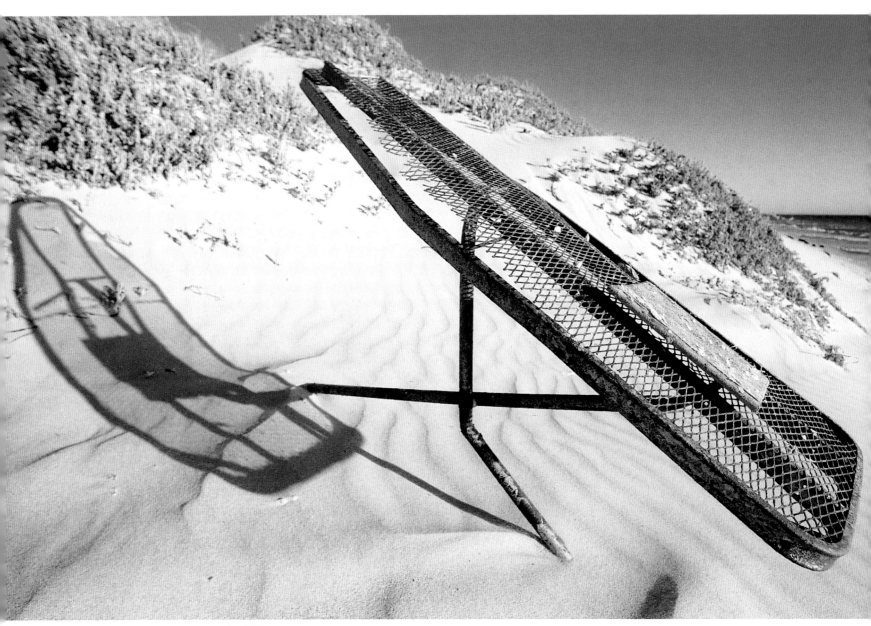

ironing board, carsons beach, WA

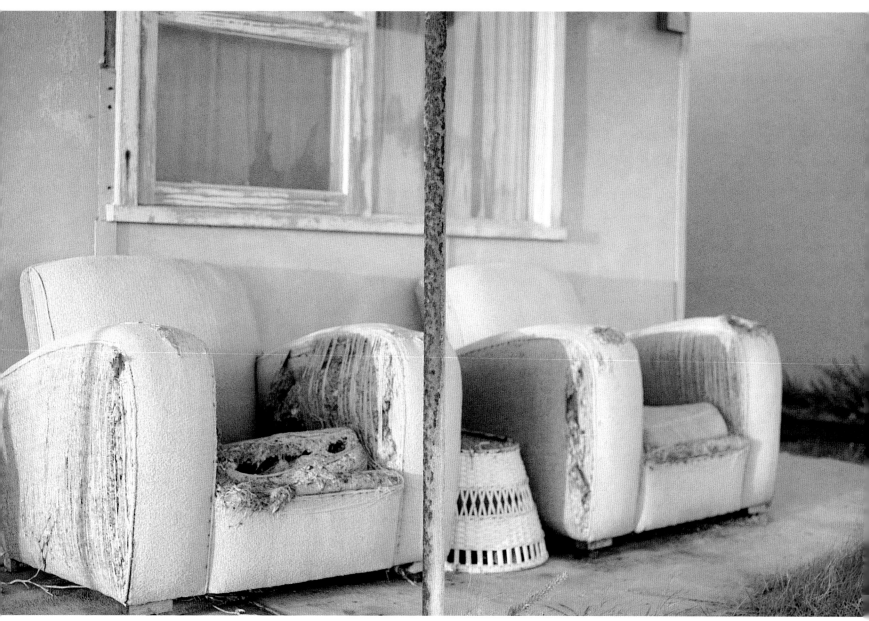

view for two, lucky bay, SA

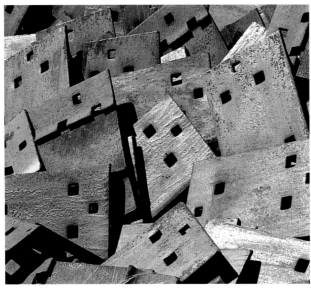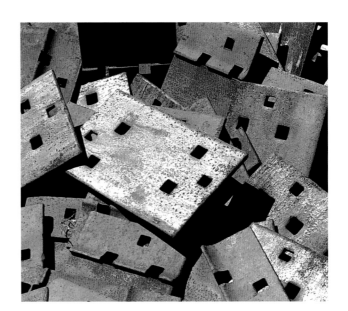

rail cleats, wiluna, WA

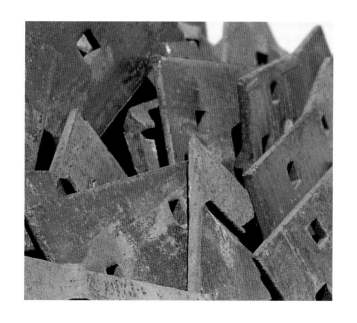

rail cleats, wiluna, WA

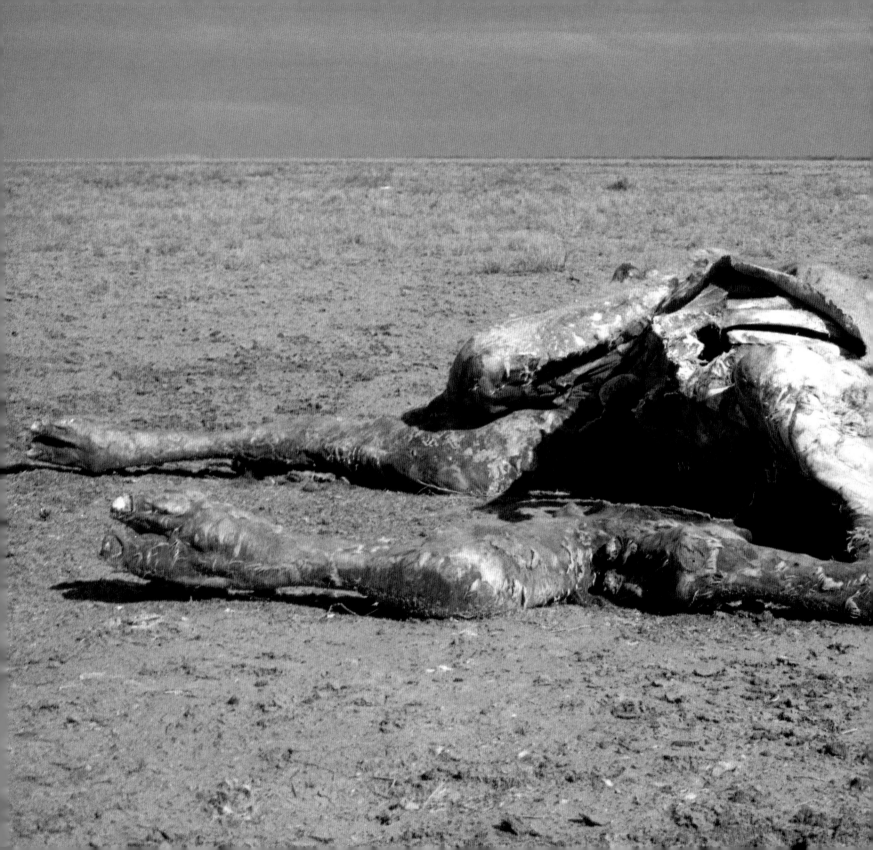

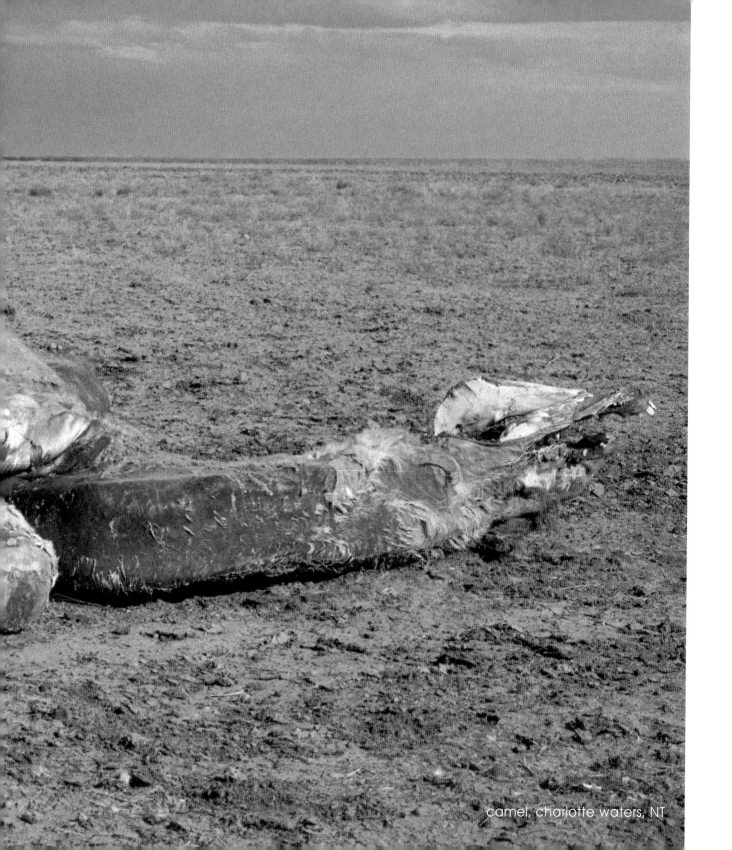

camel, charlotte waters, NT

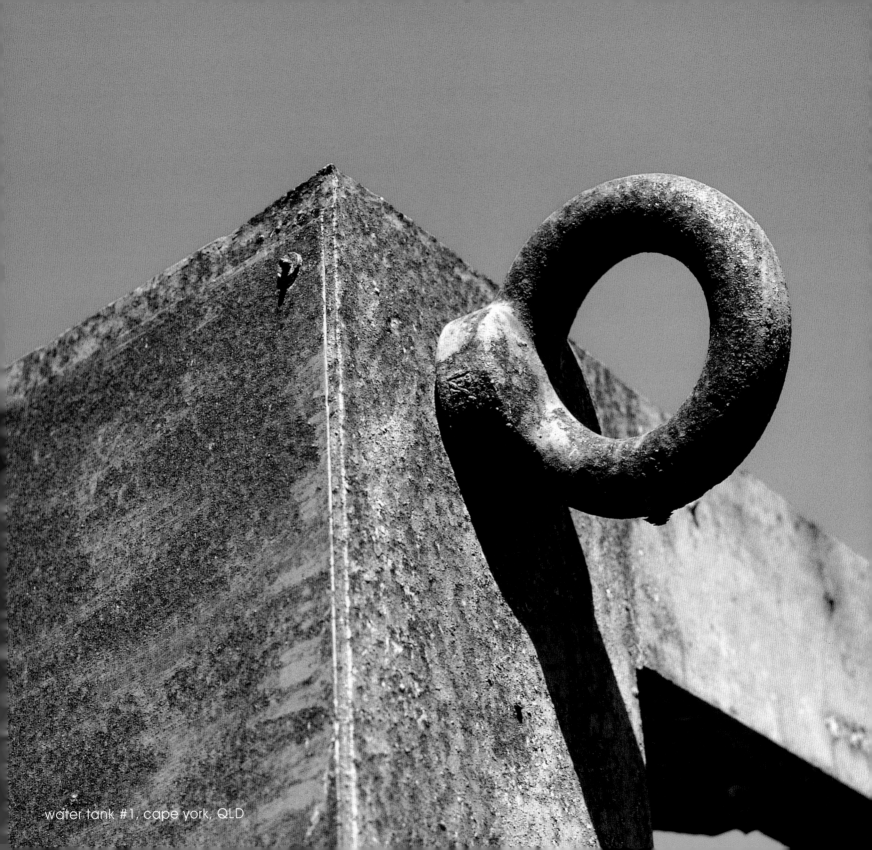

water tank #1, cape york, QLD

water tank #2, cape york, QLD

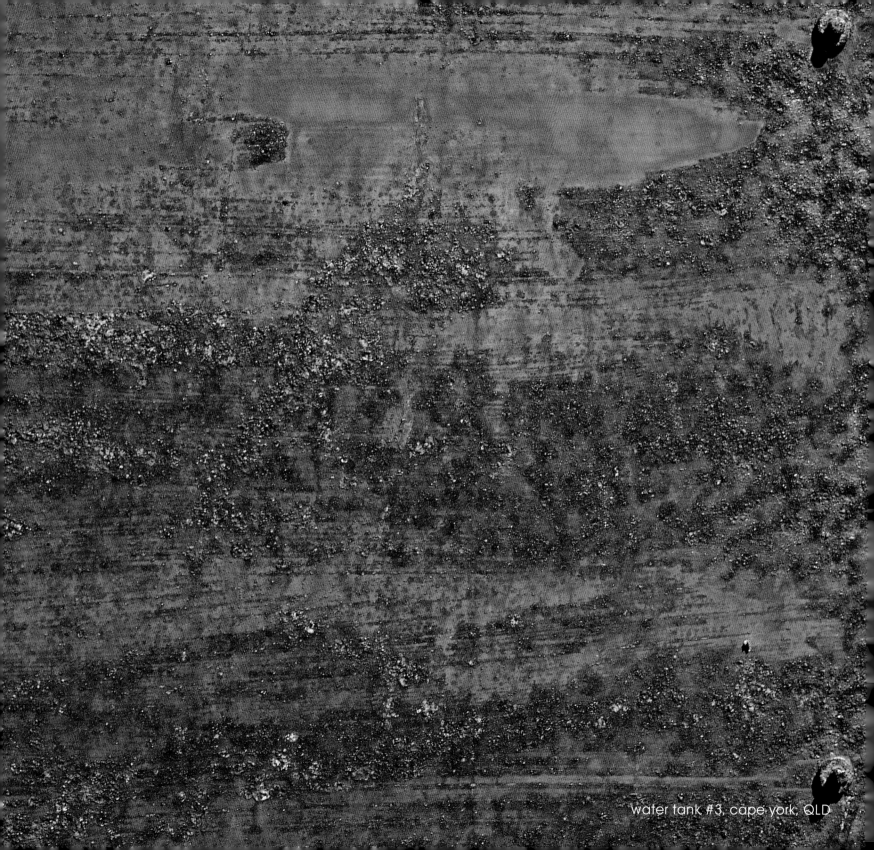

water tank #3, cape york, QLD

grave, coolgardie, WA

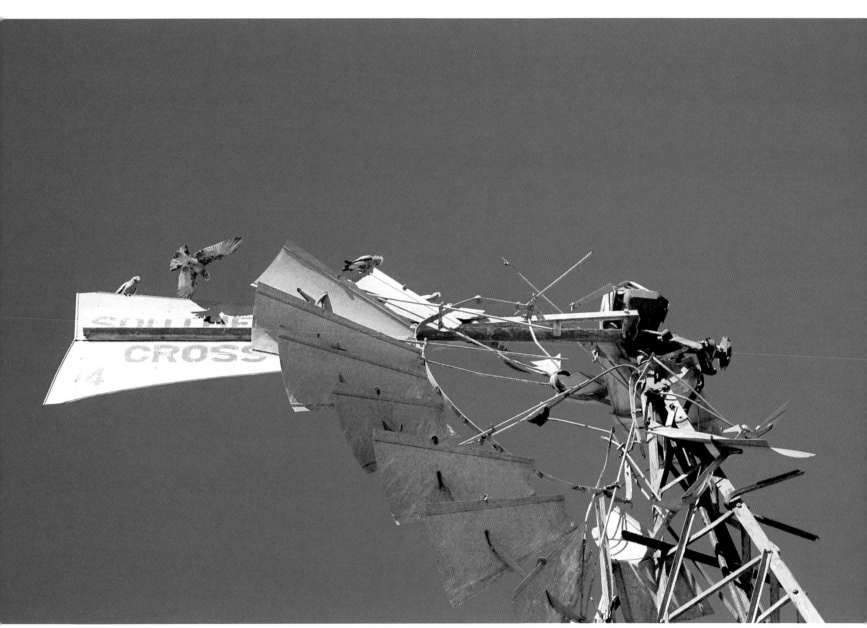

galahs, cameron corner, NSW

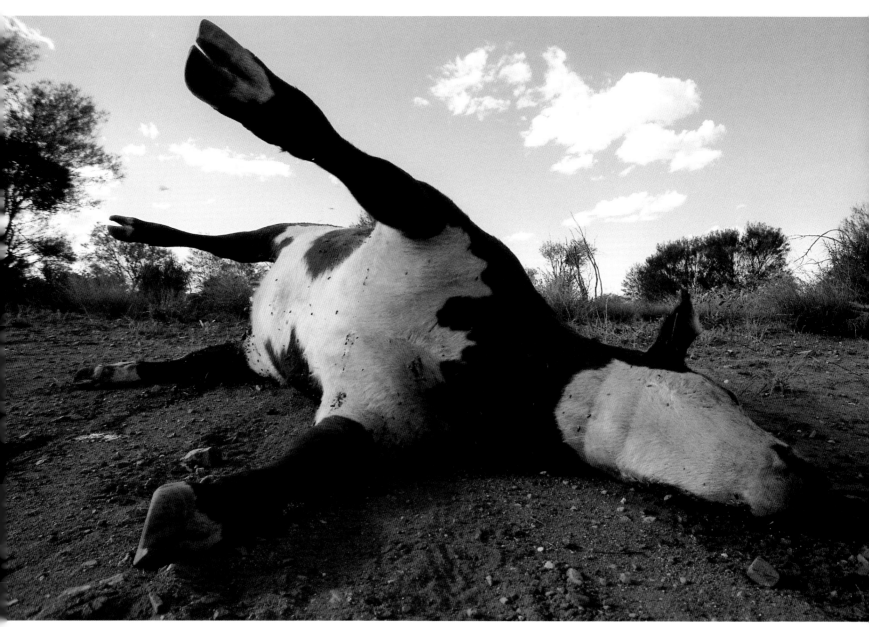

cow, wollogorang station, NT

Shifting sands

Evolving sculptures in constant flux. Desolate and hostile, sublime and inviting.

dune, ceduna, SA

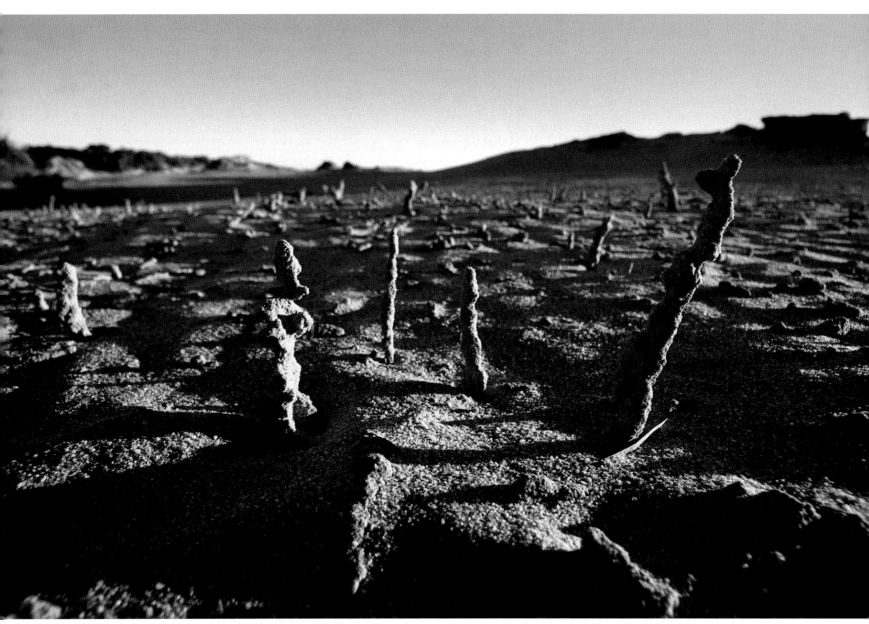

sandstone figures, pinnacles national park, WA

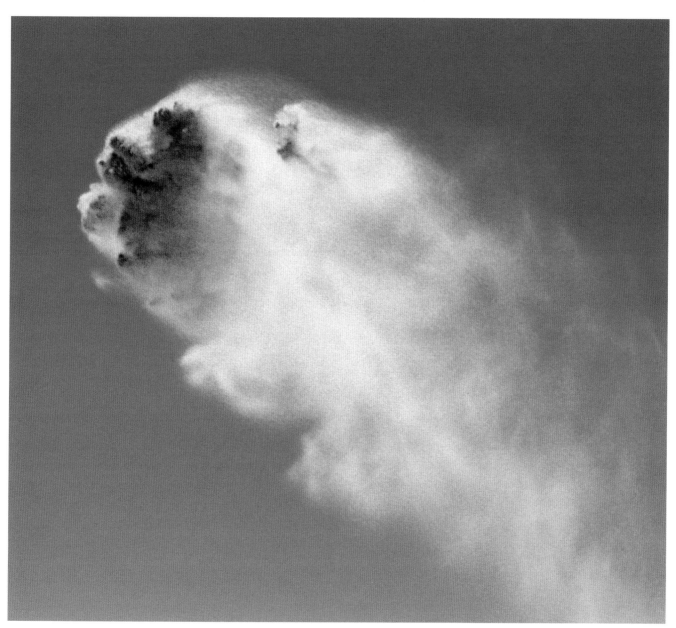

flying sand, smoky bay, SA

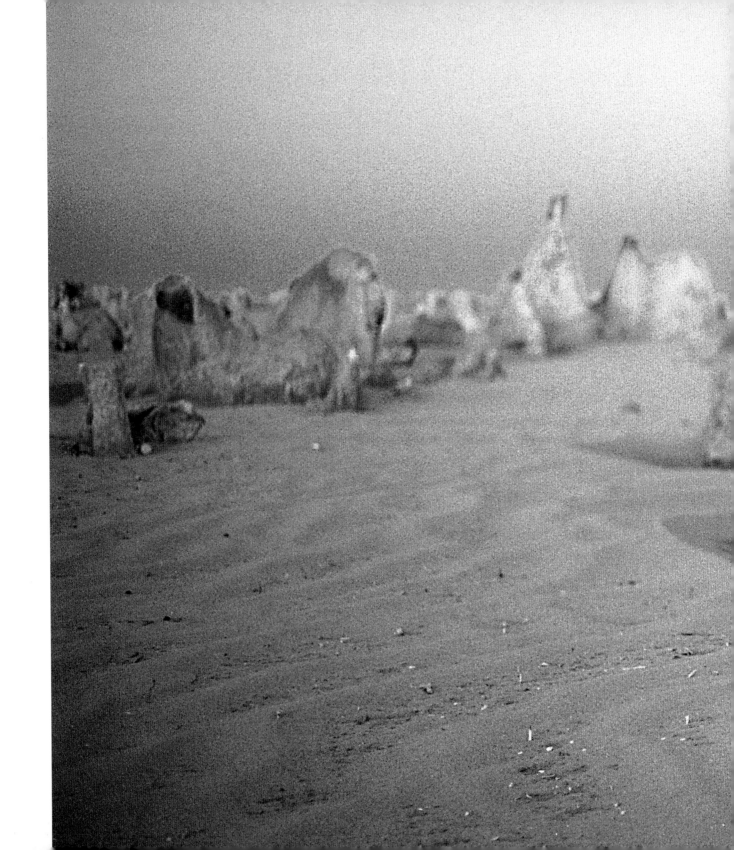

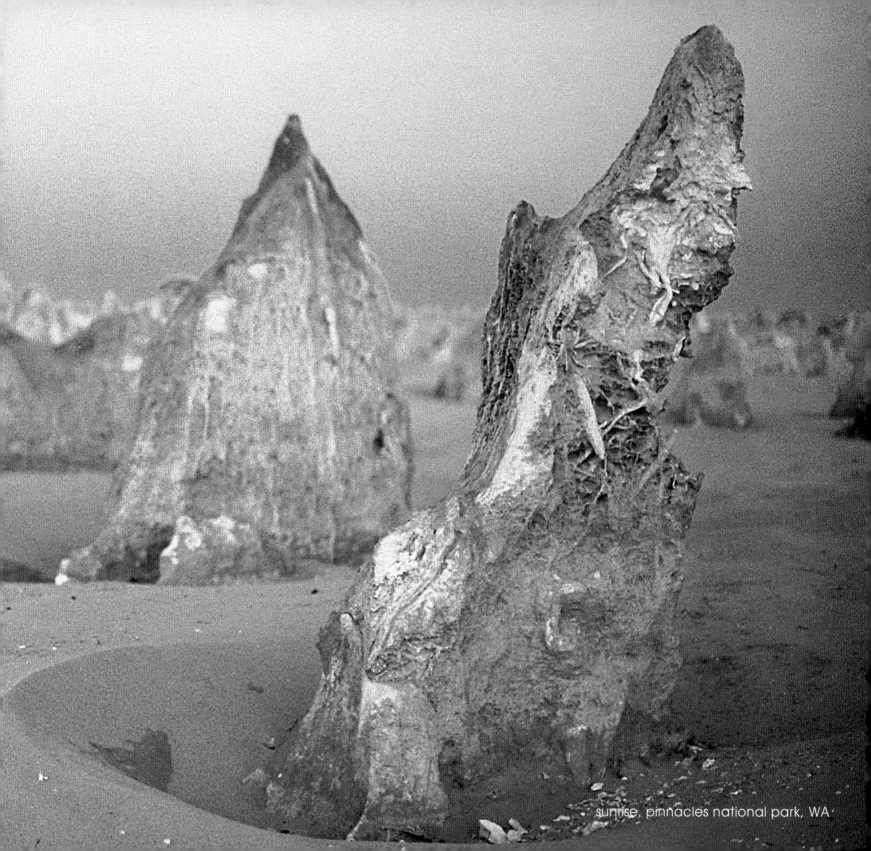
sunrise, pinnacles national park, WA

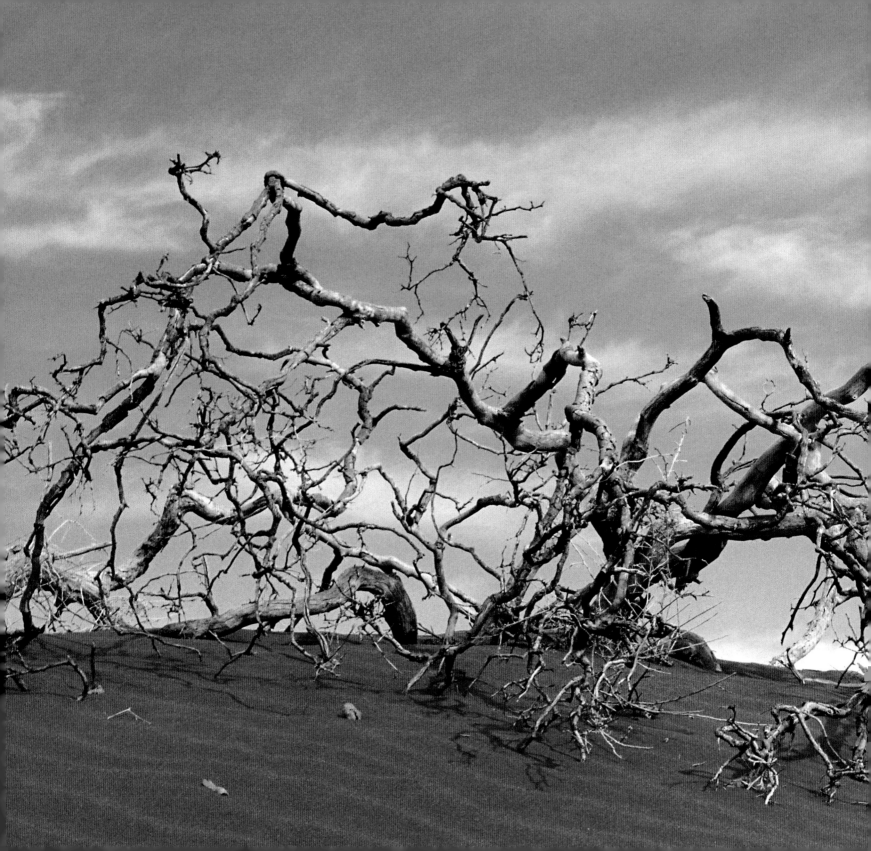

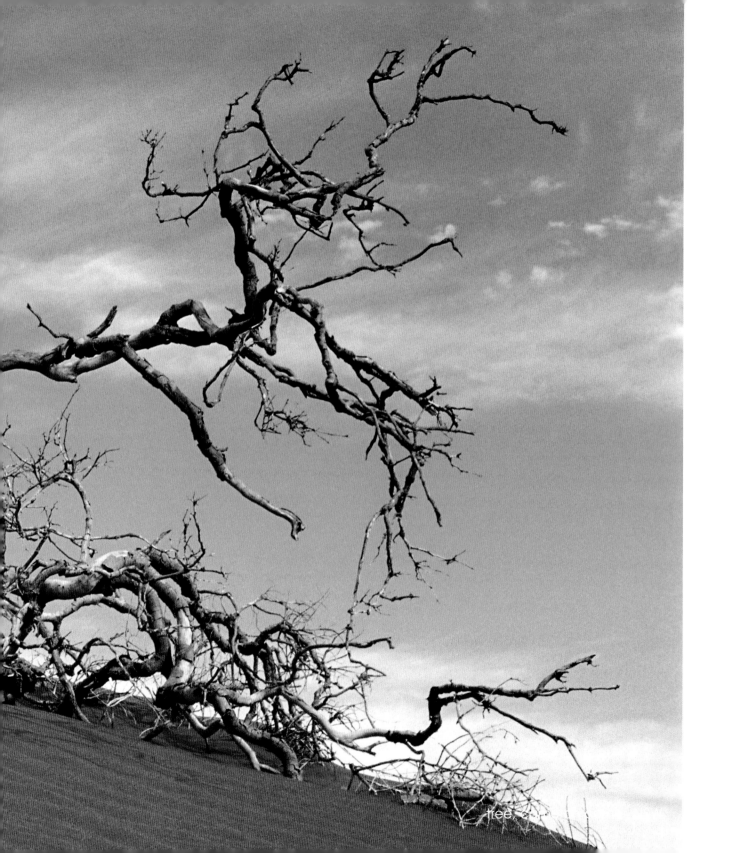

footprint, margaret river, WA

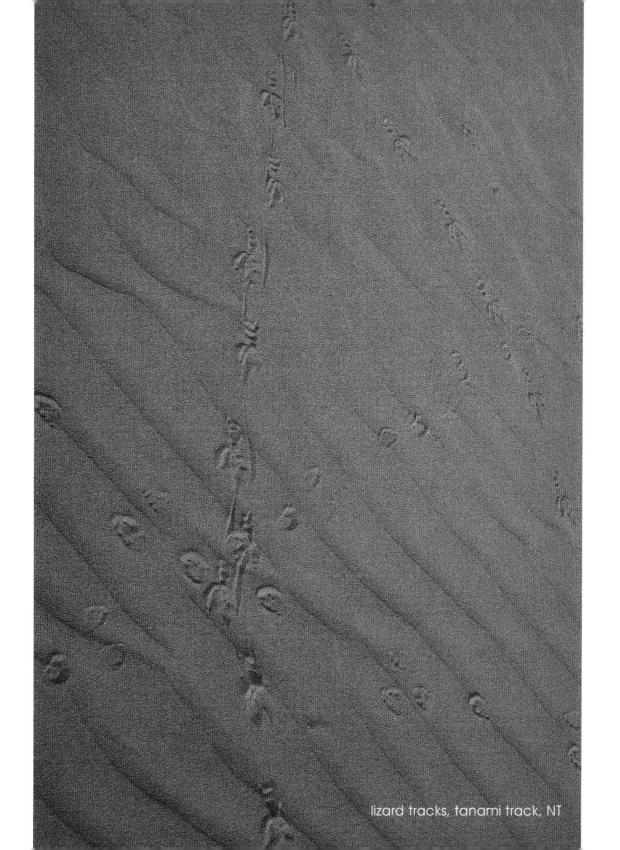

lizard tracks, tanami track, NT

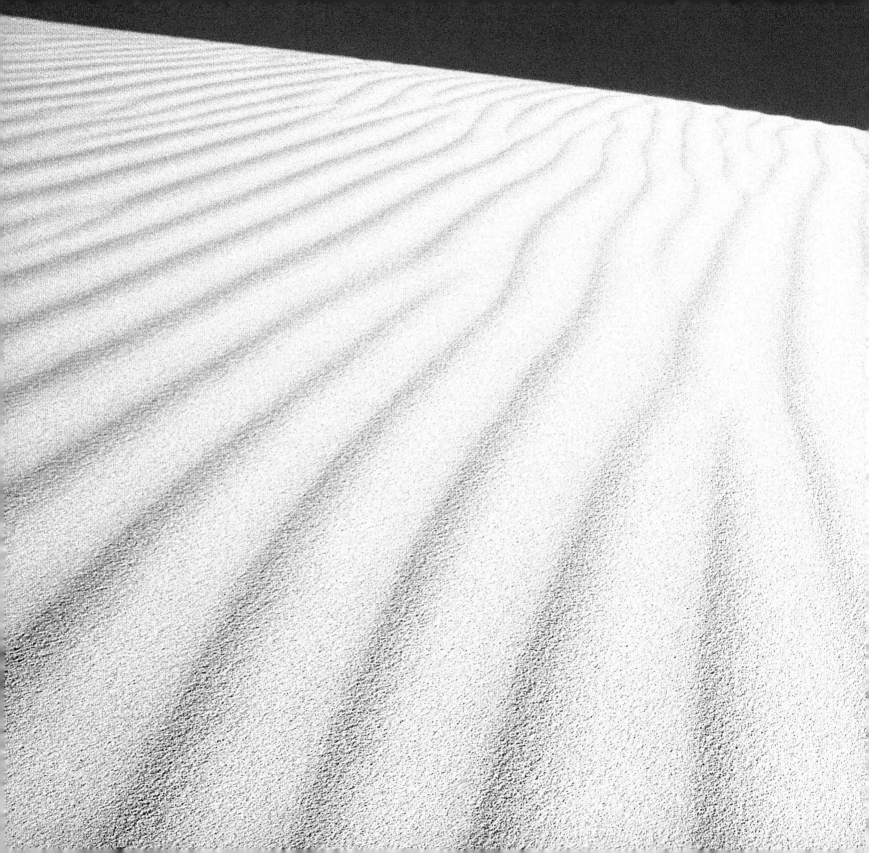

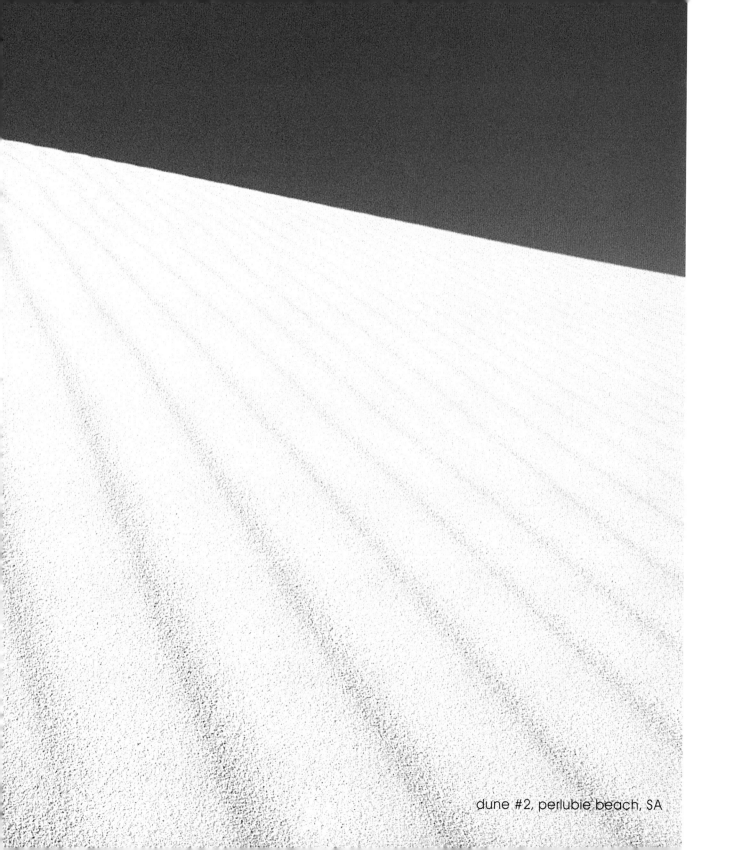

dune #2, perlubie beach, SA

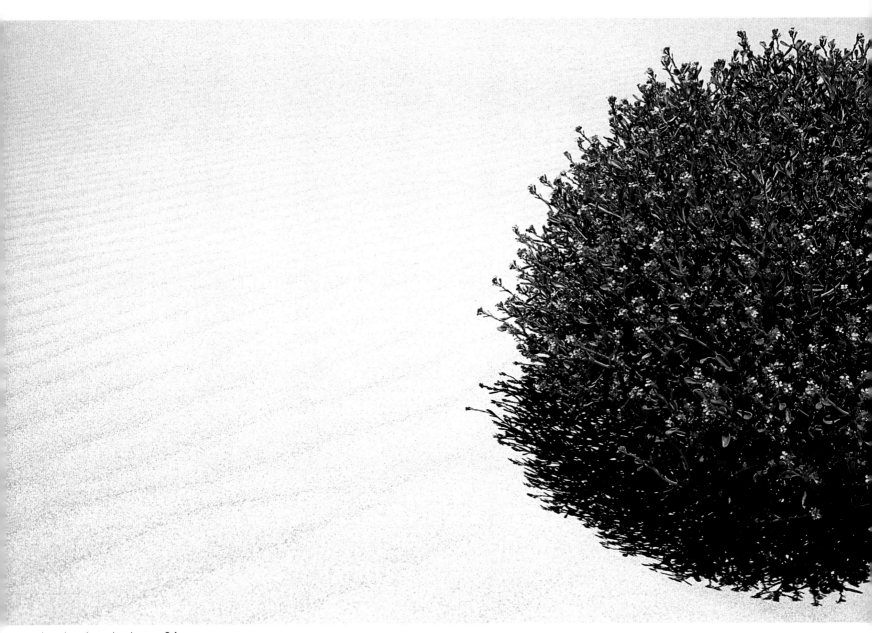

bush, streaky bay, SA

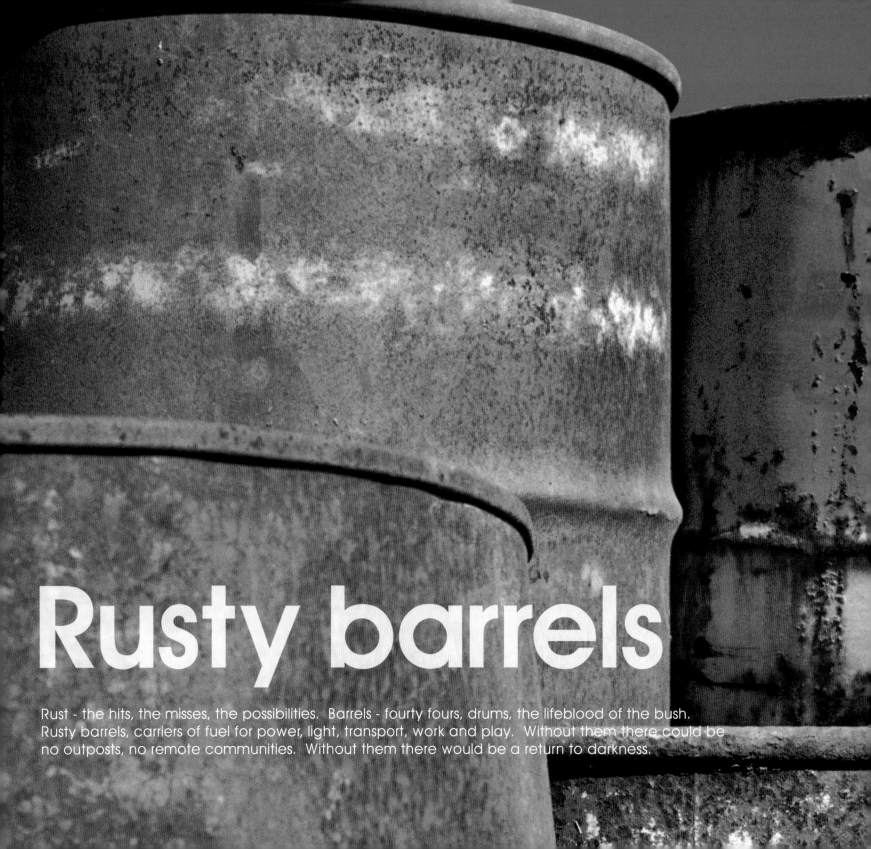

Rusty barrels

Rust - the hits, the misses, the possibilities. Barrels - fourty fours, drums, the lifeblood of the bush.
Rusty barrels, carriers of fuel for power, light, transport, work and play. Without them there could be
no outposts, no remote communities. Without them there would be a return to darkness.

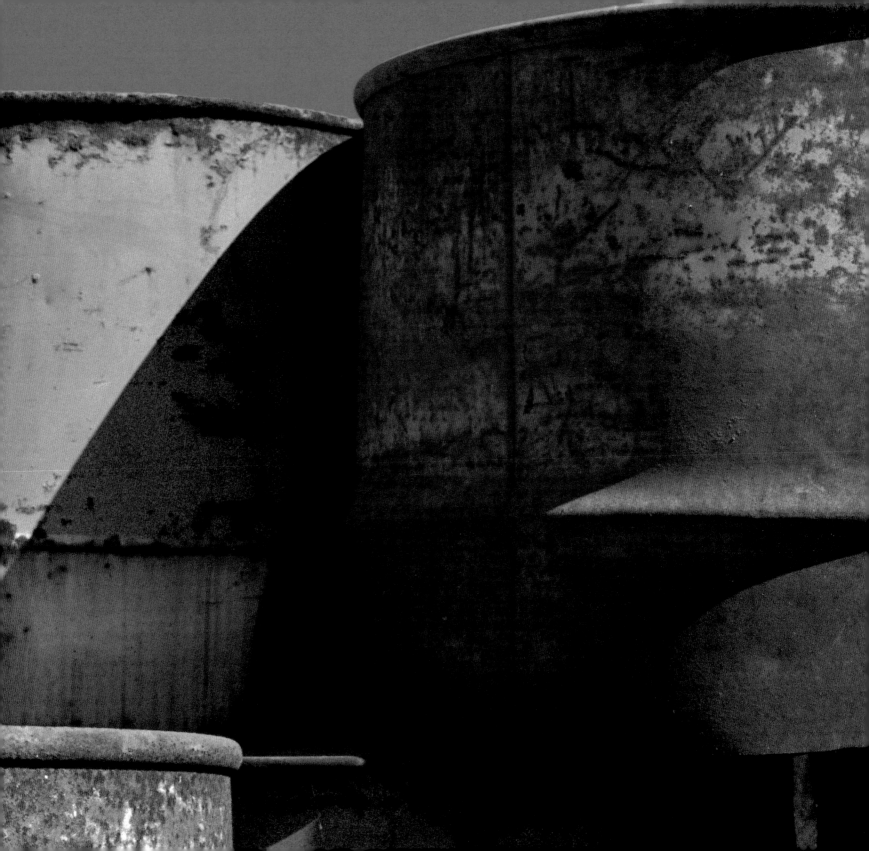

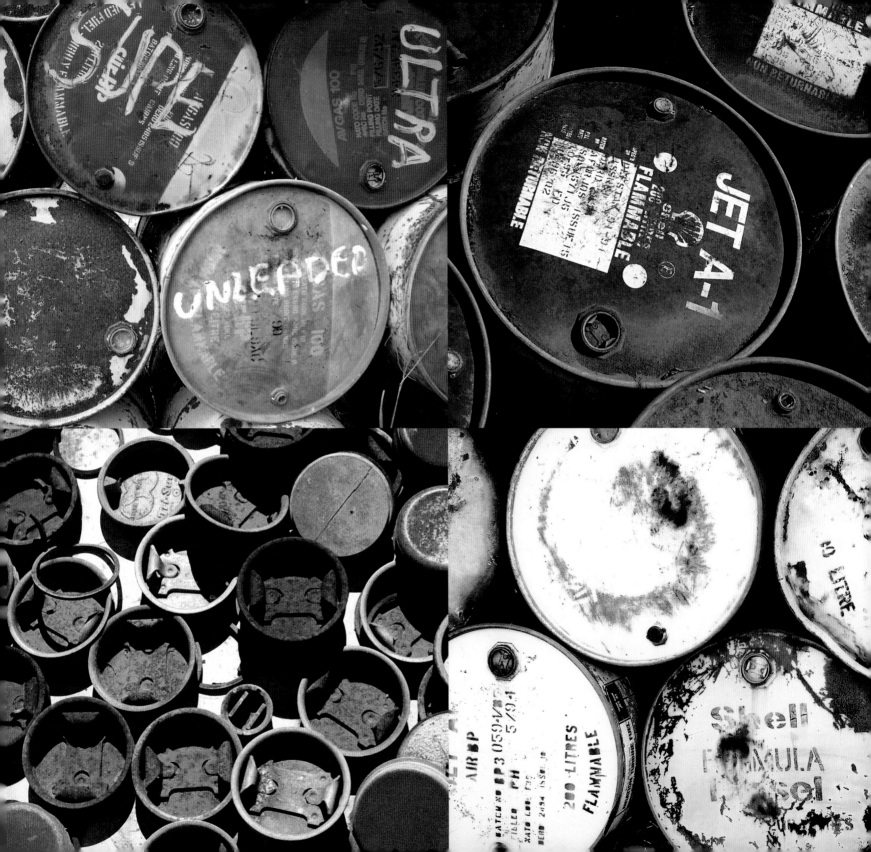

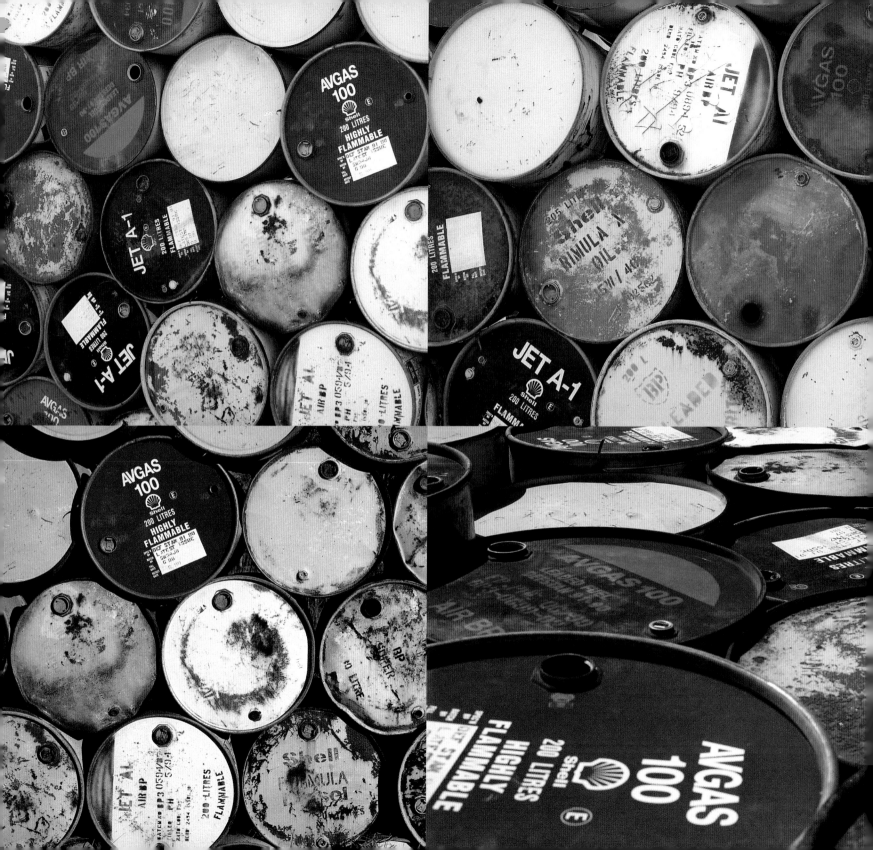

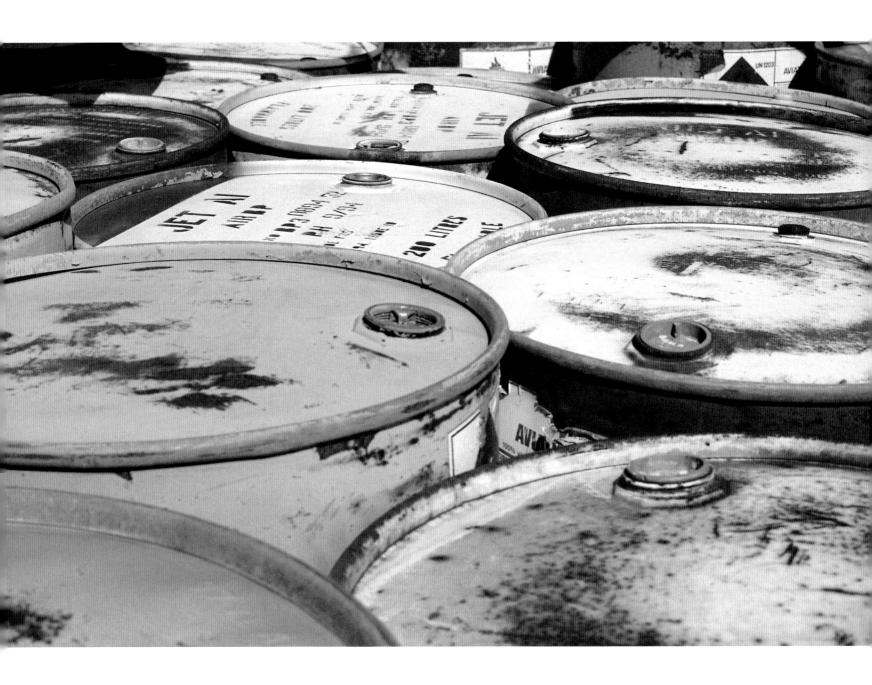

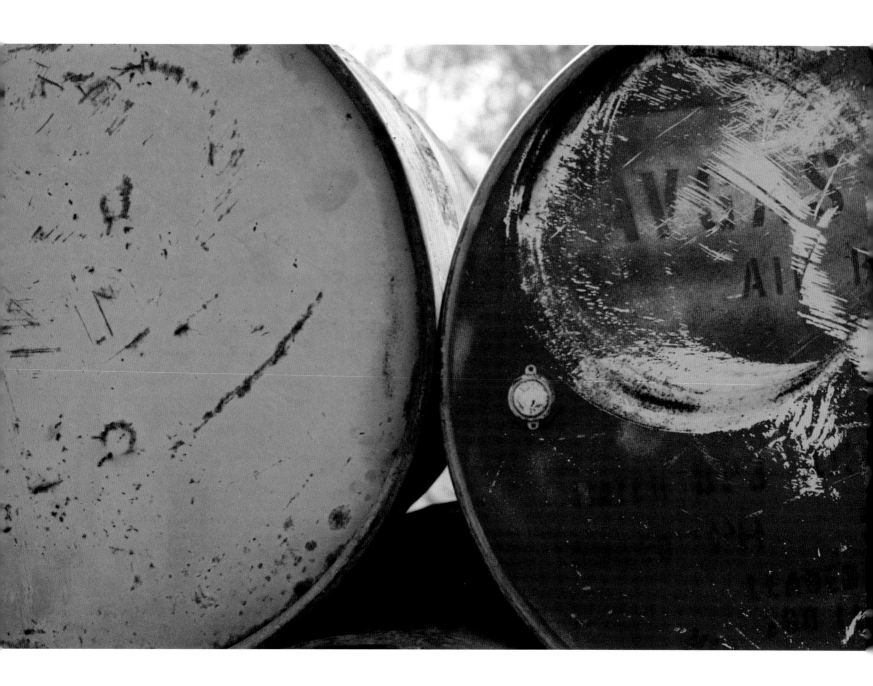

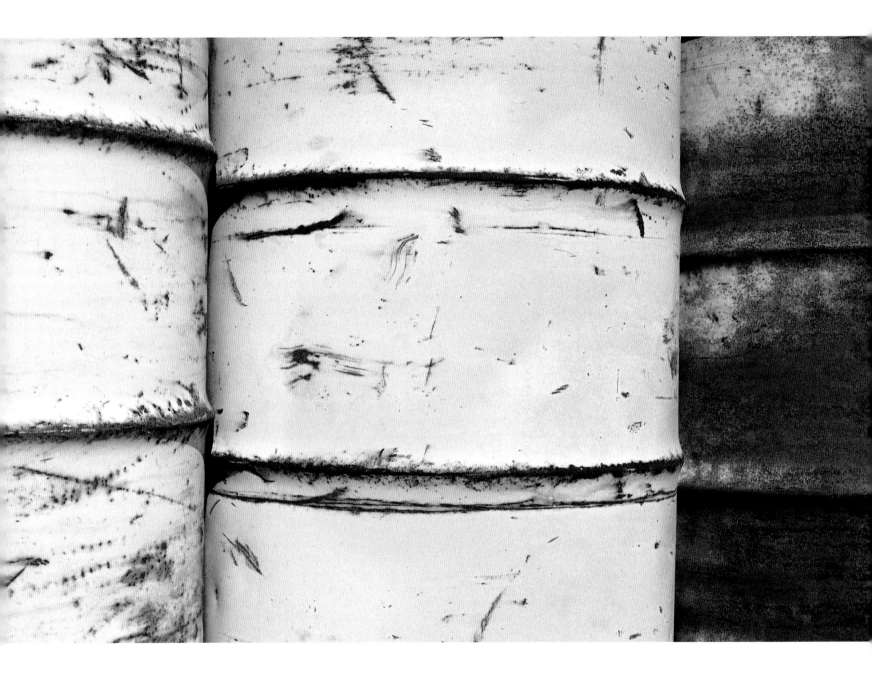

Dry lakes

Dry lake, pink lake, clay pan, salt pan. Call them what you will. Lonely, desolate, beautiful, tranquil.

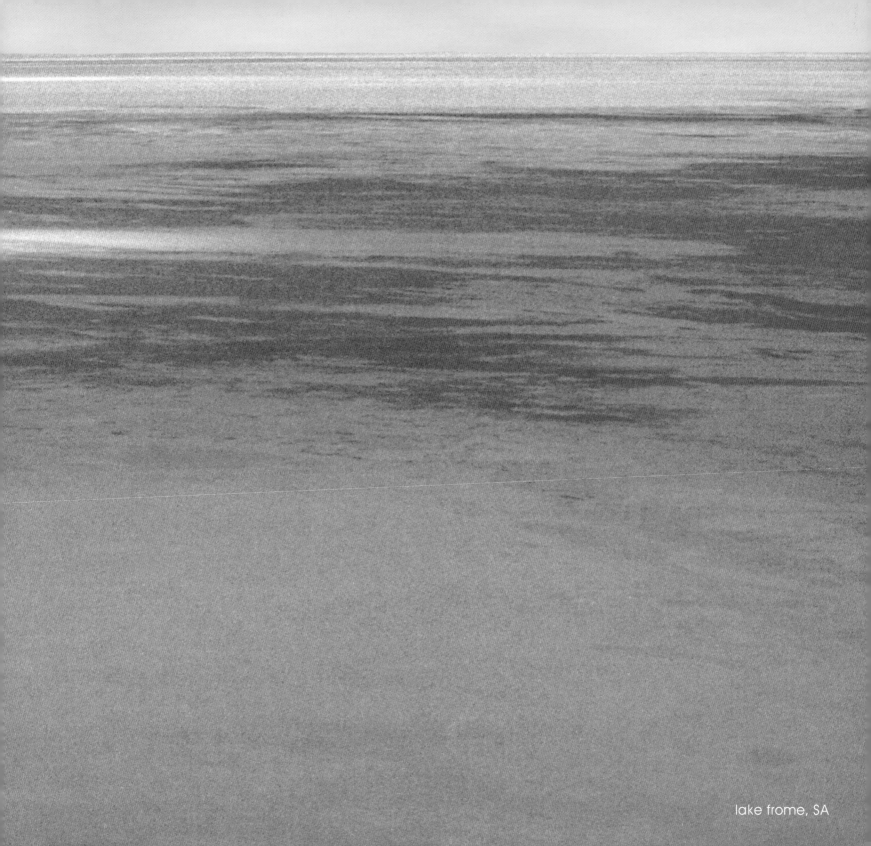

lake frome, SA

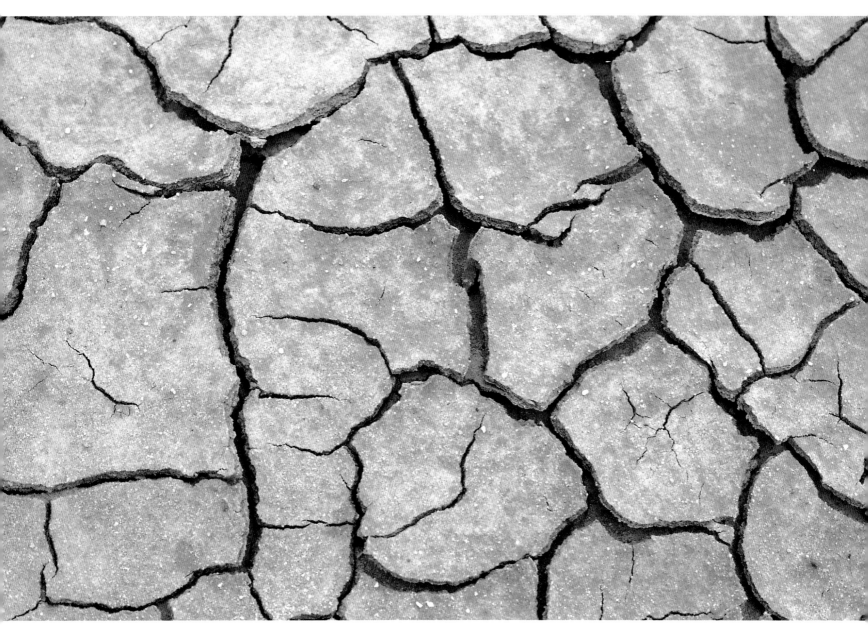

dry creek bed, alice springs, NT

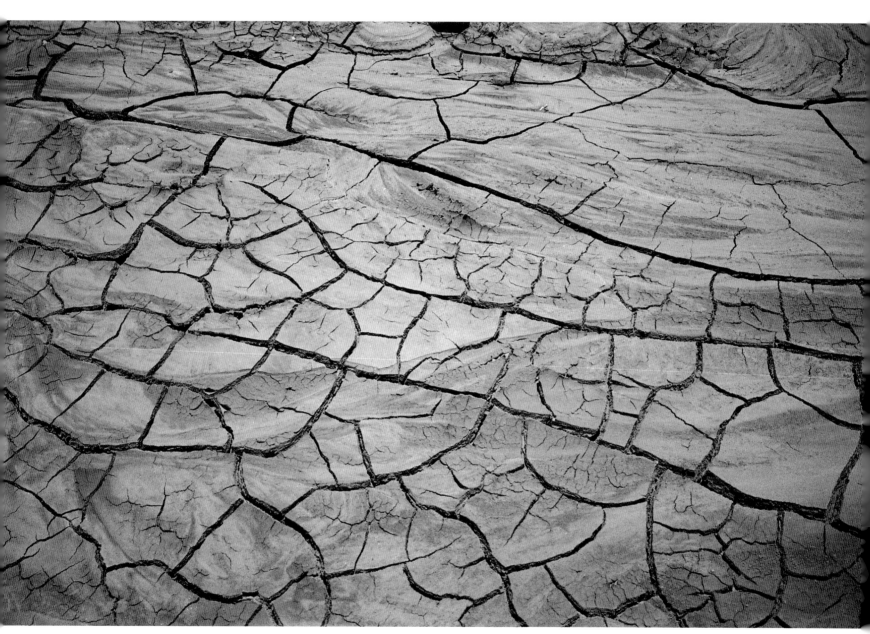

dry lake, innaminka, SA

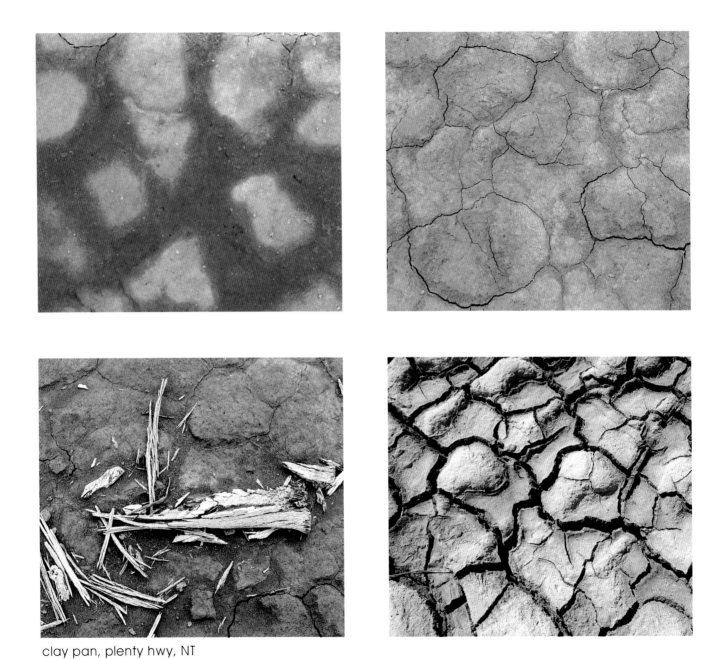

clay pan, plenty hwy, NT

willy willy, lake torrens, SA

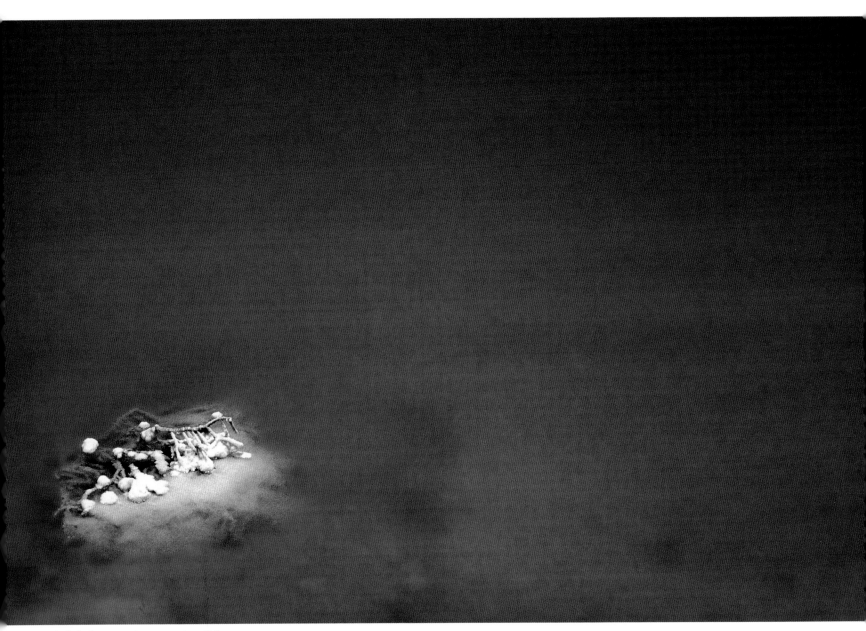

pink lake, port augusta, SA

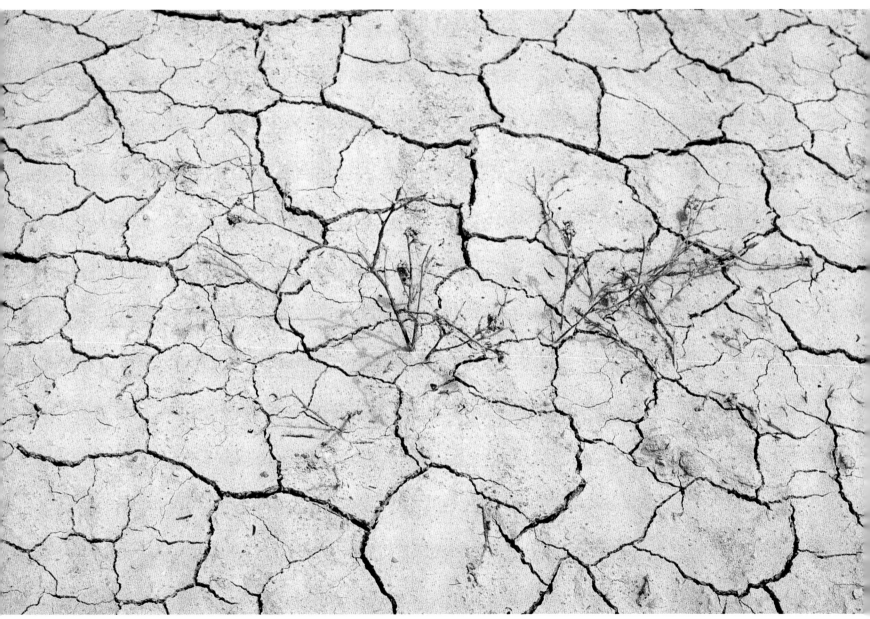

salt bush, lake eyre, SA

salt lake, andamooka, SA

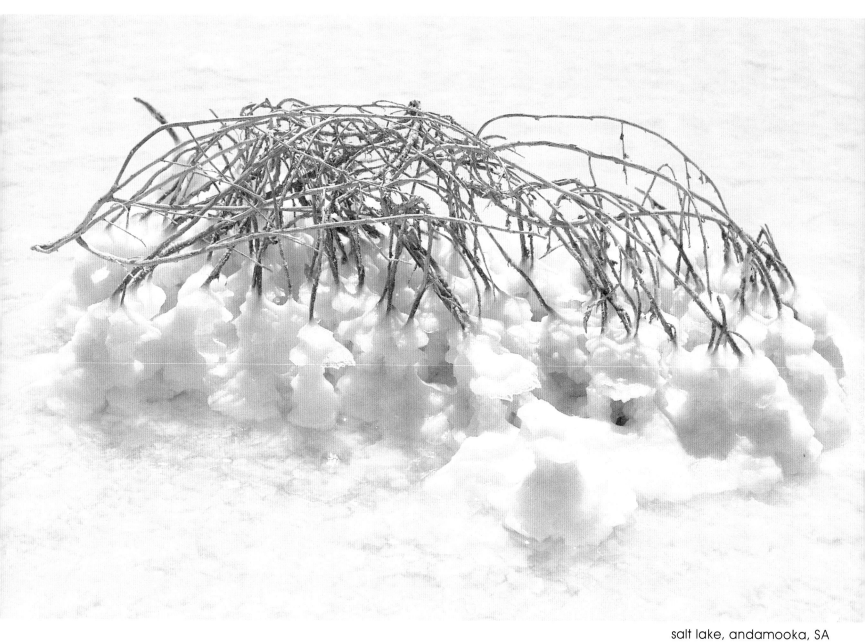

salt lake, andamooka, SA

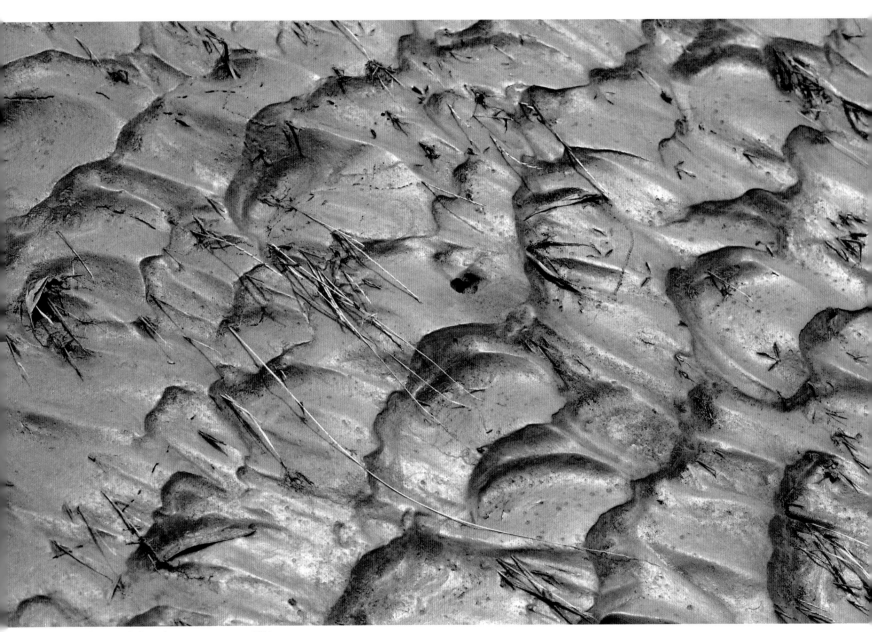

flooded creek bed, esperance, WA

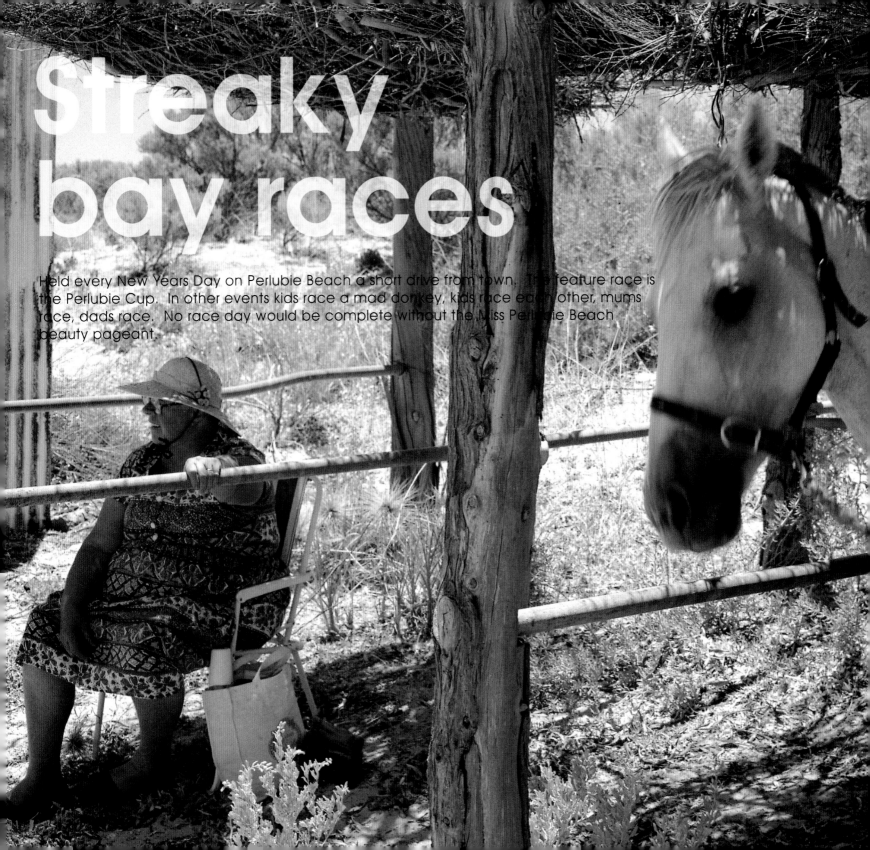

Streaky bay races

Held every New Years Day on Perlubie Beach a short drive from town. The feature race is the Perlubie Cup. In other events kids race a mad donkey, kids race each other, mums race, dads race. No race day would be complete without the Miss Perlubie Beach beauty pageant.

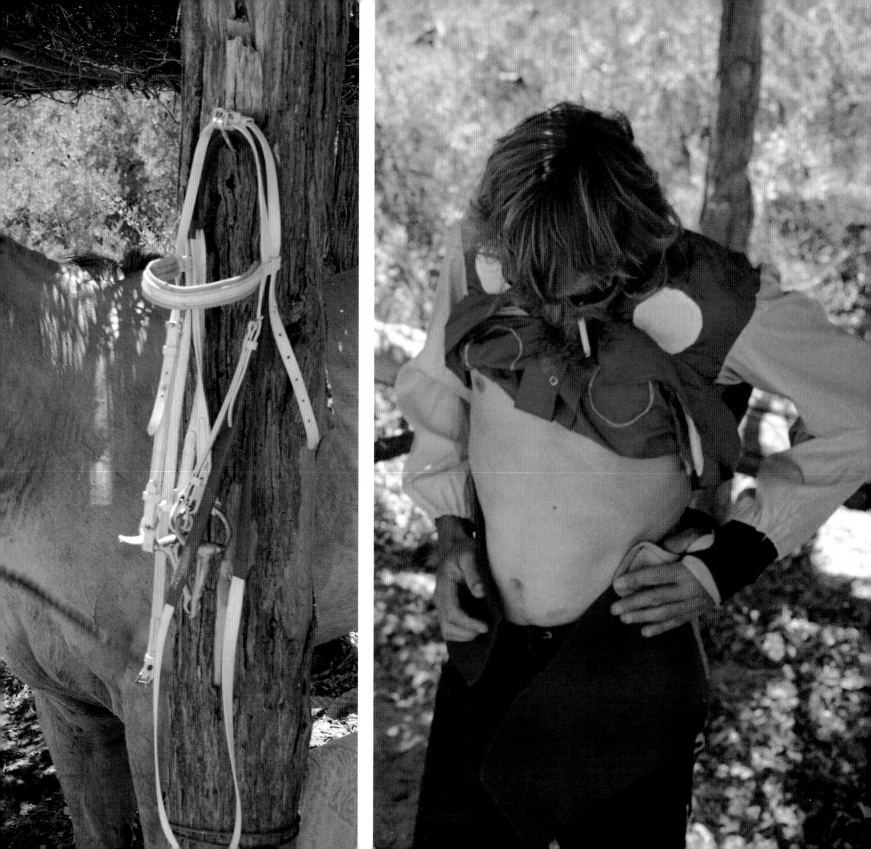

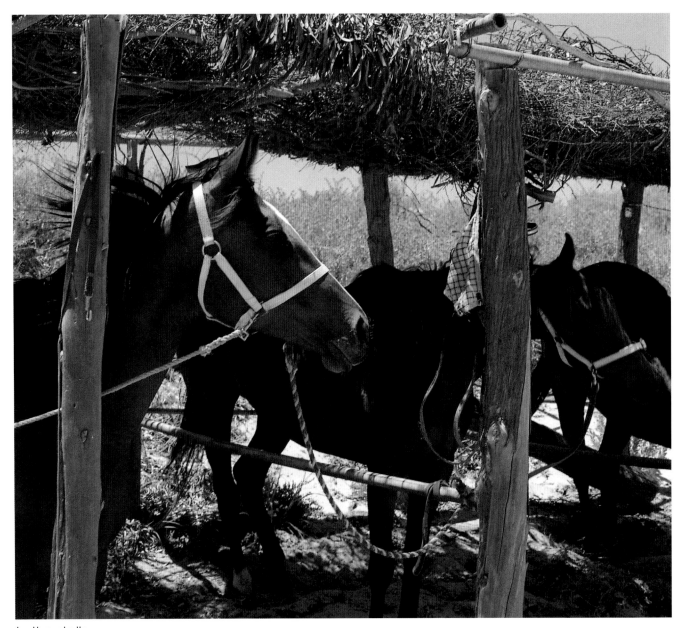

in the stalls

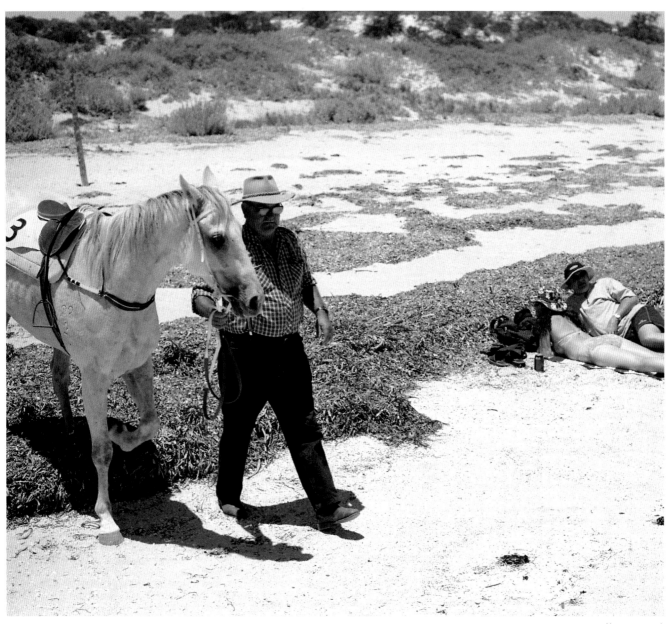

mounting yard

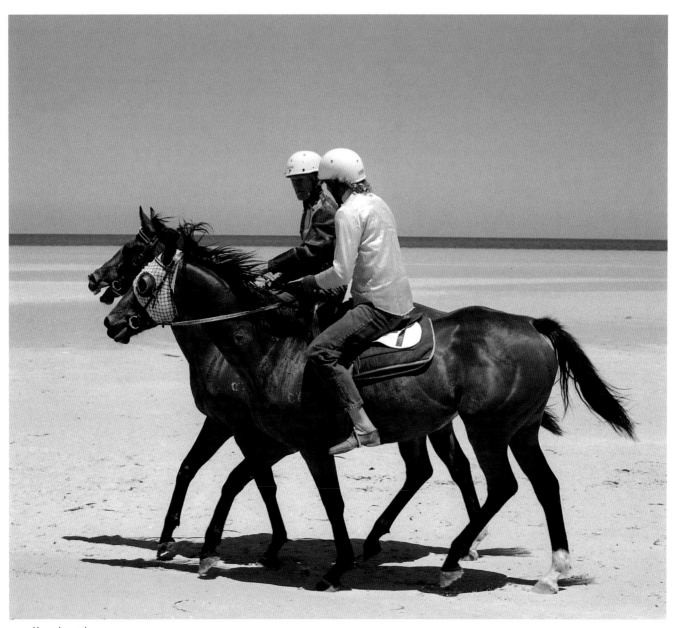

on the track

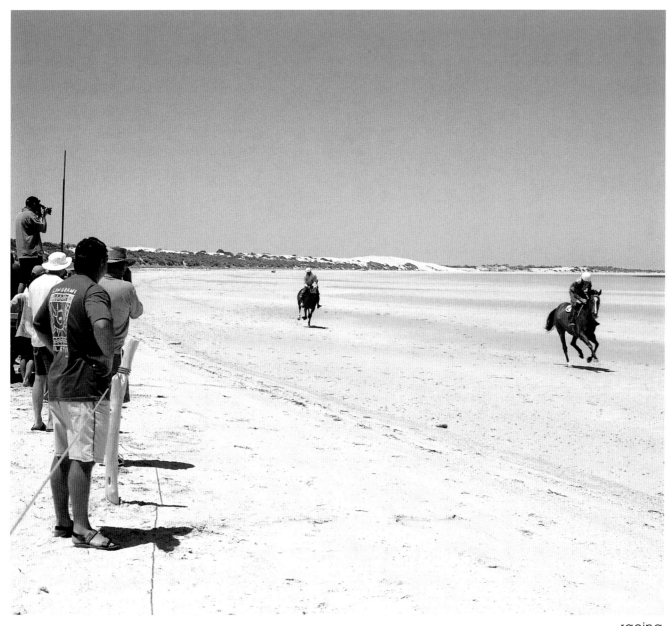

racing

beauty pageant contestants #1

beauty pageant contestants #2

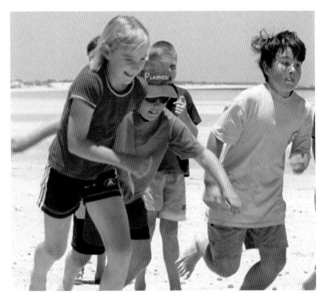

on your marks

Eye in
the sky

Sometimes you just need a different perspective.

crops, kununurra, WA

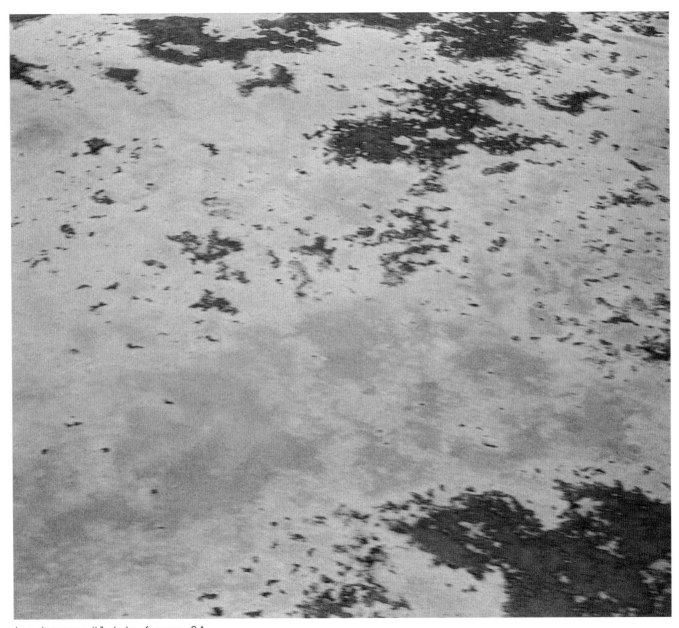

landscape #1, lake frome, SA

landscape #2, gammon ranges, SA

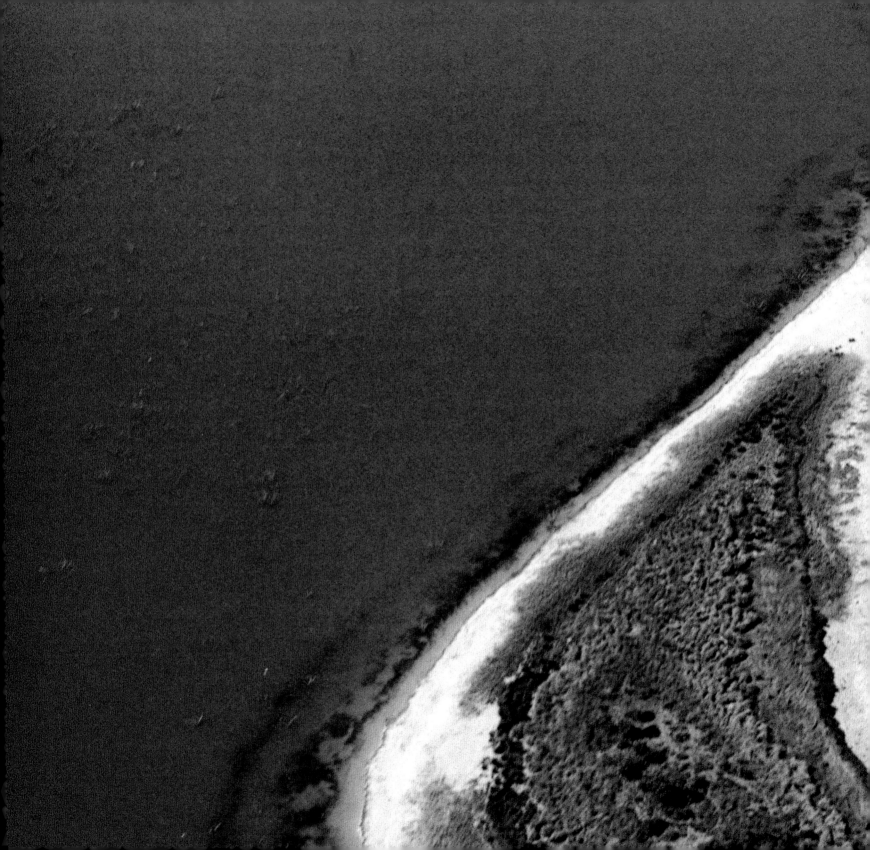

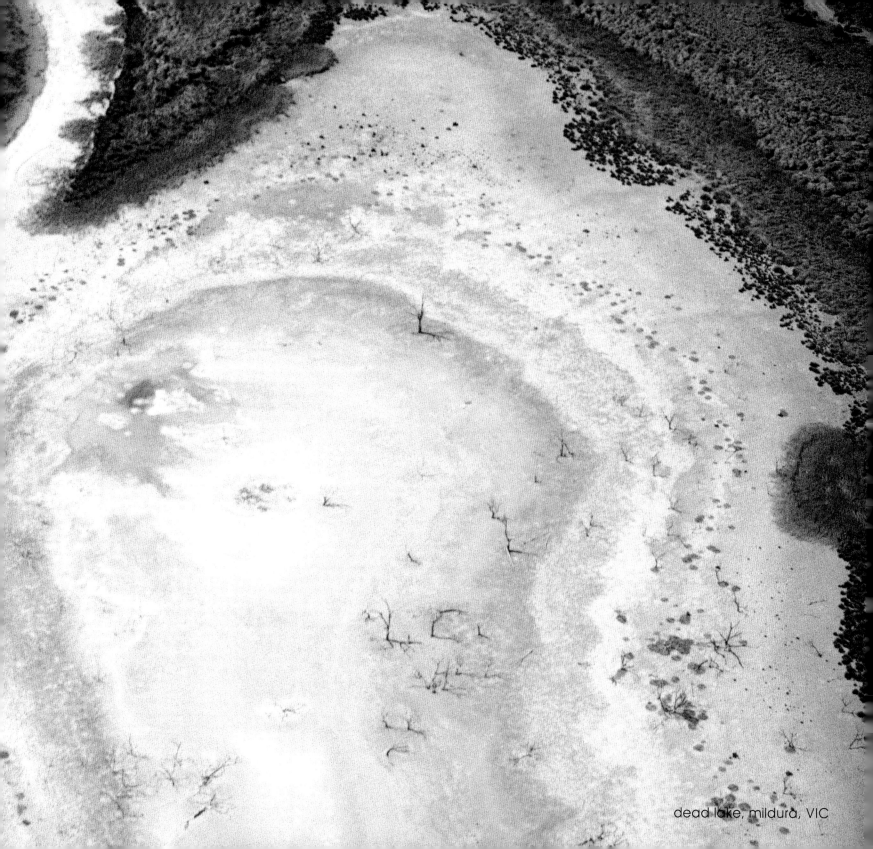

dead lake, mildura, VIC

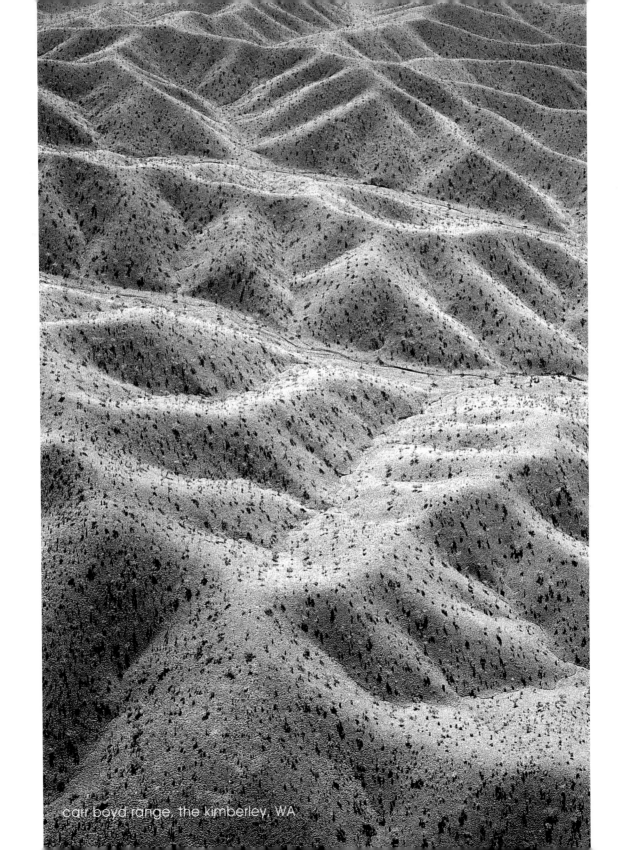

carr boyd range, the kimberley, WA

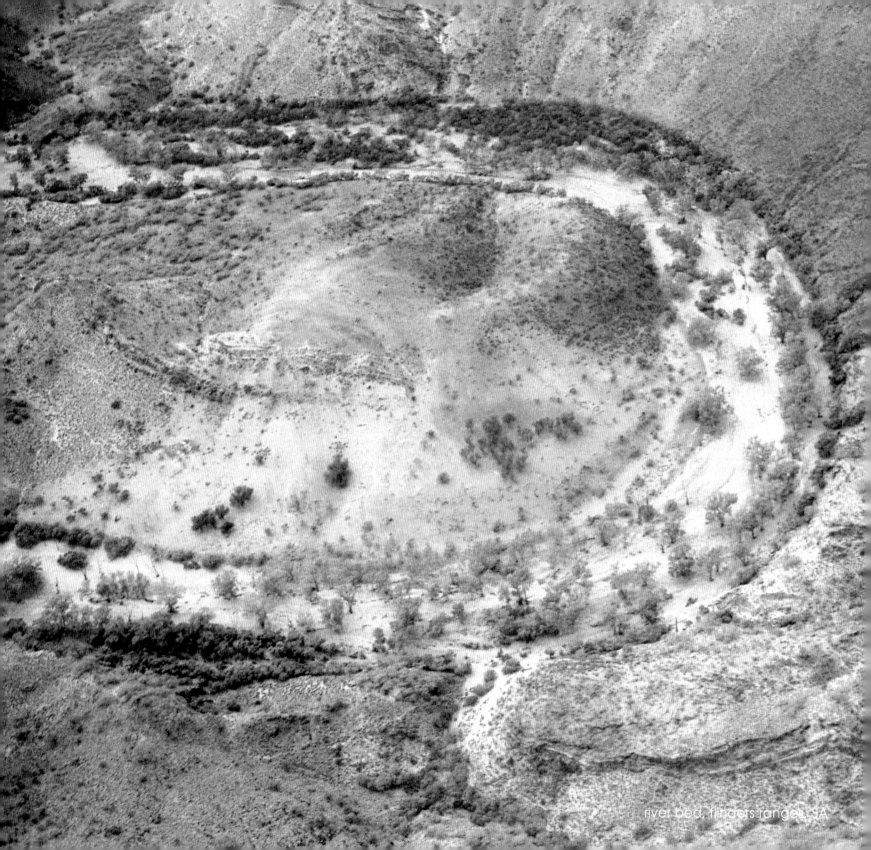

river bed, flinders ranges, SA

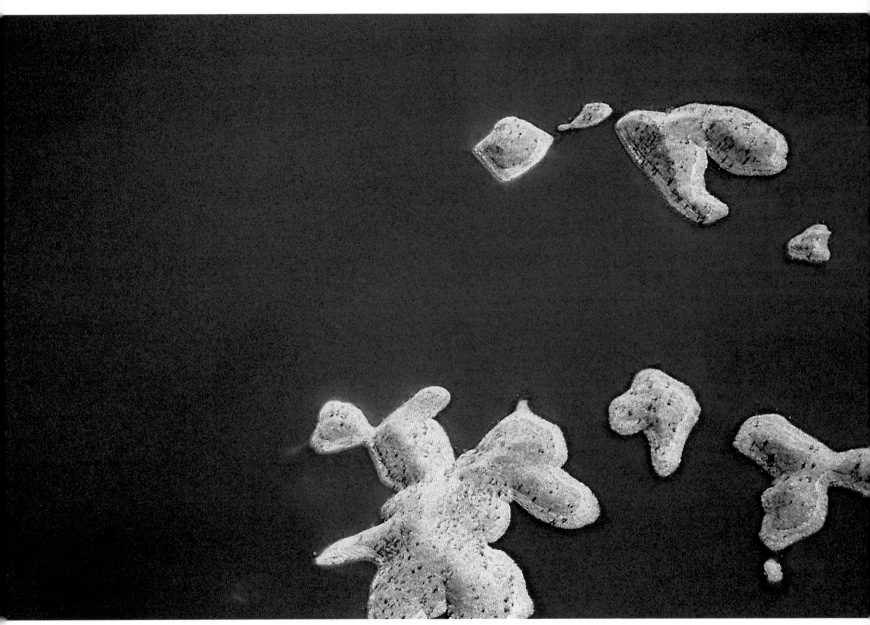

islands, lake argyle, WA

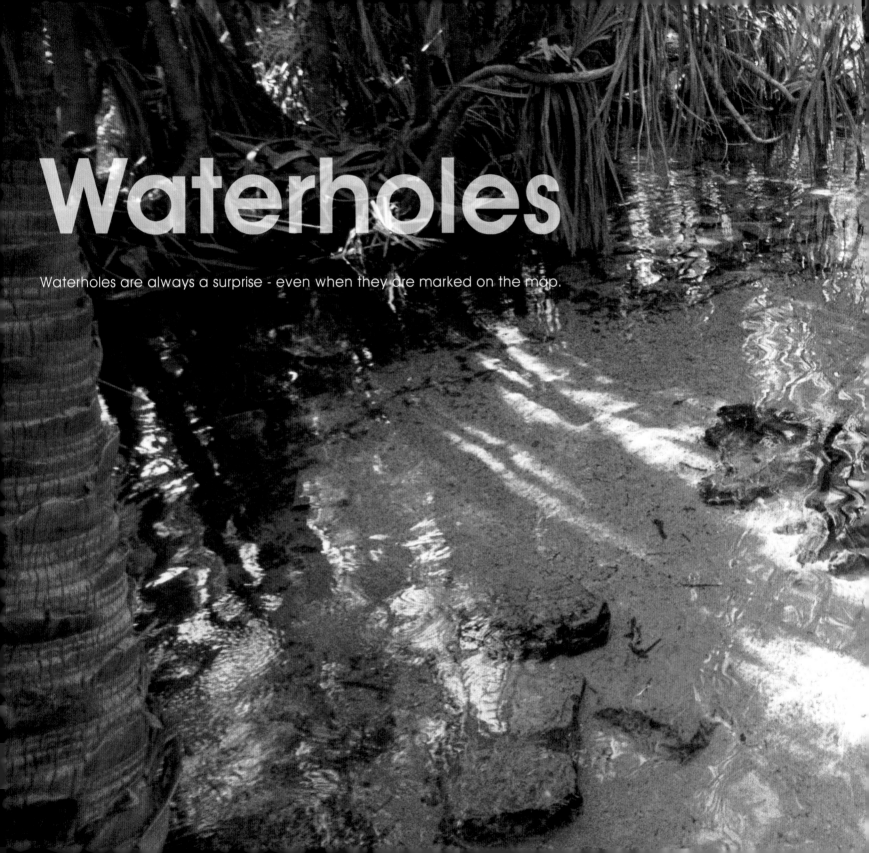

Waterholes

Waterholes are always a surprise - even when they are marked on the map.

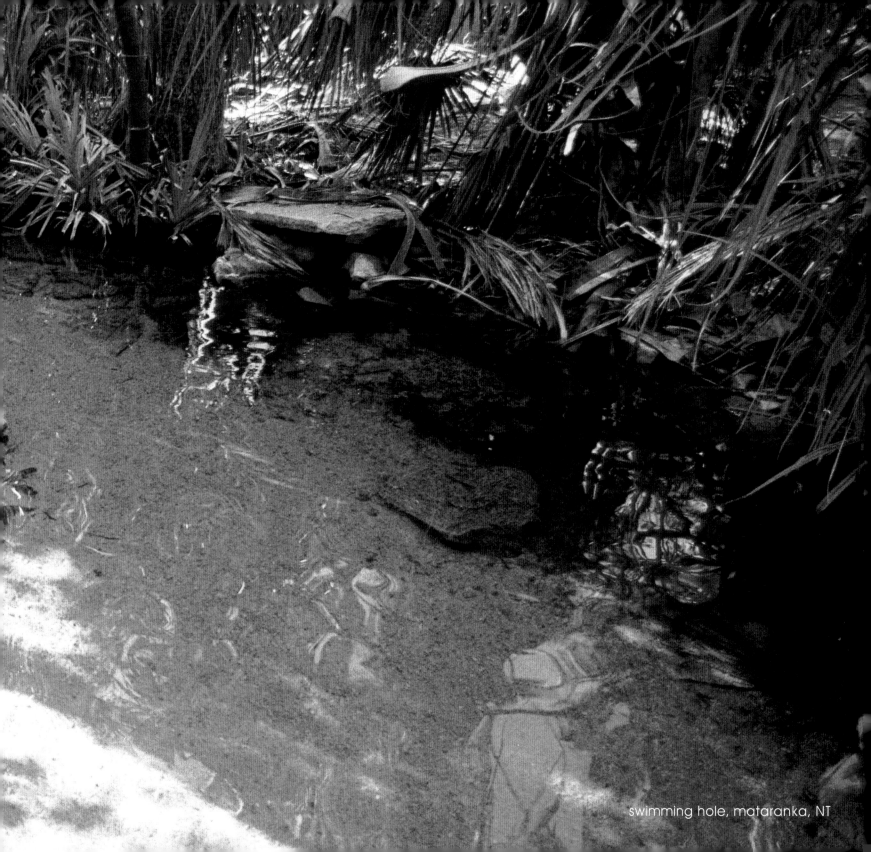

swimming hole, mataranka, NT

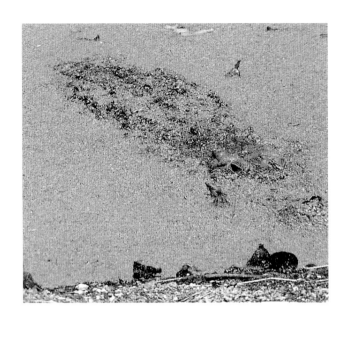
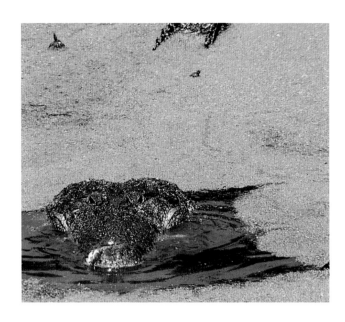

crocodile, darwin, NT

crocodile, darwin, NT

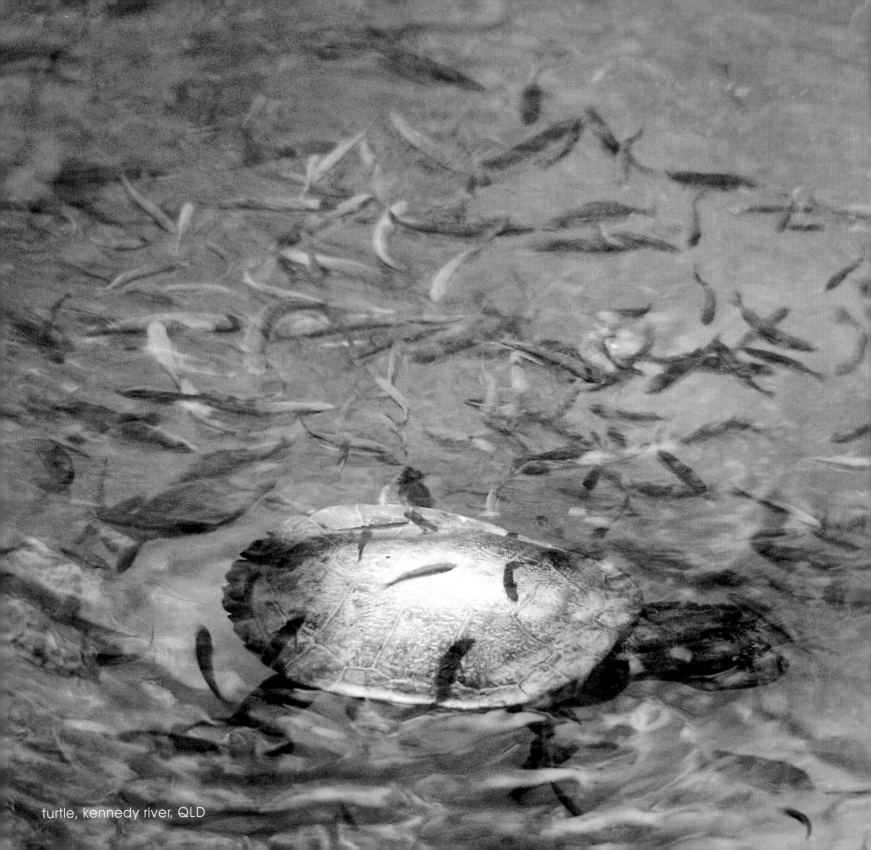

turtle, kennedy river, QLD

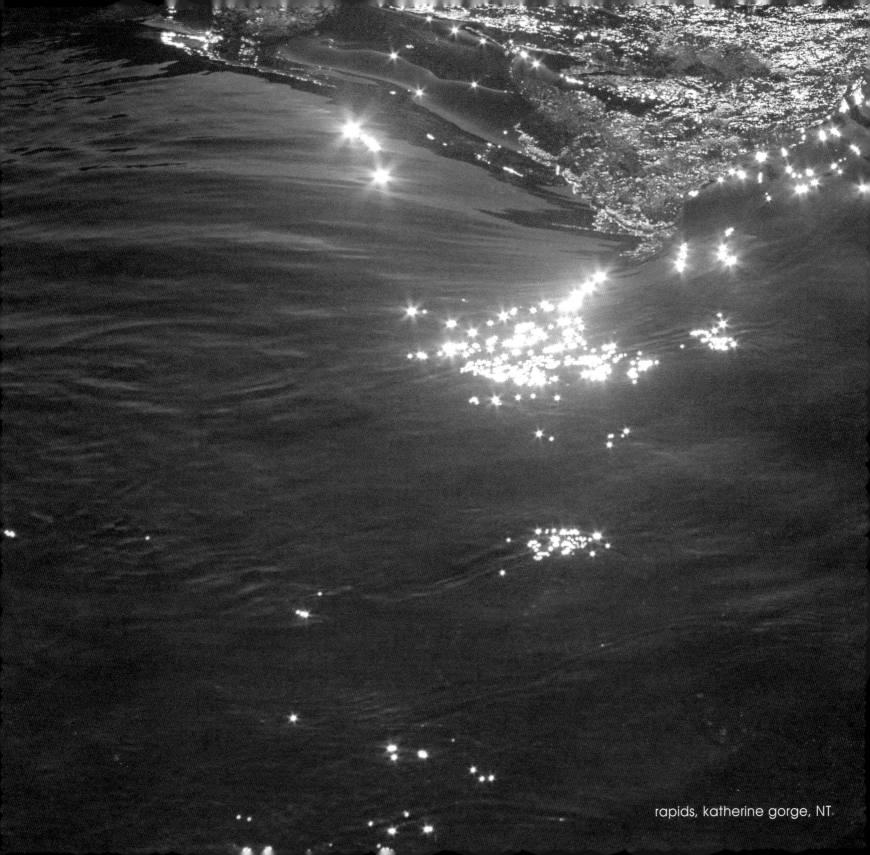

rapids, katherine gorge, NT

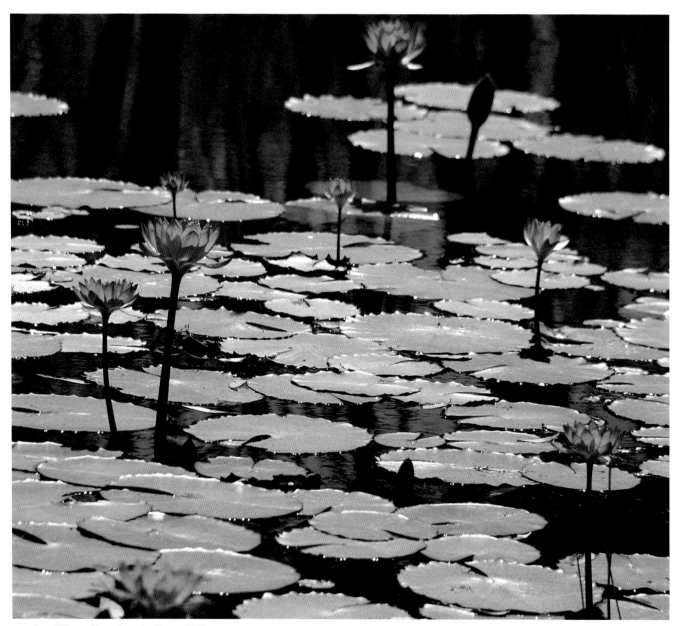

water lillies, theda station, WA

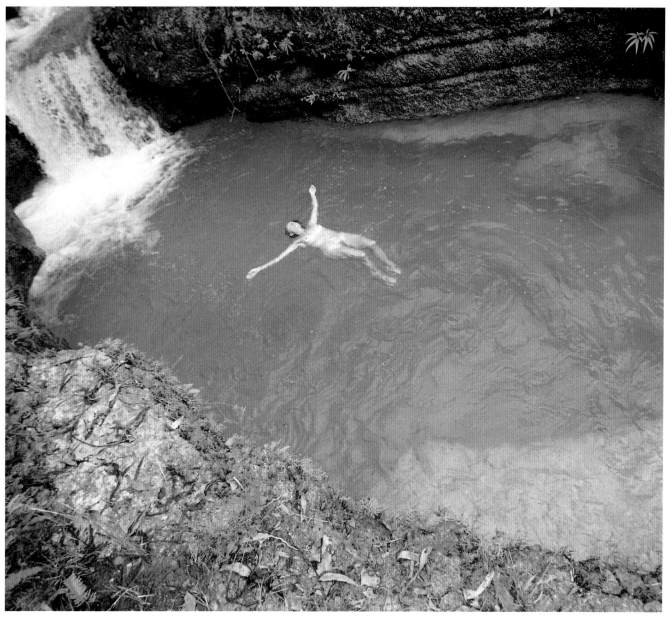

water woman, eliot creek, QLD

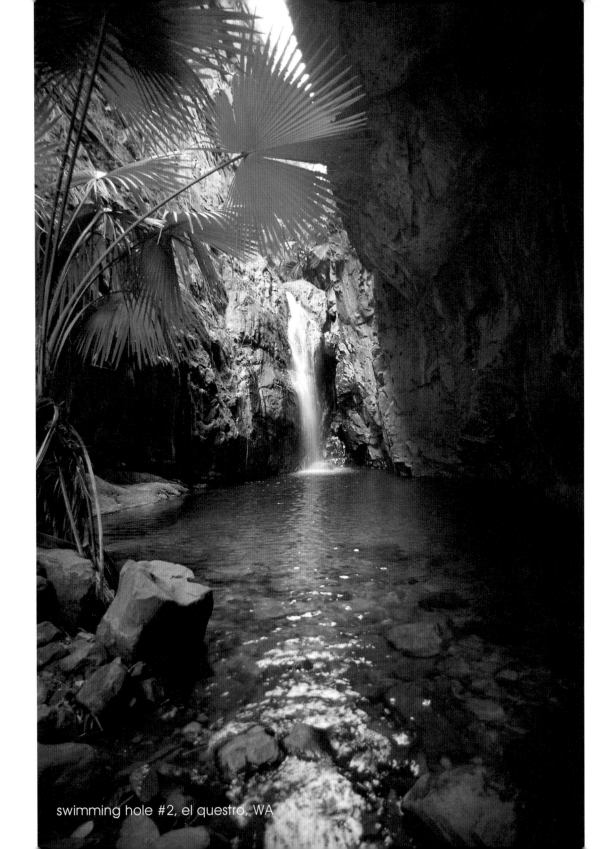

swimming hole #2, el questro, WA

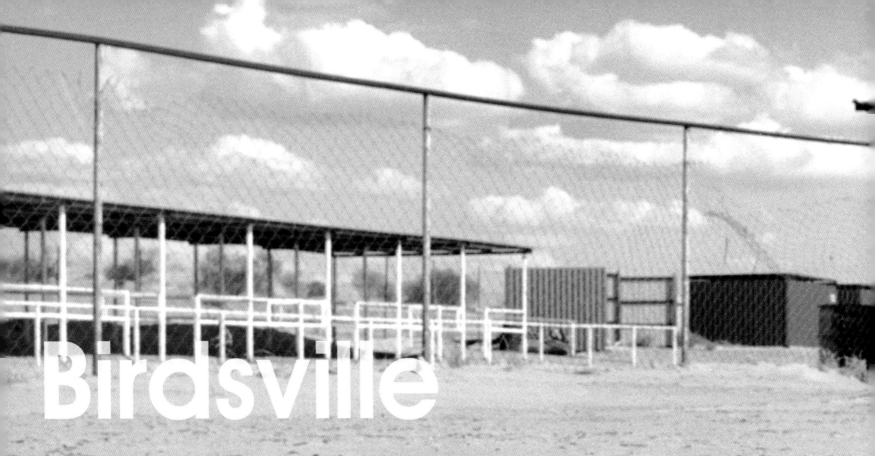

Birdsville

It has been said by the locals, 'Why would you call this place Birdsville when there aren't any? It should be called Blokesville.' This is followed by 'Yeah, the women folk don't go so well out here, they only last a year or two, then go back home. Not fancy enough for them, nothing to do.' This may be true except for race week when the town swells from a population of one hundred and thirty to over six thousand as revellers arrive to see the running of the Birdsville Cup, drink beer and see Fred Brophy's travelling boxing troupe in action.

Fred Brophy is undoubtedly Australia's greatest showman. He tours the remote areas of South Australia and Queensland with his boxing troupe. He is the last of his kind in Australia. Boom...bo-boom...bo-boom...bo-boom. Fred flays his drum, rallying the crowd to the stage where he introduces his boxers. 'We've got a real good fighter here tonight, unbeaten in over two thousand bouts and he's called the 'friendly mauler'. That's right folks, the more you punch him, the friendlier he gets! He's looking real friendly tonight folks, I give you 'the friendly mauler'. Give him a rally. Boom...bo-boom...bo-boom...bo-boom...Boom...bo-boom...bo-boom...bo-boom... 'That's right folks, if you haven't been to Birdsville, you're not a true Australian.' The crowd cheers wildly, endorsing Fred's call.

BIRDSVILLE RACE CLUB INC.
ENTRANCE

ADMISSION
*ADULTS $10ea *CHILDREN FREE
*MEDALLION HOLDERS FREE

race track entrance

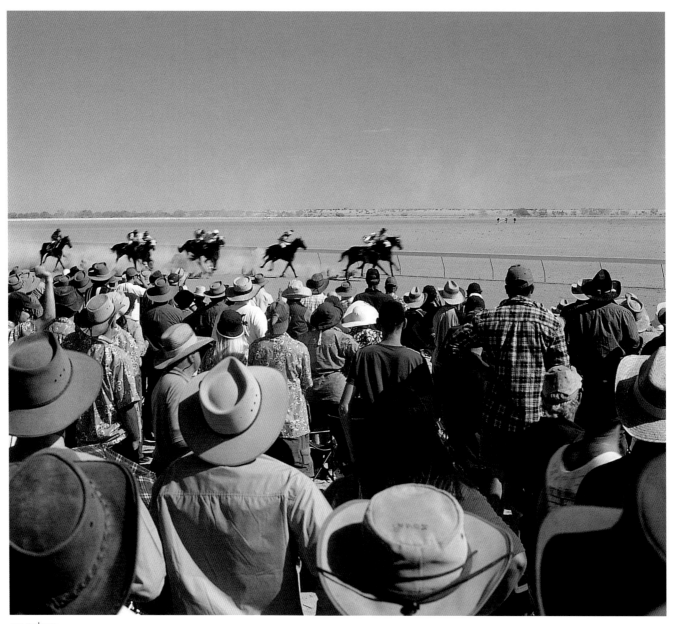

punters

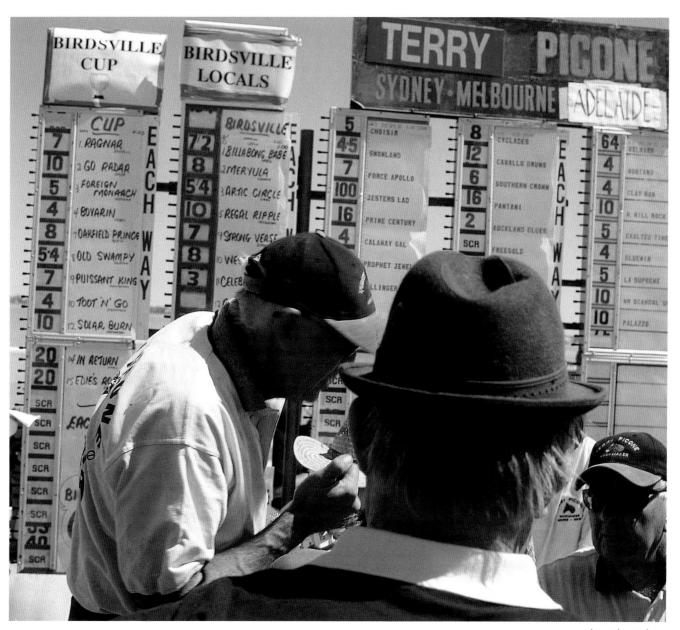

bookmaker

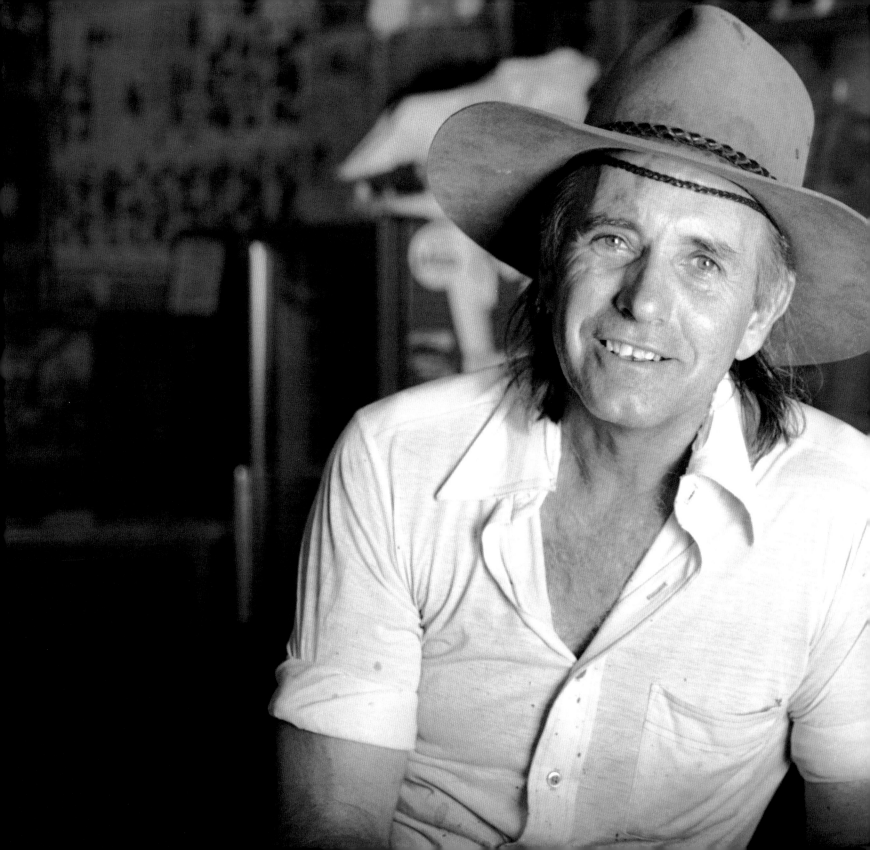

John, working museum

dog in ute #1

dog in ute #2

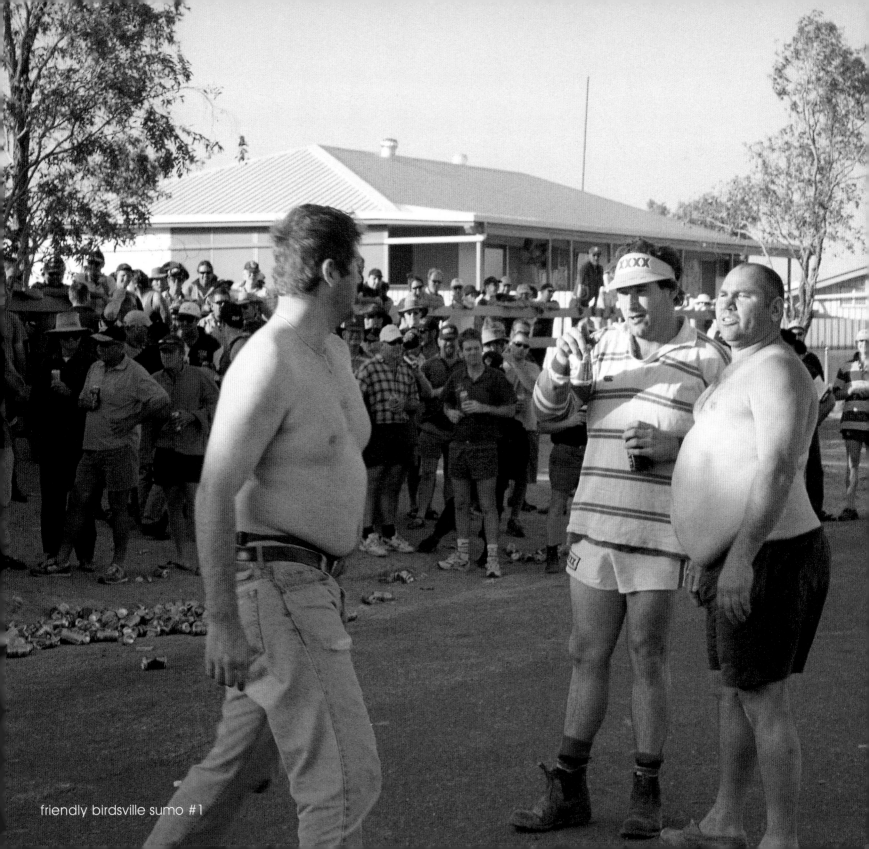

friendly birdsville sumo #1

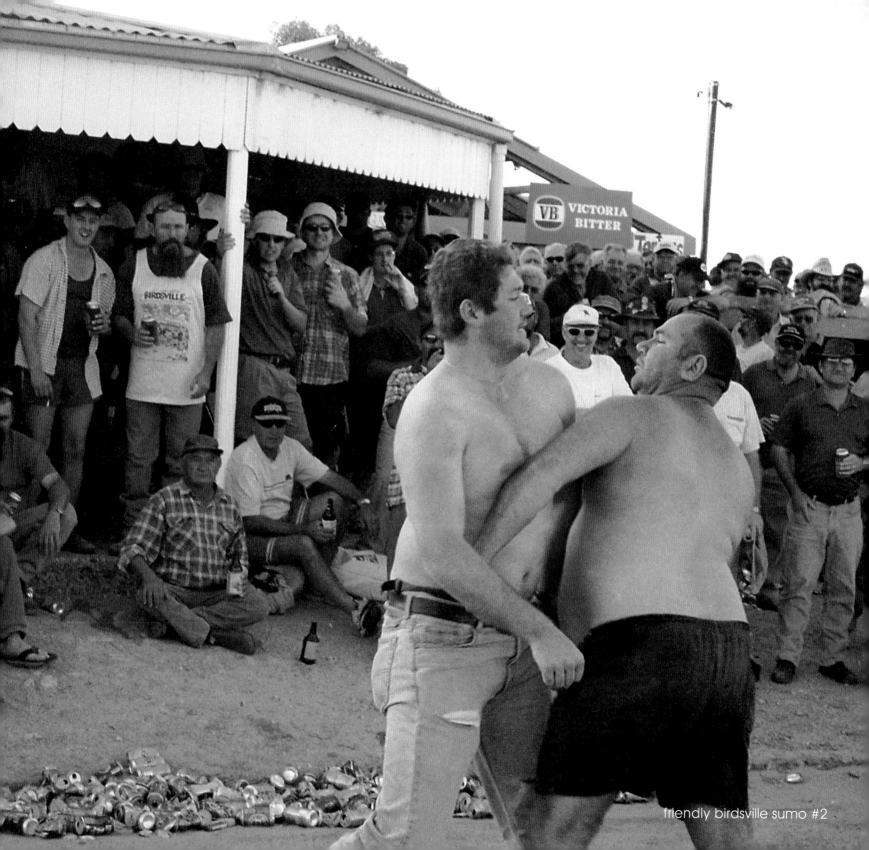

friendly birdsville sumo #2

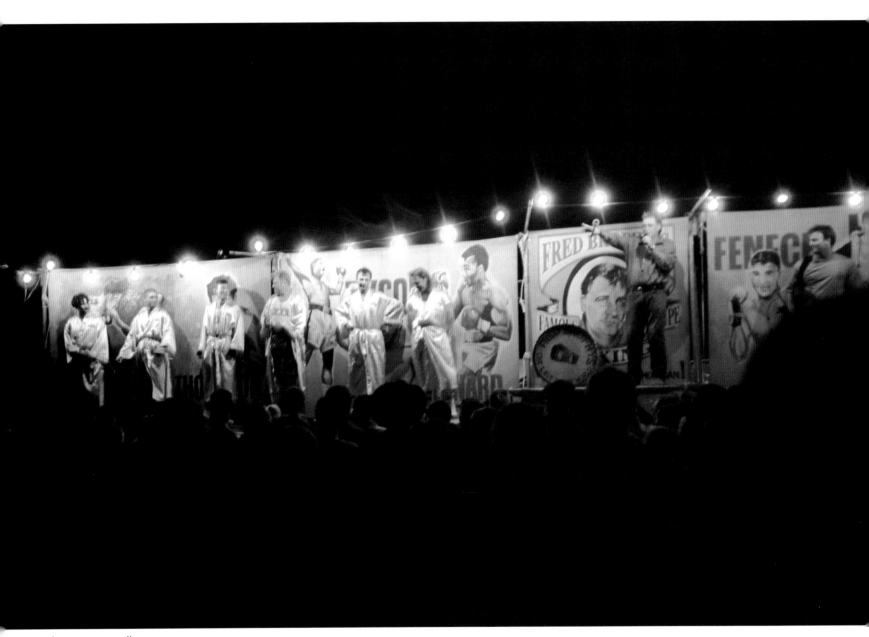

give me a rally

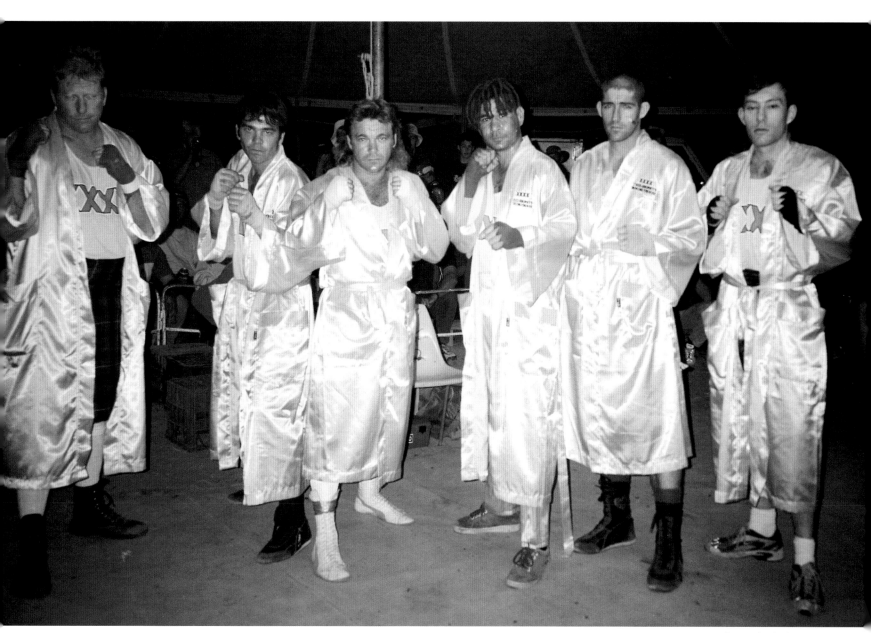

brophy's boxers

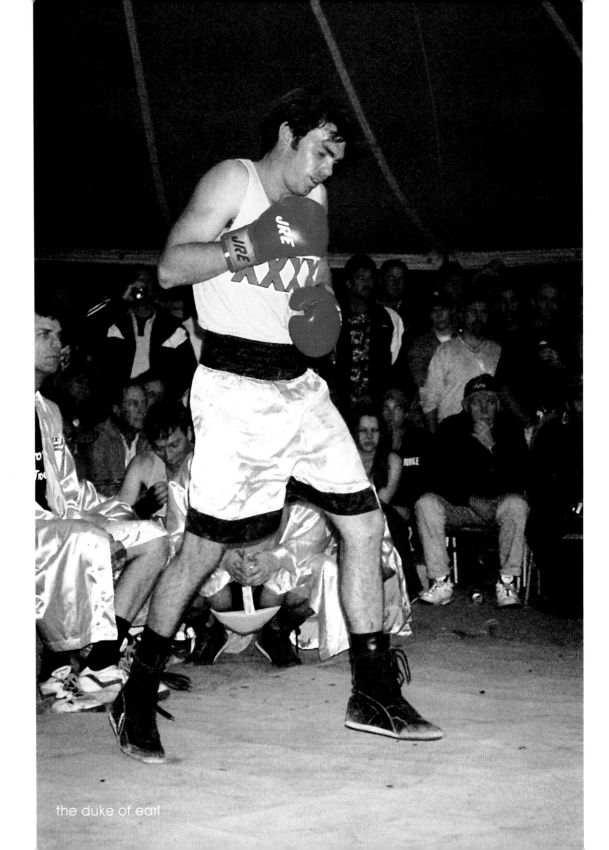

the duke of earl

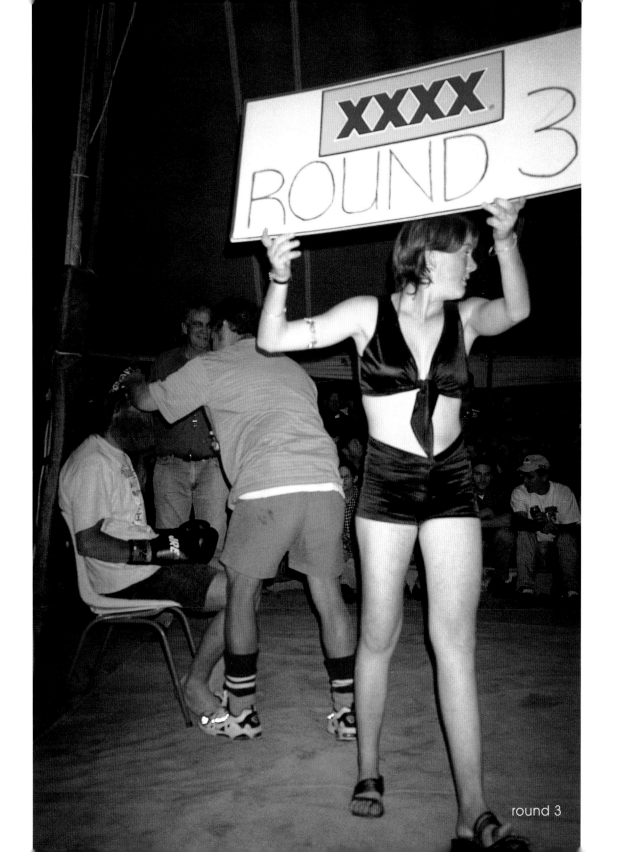

round 3

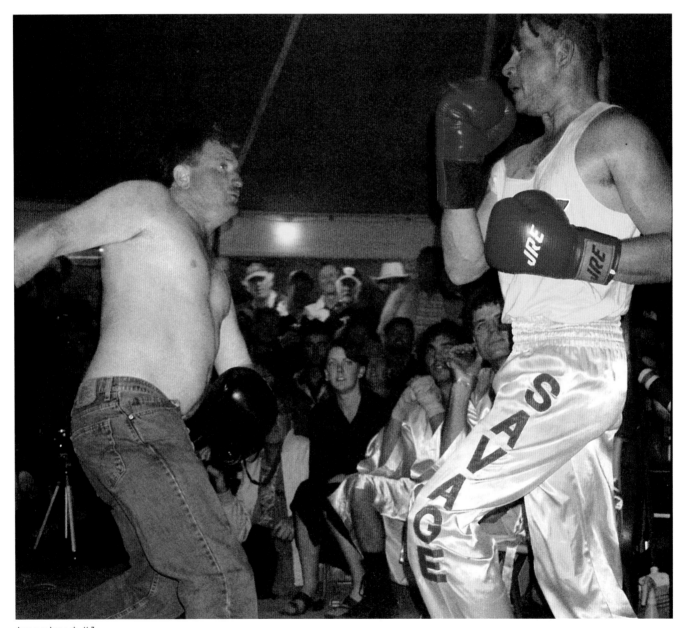

knockout #1

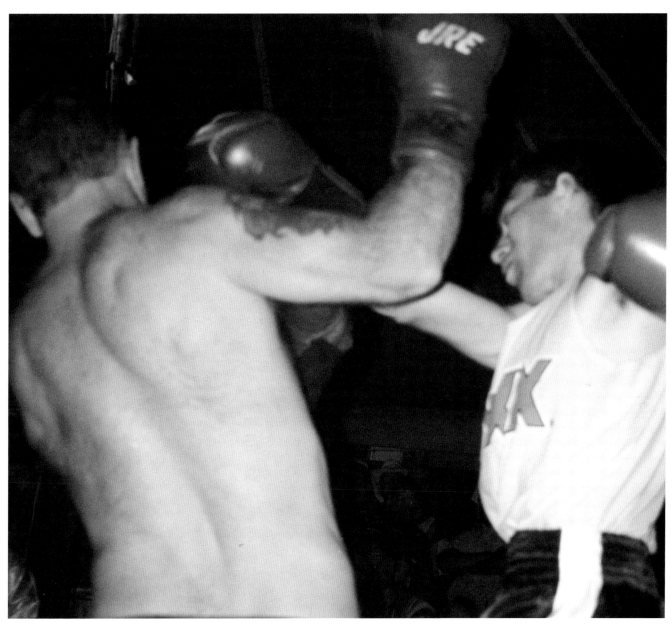

knockout #2

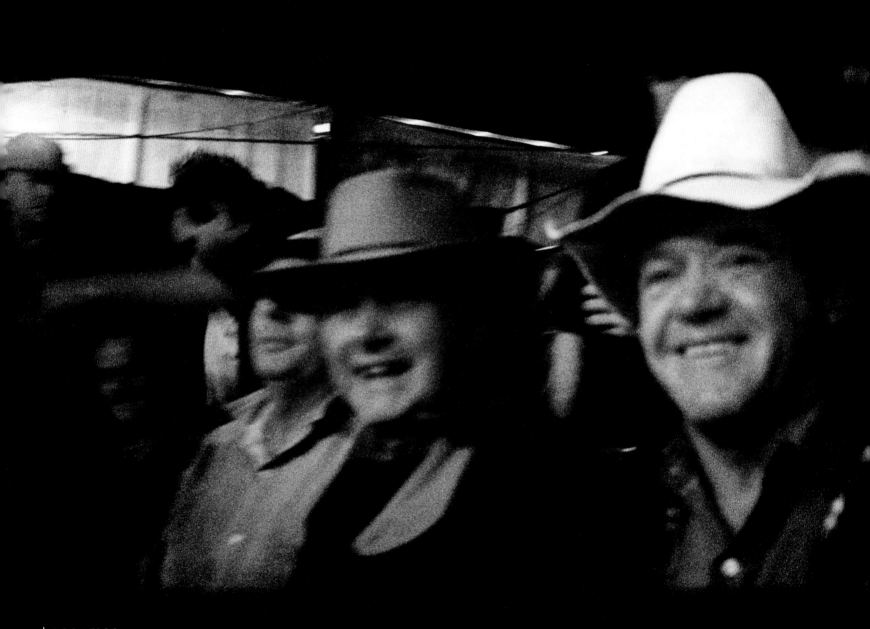

happy men

Land
meets sea

Land meets sea
the ripple returning
into breaking wave

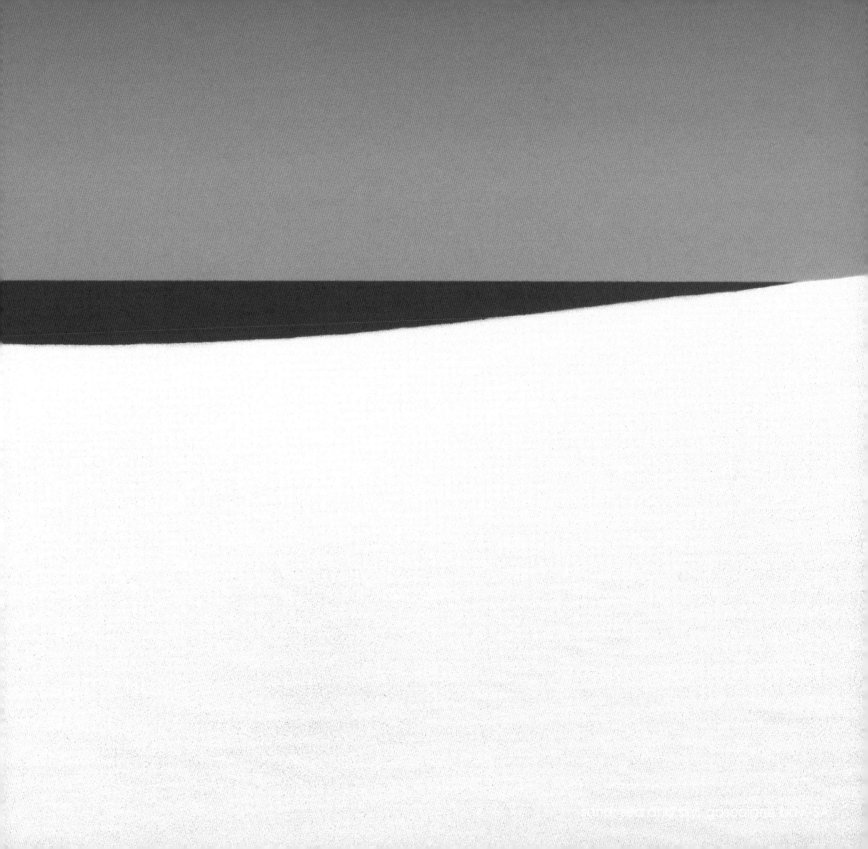

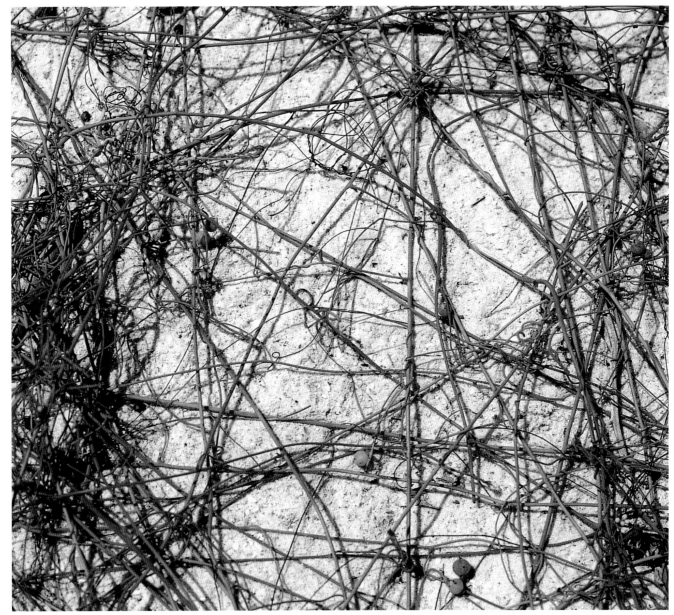

vines, bamaga, QLD

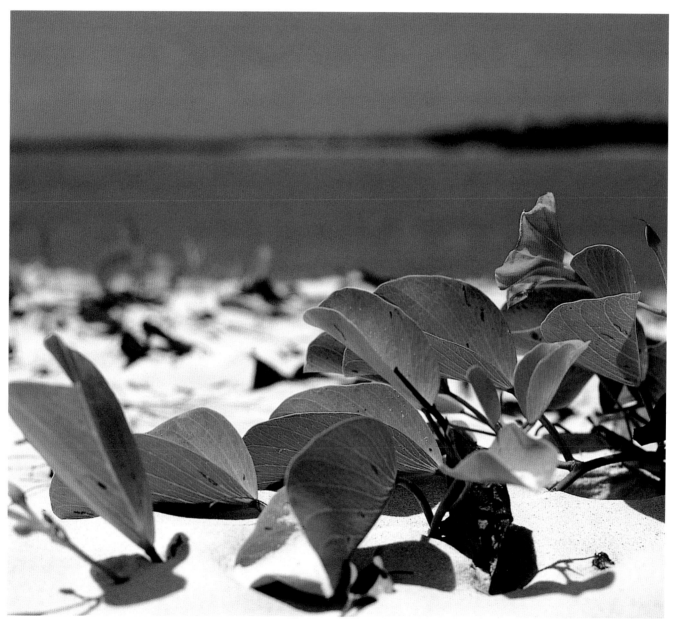

flower, bamaga, QLD

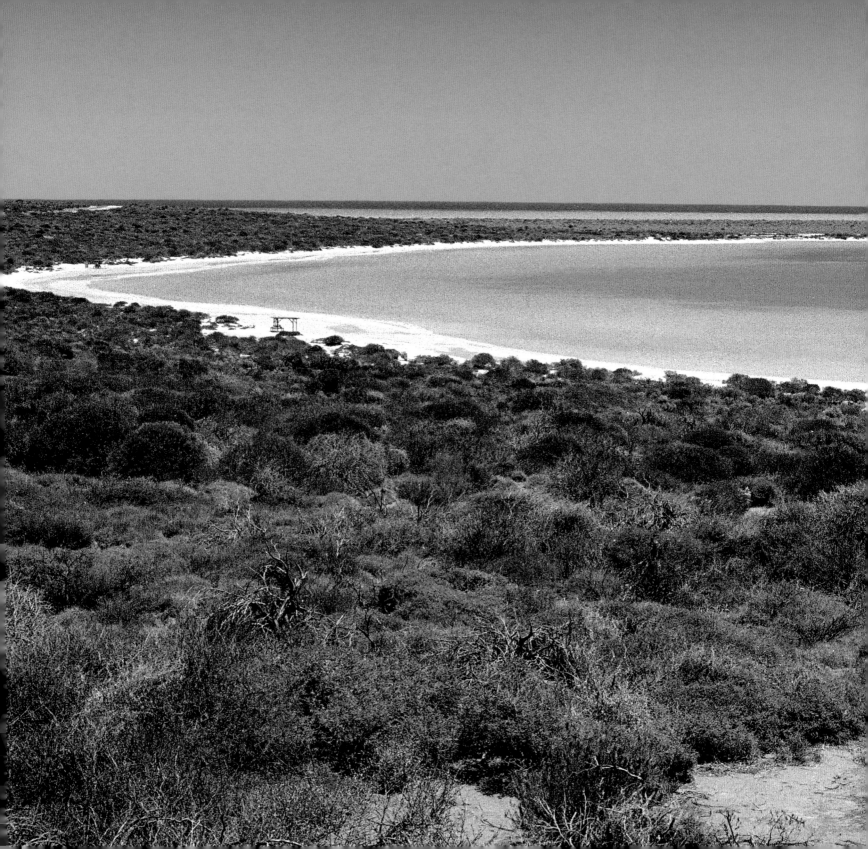

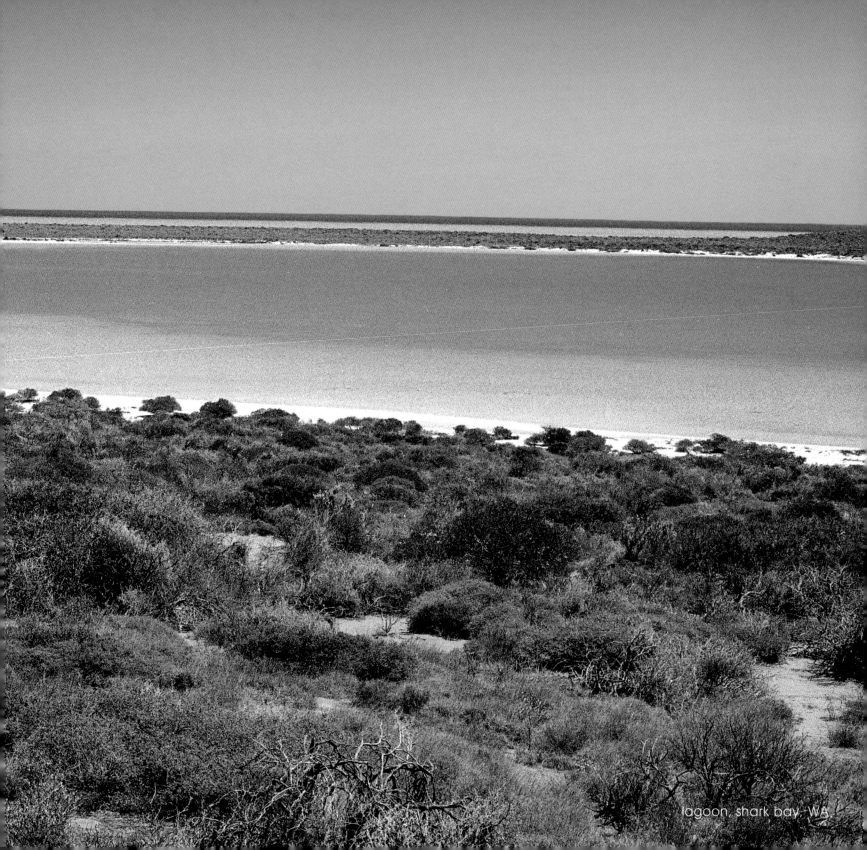

lagoon, shark bay, WA

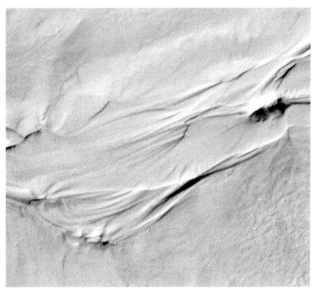

sand sculpture, byron bay, NSW

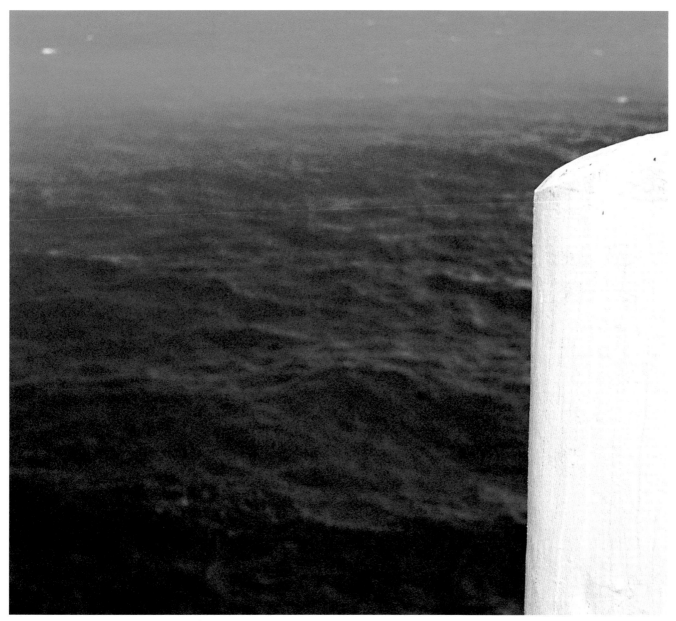

jetty, thursday island, QLD

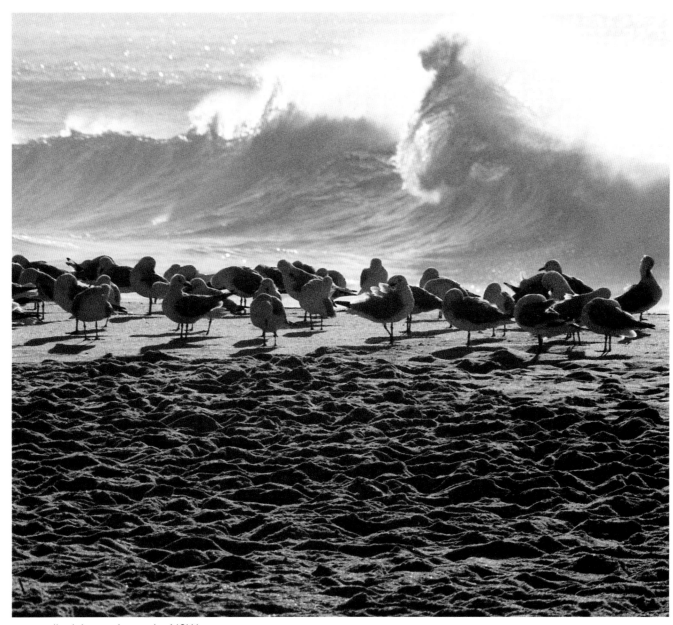

seagulls, blueys beach, NSW

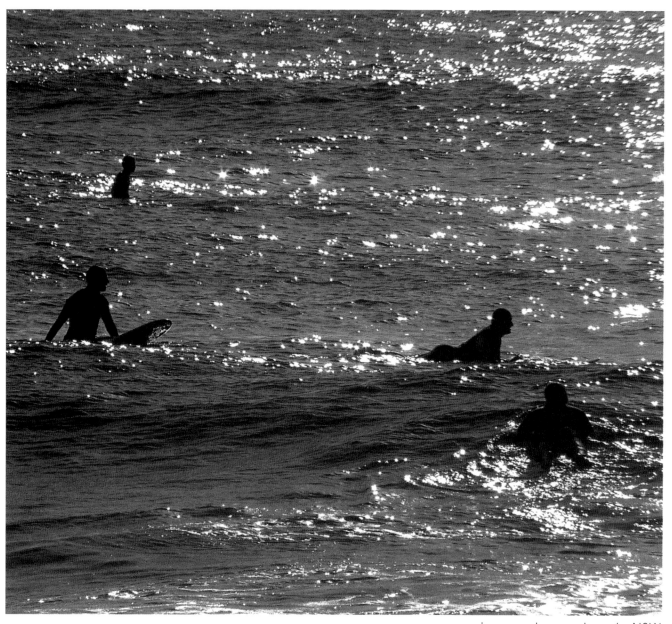

sunrise, nambucca heads, NSW

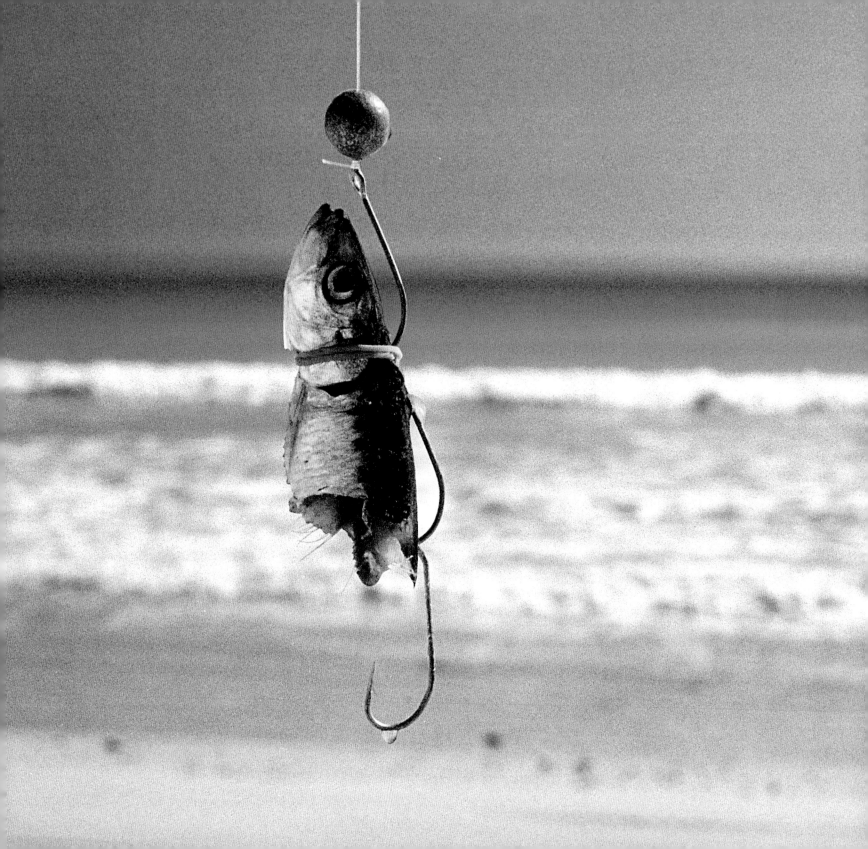

pilchard, cable beach, WA

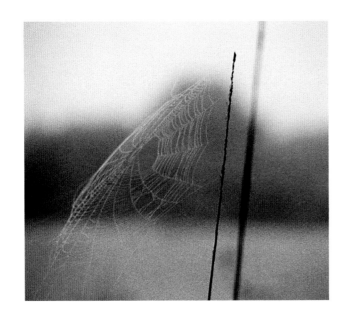

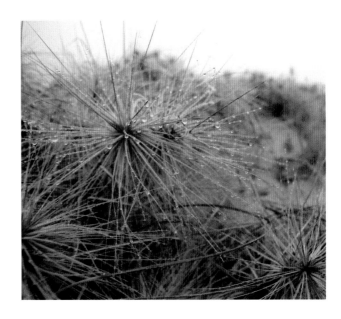

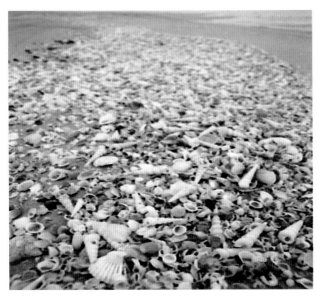

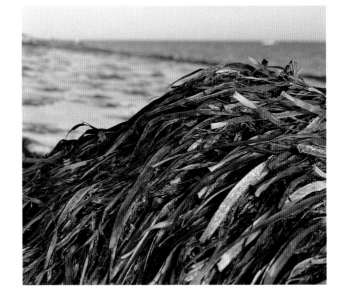

gulf of carpenteria, QLD

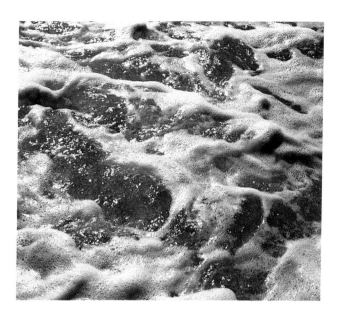

mallacoota, VIC

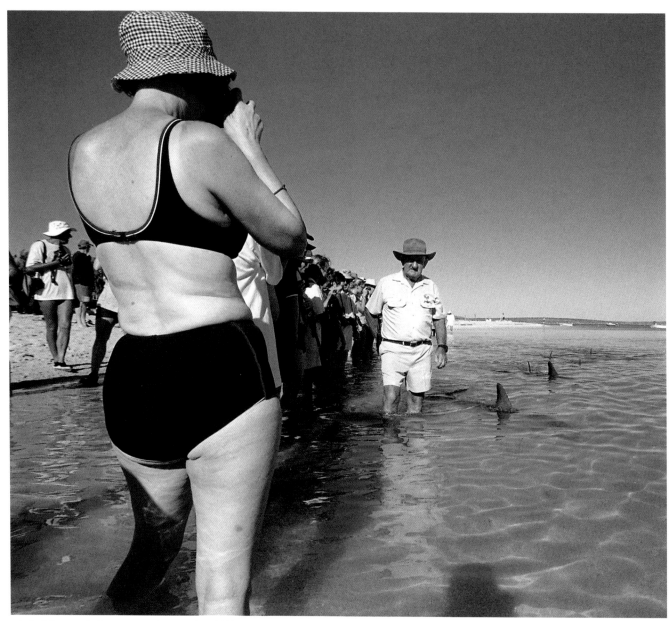

dolphin watcher, monkey mia, WA

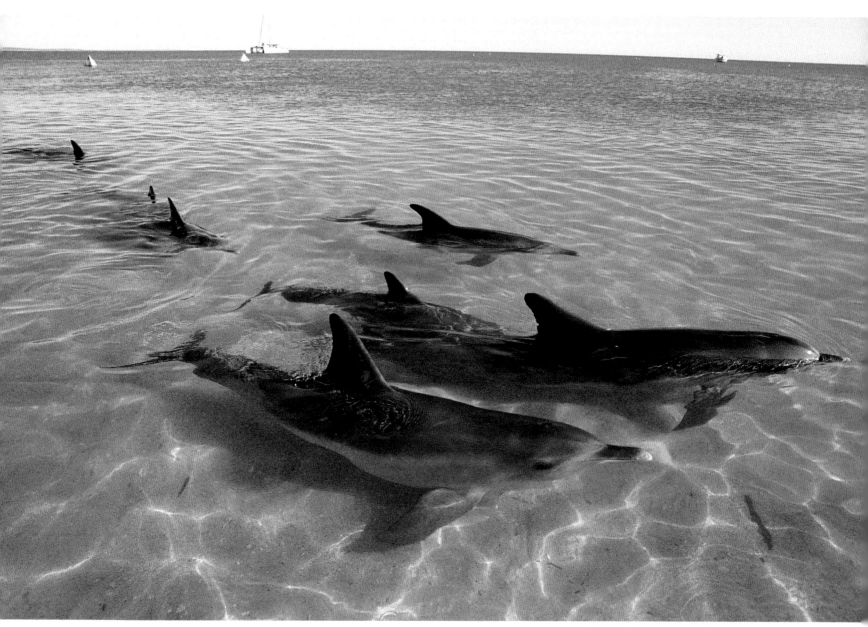

pod, monkey mia, WA

pool, bronte, NSW

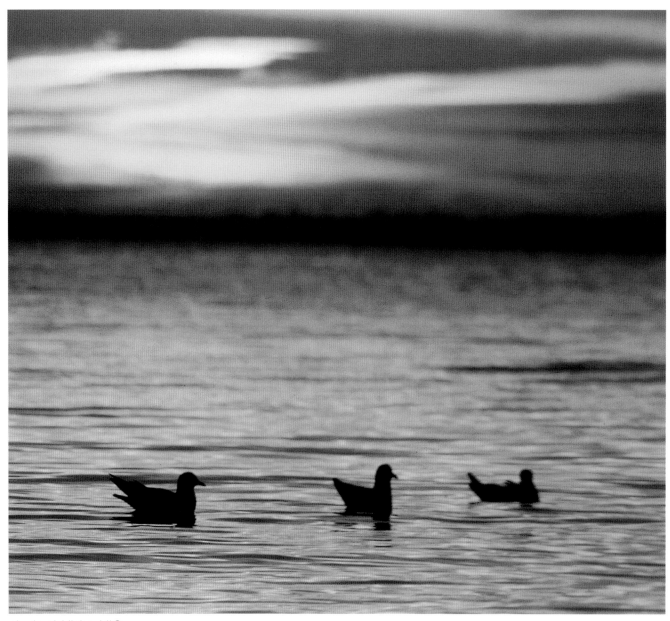

dusk, st kilda, VIC

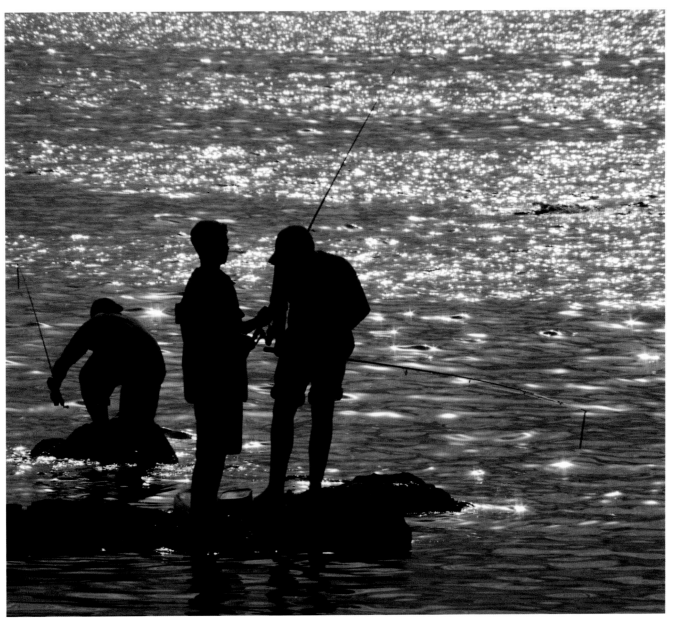

three boys, mornington, VIC

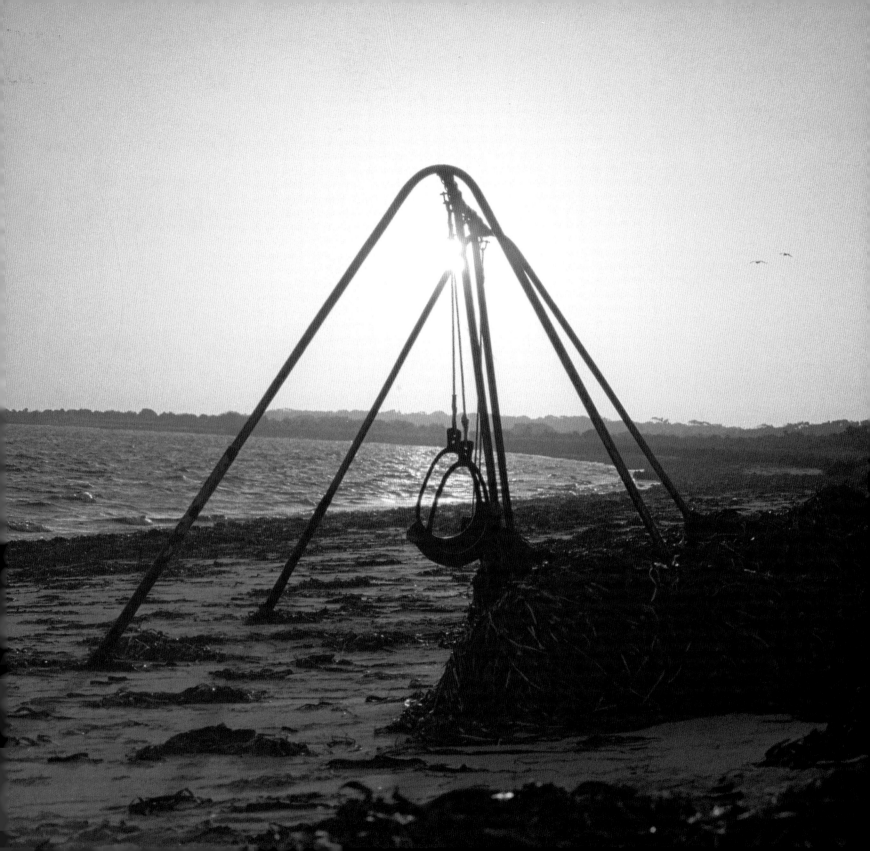

swing, lucky bay, SA

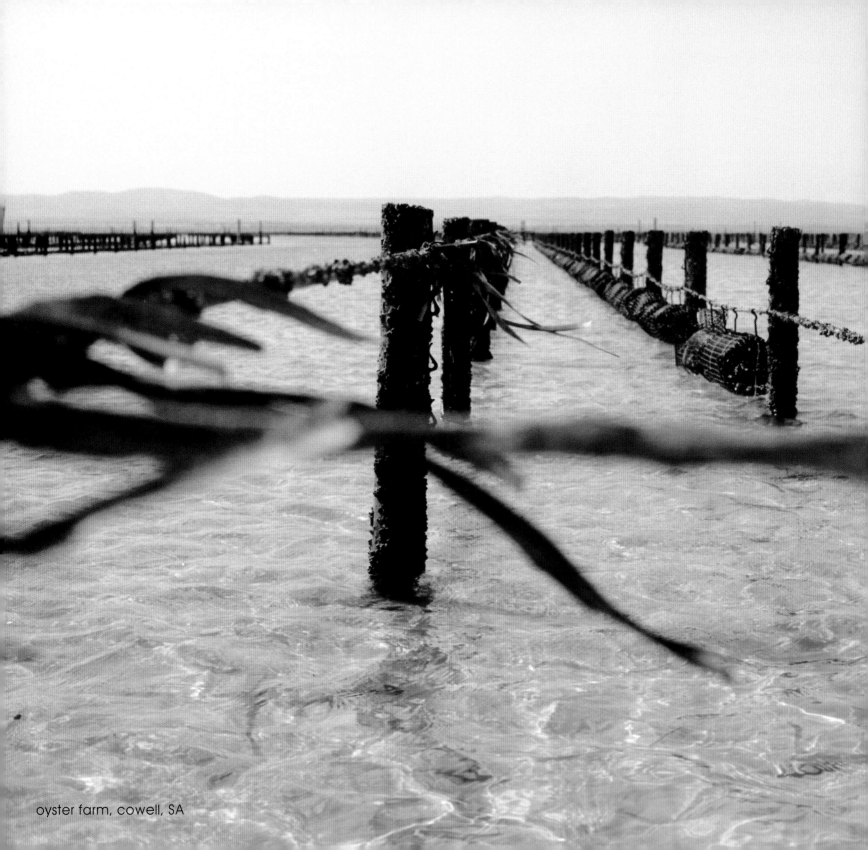

oyster farm, cowell, SA

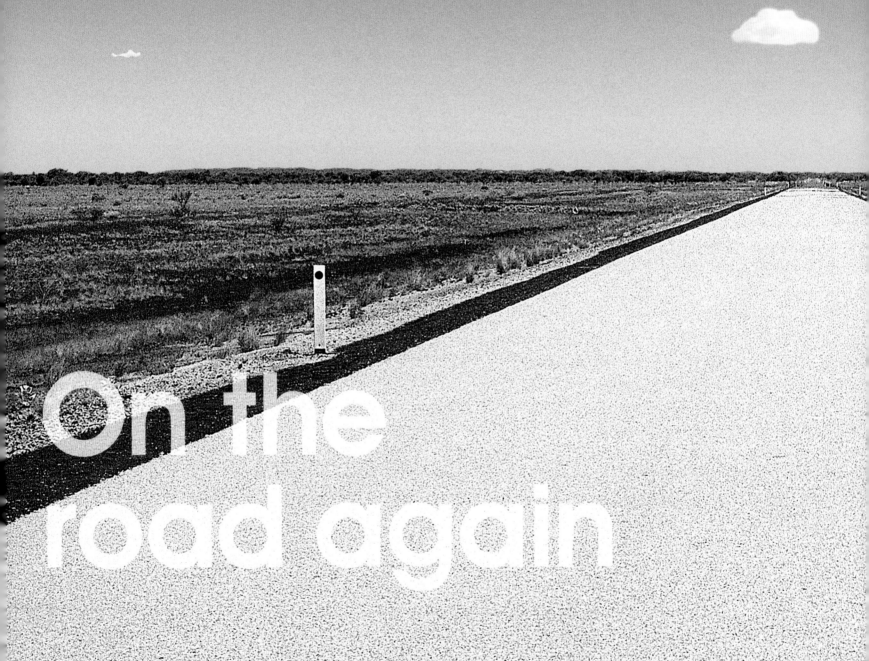

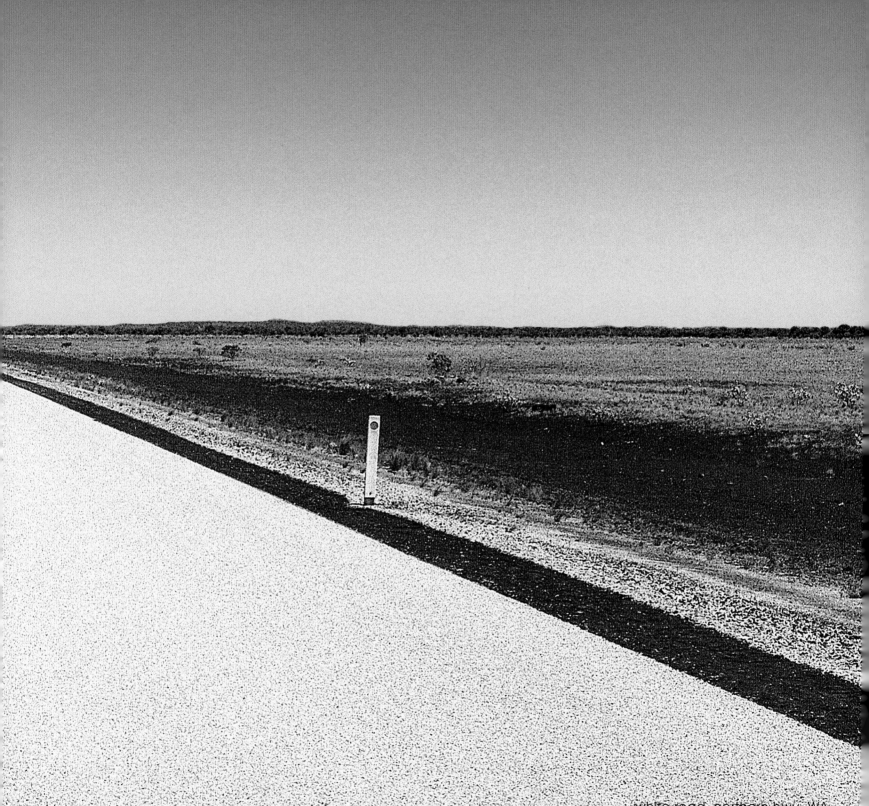

white road, northern hwy, WA

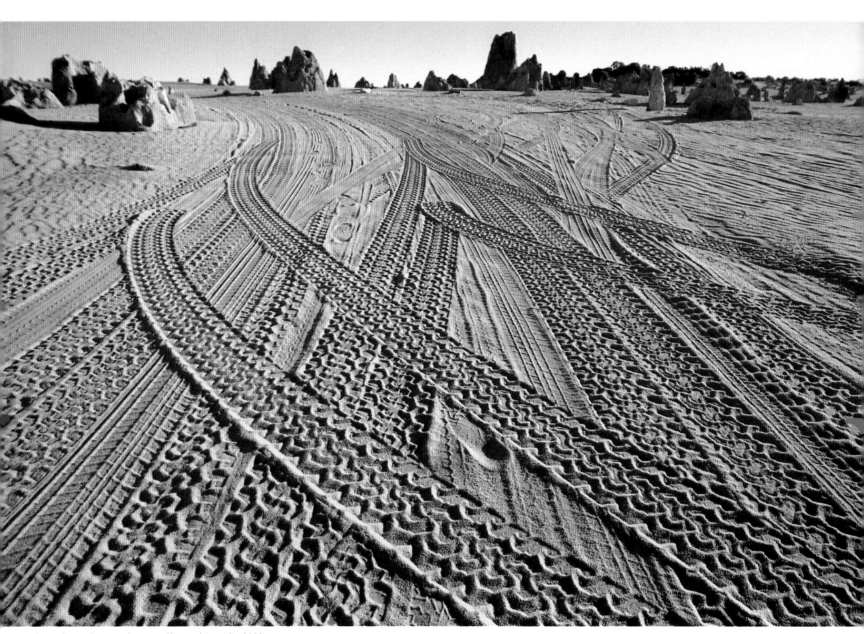

tracks, pinnacles national park, WA

orange dust, gibb river road, WA

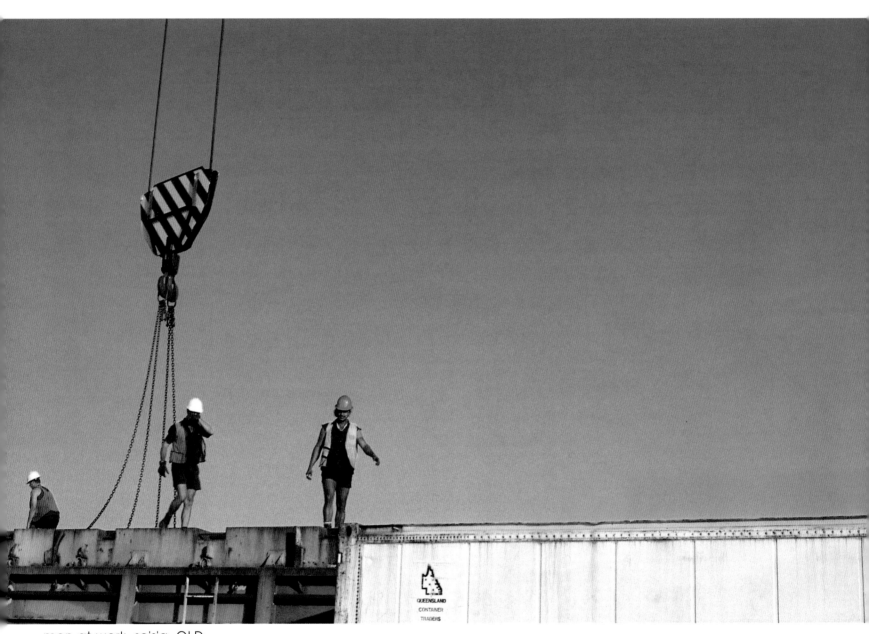

men at work, seisia, QLD

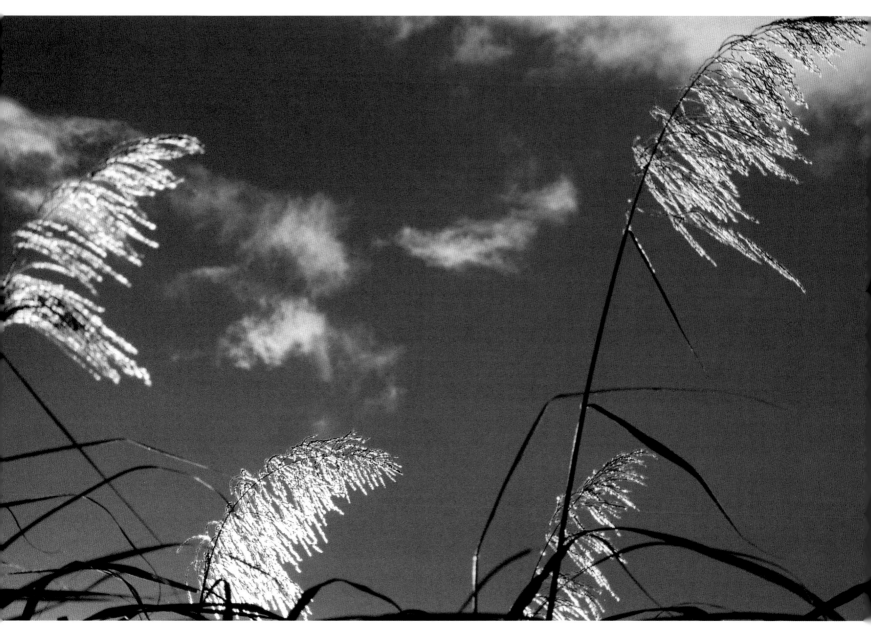

sugar cane, mossman, QLD

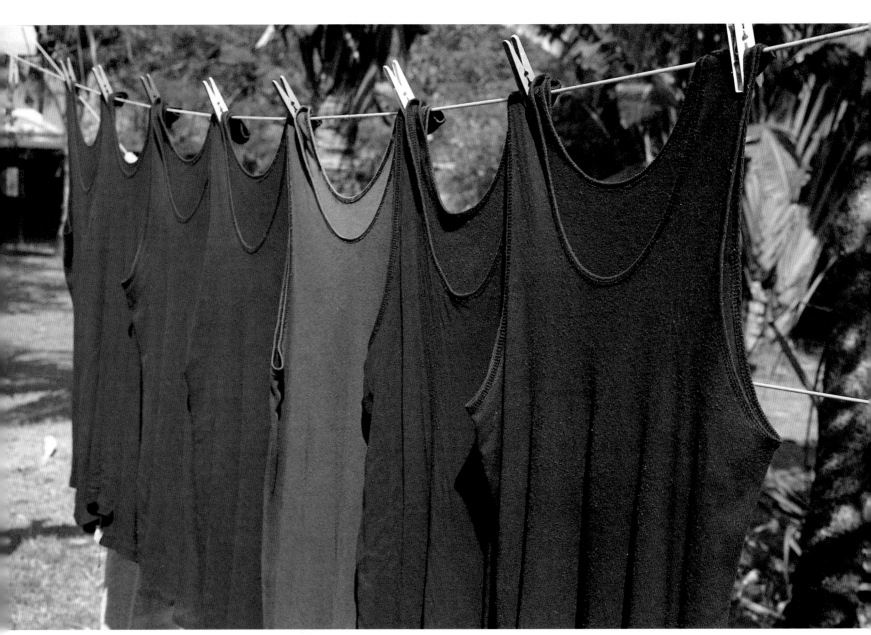

seven singlets, lombadina, WA

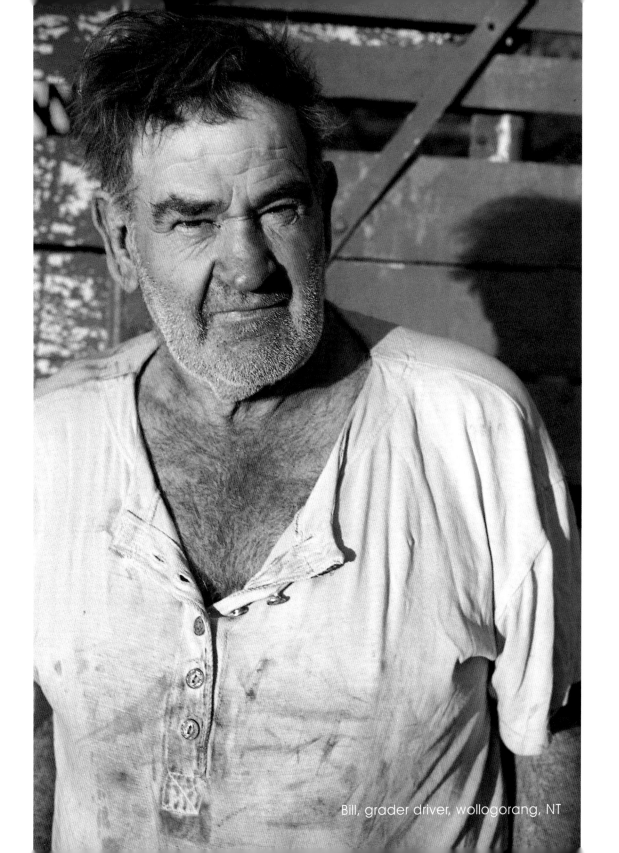

Bill, grader driver, wollogorang, NT

flooded creek, newman, WA

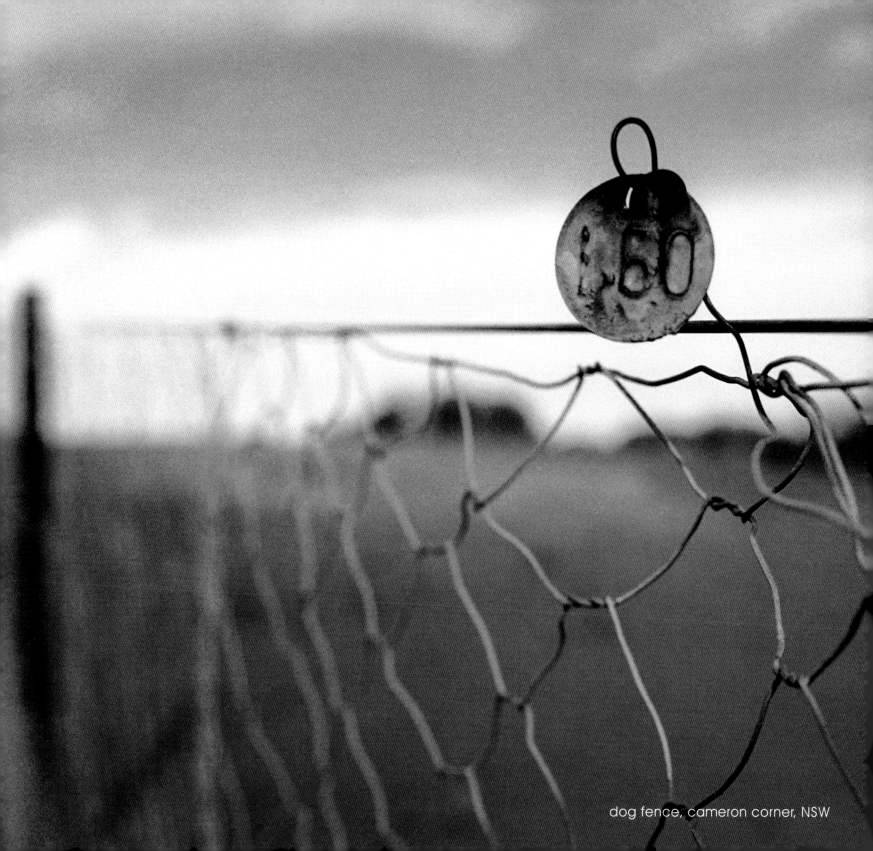

dog fence, cameron corner, NSW

town lookout, kalgoorlie, WA

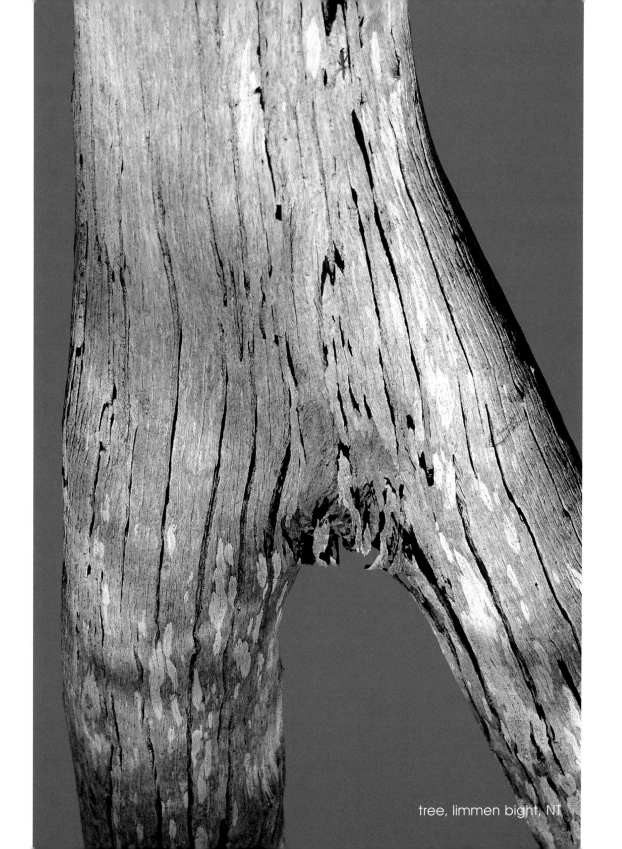

tree, limmen bight, NT

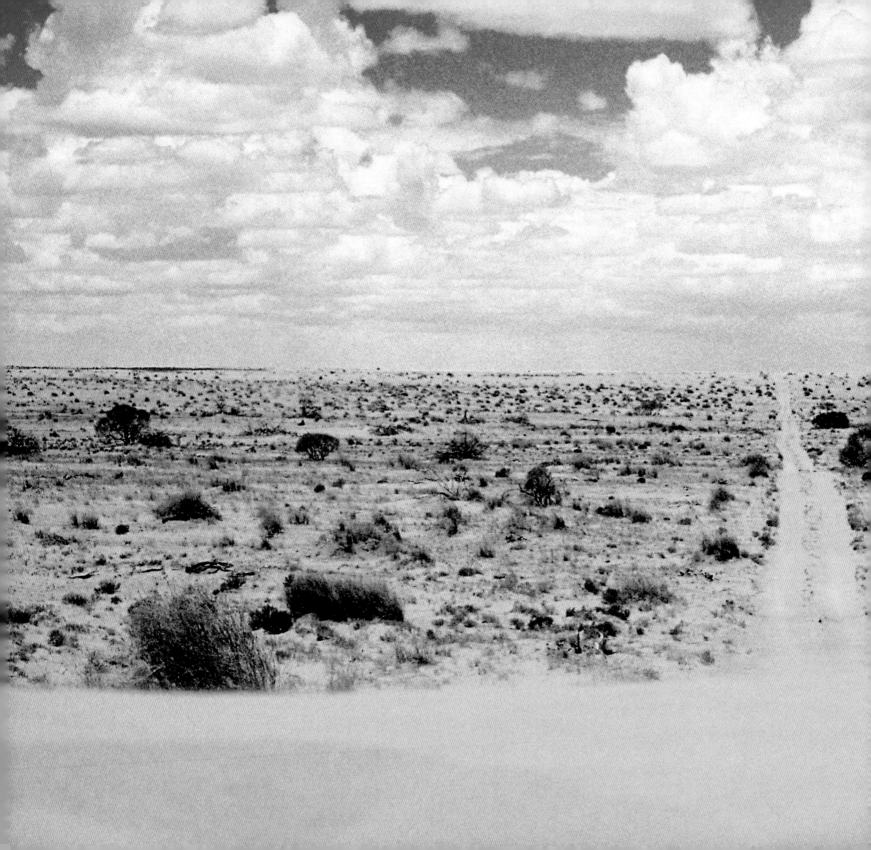

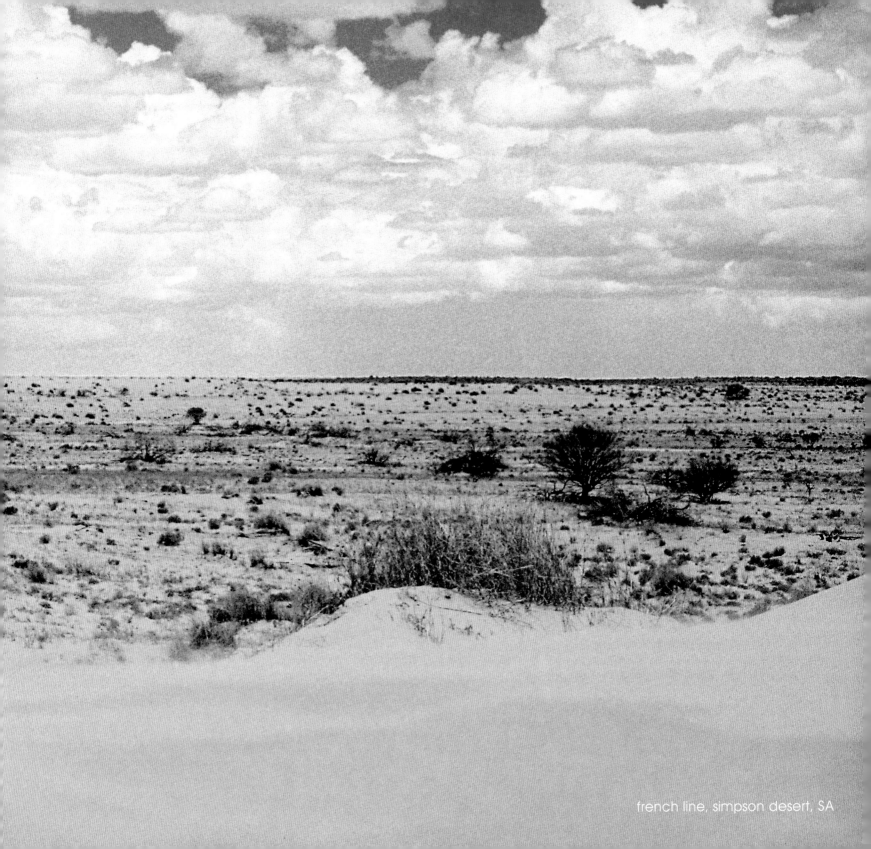

french line, simpson desert, SA

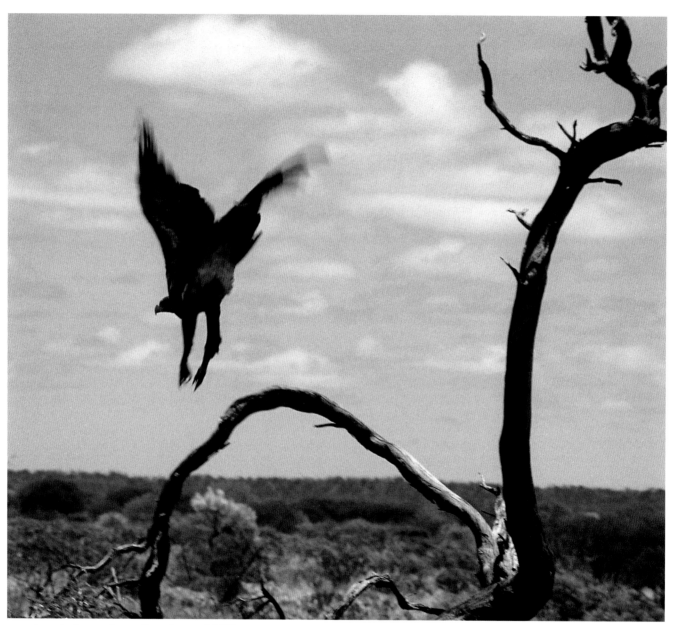

wedge tail eagle, milparinka, NSW

Behind the scenes

the vehicle

Fitting out the vehicle is half the fun. You are like a kid at Christmas, except the excitement continues for the entire four months that you spend fitting out the vehicle. A winch here, a cargo barrier there. Constantly adding bits and pieces to the vehicle. The process is deliciously endless. Driving lights, the radio telephone, with its ridiculously long antenna sprouting from the bull bar, is installed for emergency calls. There is something about a ridiculously long antenna that makes you feel as if you belong in the bush, or at least look as if you belong. Then there is the water tank. Ahh... the water tank. You think of self sufficiency and the dream of being so remote that you and your wife, Caroline, are away from all services and supplies - away from contact with any other human being. Your most valuable supply is water. You must take it with you. Back to the water tank, you have delusions of grandeur, camped in the desert or on some remote beach for weeks on end, you will need a heap of water. You end up installing a two hundred litre, stainless steel tank on the floor behind the front seats. You have gone for serious overkill. You will not die of thirst!

You are into tanks. You move onto the long range fuel tanks. You go for a ninety litre fuel tank to compliment the existing one hundred and 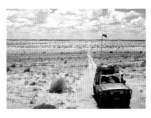 twenty litre tank. Your extra range makes you feel powerful in a strange sort of way. You can drive all day without running out of fuel. You install heavy duty drawers in the back, you mount the fridge on to these. You go for a tow bar, you also get a 'recovery kit', which includes a pulley, snatch straps, u bolts and serious leather gloves. You are really building a sense that you actually know what you are doing with all this gear. You invest in tie downs for the roof rack, did I mention the roof rack ?

You develop a deep love for your roof rack. You bolt a tool box onto it's back end, you fill it with the light weight cooking and fishing gear. You attach your extra spare tyre with a custom made bolt, you are loving this. Everything works. It is at this point that you can't help yourself and you overdo it. You get a chair custom-made that will be bolted onto the roof to allow you to be seated on top of the roof rack, whilst the vehicle is barrelling along some remote stretch of road. You try it one day on The Nullarbor Plain. You ask Caroline to take it up to 80km so as you can photograph the dust as it rises behind the vehicle. The 80km is your first mistake. You end up taking very few photographs. Sitting on the roof gives you a far greater sensation of speed than the normal position behind the wheel, you very nearly shit yourself as you wonder how much longer you can hang on as Caroline continues to accelerate from the safety of the driver's seat. Your

cries of anguish cannot be heard. Caroline finally hits 80km, it feels like 120km. You hang on for your life, knuckles turn white, the speed eventually backs off. You put this down as an experience not to be tried again.

the camera

How your camera became your camera is a story. You go on a family holiday in 1982, you love using mum's camera, the way it feels, the way it shoots, the way objects appear when you look through the view finder. You borrow it. In fact, you borrow it for the next twenty years. You tell your mother that you have done so. Rather you thought you had told her but you hadn't. You show her your photographs from your trip around Australia, she asks what camera you used, you answer - 'My old SLR 35mm that I have had for some years.' You watch surprise drift across her face, 'Your camera! Is that where it has been?' You tell her that you thought she knew you had it, she laughs and says something about a pigs bum. Now you realise that your mother has been searching for her camera every time that she went on a holiday since 1982.

You have not planned to do this book or a photographic exhibition before you leave home. It is not until you receive the first fifteen rolls of film that you had sent back home for processing that you think, 'Gee, some of these are looking great, keep it up, who knows, one day I might make something of it.' You are constantly on the hunt for great shots. You begin to test Caroline's patience.

You check out everything that interests you, ruins, sand, dust, rust, signs, people, watercourses, buildings, silos, machinery, fences, the road itself. You constantly pull off the road and stop. It is often 40 degrees in the shade. Hundreds of flies miraculously appear the moment you stop. You lose the breeze of the moving vehicle. You drive past something that could be interesting to photograph then you think about how it could be interpreted, this way or that, you consider the light. You are still considering, still driving. Your mental picture goes on for a few minutes, you finally decide it is worth pulling over for further investigation.

You have driven 5kms past the subject. You swing into a sweeping U-turn, Caroline gives you a look of controlled patience as she reaches for a book. You are always curious, your camera goes with you everywhere. You are self-taught. You don't own a tripod. You hope that your photographs will inspire Australians to travel to the remote areas of their country, to have a better understanding of this place, this other country.

the bush camps

You travel to some amazing places as you move about the country. When in a town you stay at a cheap motel. When on the track you camp. Your favourite nights together are spent camping. You will start to look for a camp site an hour before sunset. You will consider - the 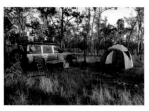 prevailing wind, flatness and firmness of ground, firewood supply, a possible view, water proximity, any spot fires in the area, distance from road, likelihood of being disturbed, direction of sunrise and ability to find the road again. You satisfy yourself that you have met most of your criteria, you pull off the road, you drive at least one kilometre away from the track. You set up camp.

The tent is always first, then the swag goes inside the tent. On clear nights you leave the fly off, you look through the mesh up at the stars, you 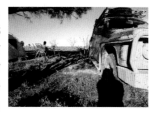 avoid ants and mosquitoes. You set up the table. You make a clearing for a small cooking fire, you collect enough firewood before it gets dark. You go for a wander, you take photographs in the soft orange light. You wonder of the vast space that only the two of you seem to inhabit, you stare into the big skies, you shout, you skip, you are truly happy. Darkness begins to fall, you start cooking, you share a beer.

 You may be grilling your catch of the day- Mackerel, Mangrove Jack, Sweet Lip, Mud Crab, Barramundi, Salmon or Queenfish, grilling up some chops, stir frying some vegies, simmering a noodle broth, baking a potato. You eat, you talk about your adventures, you relax in your camp chair with the adjustable arm rests and back angle. You are delighted that you paid the price for this camp necessity. You consider your camping equipment, you assess your top 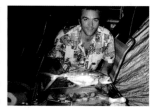 ten items. You make a mental list. In rough order they are - **1** Swag, can't sleep without it. **2** Tent, keeps out insects, weather. **3** Fridge, fresh food, cold beer. **4** Camp Oven and Billy for cooking and boiling. **5** Chairs, eating at table, resting (must have head support). **6** Table, food preparation, writing. **7** Water Tank, 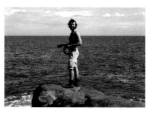 drinking, cooking and washing. **8** BBQ Grate, set up for Camp Oven, Billy and all grilling. **9** Shovel, moving hot coals, digging toilet holes and clearing tent site - a rake is very good for this also. **10** Heavy Duty Gloves for all movement of hot cooking equipment. You love this bush camping together.

I don't drink spirits

Your activities at race week are very basic. You drink beer, you go to the horse races, you bet. You go to Fred Brophy's Travelling Boxing Troupe, you drink more beer, you sleep, you wake, you do it all again. You love it. Fred's Boxing Tent is the last of it's kind in Australia. Every night, for three nights you answer Fred's rally, calling you to the boxing tent. Fred introduces his fighters - The Stallion, Johnny Valentine, The Ranger, The Caveman, The Chinaman, The Scotsman, The Barramundi Kid, The Duke of Earl, The Afro Savage and The Friendly Mauler. The more you punch him the friendlier he gets. You see the challengers climb up onto the stage, you go inside the tent, you watch some fearful poundings dished out by Fred's Boxers, you cheer wildly, you take photographs, you wonder what would make anyone in their right mind climb up onto the challengers platform to take on Fred's boxers. You will not have to wait long for your answer.

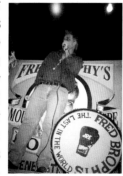

You have been at the last day of the races to witness the running of the Birdsville Cup. You return to town, you have been drinking steadily for a few hours. You attend the first boxing session at seven thirty, you watch, you cheer, you leave. Fred calls the rally for the second session at nine o'clock. It is now that things become strange. Your strangeness comes from a can of rum and coke that you foolishly consume. This may not seem like a drama for drinkers of spirits, but you are strictly a beer drinker, as in beer only. You drink the strong sweet brew, you feel instantly silly. Fred thumps his drum as he calls for the first challenger. Before your brain can stop you, you find your arm strangely lifting itself, in an aggressive fashion. You shout, 'Over Here!' as you make your way to the stage. With Caroline you briefly discuss your sanity and possible injuries that may be inflicted upon you. Caroline seems strangely optimistic. You climb the stage to an enormous cheer, you state your occupation as bar owner and your residence as St Kilda. Fred hails you as 'The Publican from St Kilda', the crowd goes wild. You wonder how the hell you got to where you are - you know the rum has something to do with it. Your whole world starts to spin.

You are matched to fight The Duke of Earl. You turn to him and ask him if he would consider going easy on you, he smiles. You wonder, what have you done? You cannot run, you cannot hide. All the challengers and boxers move into the tent. You get seated and wait for your fight - you look over to Caroline, she has become a celebrity with a dozen or so revellers sitting around her. 'Wow! Is that your husband over there?' they point at you, a couple of them give you the thumbs up, you don't know whether to laugh or cry. You search for a positive, you cast your mind back to your last boxing bout, grade six. You recall that you lost convincingly. In fact, you can't box chocolates !

Your fight is announced. You see your opponent The Duke prancing about, shadow boxing in his shining yellow robe, you pinch yourself. Yes it is real. You survey the surroundings, you see the rudimentary square of canvass that is the ring, you look to Caroline who appears confident, you immerse your self in the moment...Your corner man sprays some water on your face, rubs some vaseline on your brow and tells you to keep your hands up. You repeat to yourself. Hands up! Hands up! Fred rings the bell. You are up and into it. You poke out a few jabs to test the waters, The Duke throws a couple back at you. You are still standing and greatly relieved. You try your luck, move in a step and land a couple of decent punches on The Duke. You look into The Dukes face, he is smiling at you loving life, you know that he is being kind and fighting to your ability. This is a huge relief. Your confidence grows, you cop a few shots to the head that get the adrenalin flowing. Hands up! Hands up! You make a charge at The Duke, landing two punches to the chest. You are astonished as The Duke loses balance and falls backwards into the front row, the crowd roars, the bell rings for the end of the first round. You are careful not to gloat.

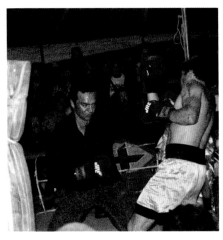

You are completely exhausted, your head is spinning, you hear, 'Go Publican,' calls from the crowd. You think that you are half a chance to go the distance. You look across to The Duke, he has not raised a sweat, your confidence ebbs somewhat. You refuse the chair at the end of the round in some desperate attempt to psyche out The Duke. The corner man sprays your face with the grubby water bottle again, your mouth is horrendously dry, so dry that you cannot speak, your chest heaves, you pant, you are absolutely stuffed.

Ding, Ding. Round two, your step has lost its spring, you hope that The Duke will not notice. You dance around, essentially trying to run down the clock, The Duke will have none of it. He comes at you. Hands up! Hands up! You cop a hammering, you lash out with a huge right thrown from the pie stand, you miss. The momentum carries you forward, flat on your face. The crowd is in hysterics, you are in survival mode, no time for embarrassment as you pick yourself up off the ground. You lunge again, you land one, you catch The Duke by surprise he goes down, hams it up, the crowd cheers for The Publican. You are absolutely rooted. Hands up! Hands up! You make a desperate assault on The Duke's defences, you swing, you miss. You let your guard down, your hands drop. The Duke sees the opening, he lands a savage right jab, you feel the full impact in your left eye, you feel instantly sick. You reel backwards, you bring your left glove to your left eye in some pathetic protective gesture, your right hand waves The Duke away

as you retreat out of the ring in a comical fashion. You hear the crowd roaring with laughter assuming that you are hamming it up, you are not. You are in a heap of trouble. You think to yourself, 'If I get hit in that area again, I may die,' you are not exaggerating. You foolishly shape up again, make brief contact before hearing the sweetest sound you have ever heard in your life - the bell to end round two.

You take the chair, in fact you take everything, the water, the vaseline, the chair, the towel, the standing count. Fred asks you how many fingers he is holding up. He holds up four. Fred

is missing half his pinky. You answer, 'Three and a half.' 'Very good,' says Fred with a smile. You think, shit! He wants to send me back out there, you regain your composure, you gargle through the blood, 'the fingers are a little blurred.' You now have claret running freely out of both nostrils, you feel like spewing. Fred breaks your thoughts, 'Have you had enough Publican?' You respond, 'Plenty!' Fred leads you back into the ring, towards The Duke, Fred lifts The Dukes arm in triumph, then, a moment later he raises your arm too. The crowd goes wild, hailing The Publican. You stand there, arm raised next to Fred and The Duke, bloodied and beaten, yet somehow triumphant, a hero to hundreds for a few moments.

You shuffle off to find a seat, you are now bleeding profusely from both nostrils and your head feels terrible. You fall into Caroline's arms. Caroline is wonderful comforting you and holding your face together. A dozen backslappers tell you well done, the St Johns nurse applies first aid. The Duke approaches, he hands you a cold can of beer, tells you well done, you mumble thanks through the wads of bandages. You give the can away, unable to drink, you now feel very sober and very sore. You are taken away to the medical room for further testing. You seem okay. You then shuffle of to your tent. You sleep very well.

The next day you depart Birdsville and you drive in the direction of Windorah. On the way a funny thing happens. You are in the habit of pinching your nose and blowing to equalise, like you do on an airplane. You are driving, you pinch your nose, you blow. You feel a strange sensation in your left eye, your eye lid has completely inflated, filled with air. You cannot see a thing out of it, it has completely closed over. You casually turn to Caroline and announce, 'Caroline, we have a 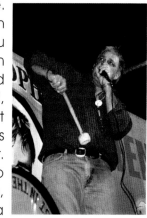 problem.' You pull over and relinquish driving responsibilities for the day. You see an ambulance paramedic that night in the Windorah pub, you are reassured that, 'she'll be right mate.'

You call your doctor the next day, he has a fit, tells you to go to the nearest hospital for x-rays, a course of antibiotics, you are also told, 'It is not good to have your eye connected to your nose for obvious reasons.' Your x-ray at the Longreach hospital reveals a broken eye socket, ouch! Your injury eventually heals. You make a note to never drink spirits again. In another foolish moment you do, the result is a mysterious puddle on Caroline's side of the the swag. That is a different story.

the surreal moment

You are driving on the service track that follows the Indian Pacific Railway from Kalgoorlie to Adelaide, the track is in an appaling condition, your maximum speed is 45km, your average is closer to 30km. You are in the middle of the Nullarbor Plain, you have not seen another person for three days. The only sign of human existence is the ever present railway track. You have been picking your way through split rocks, pot holes and broken boulders for eight hours, the driving requires the utmost concentration, you are exhausted. You have passed the longest stretch of straight railway in the world, some 477kms with out a bend. The track 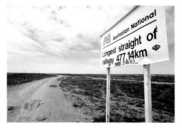 does not share this characteristic, it bends, it twists, it dips, it becomes almost invisible. Your patience is wearing thin, the sun is getting low, you decide to stop soon. You hear a loud

bang! You feel the vehicle drop instantly. You have just experienced a blow out.

You get out and inspect the damage, you inspect the burst tyre wall, sliced like a cake. You begin to remove the jack from the back of the vehicle, you look across to the west, the sun is slowly sinking. You are in one of the most desolate, lonely places in Australia, the middle of the Nullarbor Plain. You are some 200kms north of the more conventional route, The Ayre Highway, that runs East West across the Nullarbor Plain. You stop to absorb the peace, the silence. Out of the corner of your eye you observe movement. You turn slowly. You see it again. You wonder - what could exist out here? There is no water, no apparent food. You see a flicker of white between two shrubs. You look again. You get the binoculars. You think you see a dog. It is a white dingo.

You and Caroline sit quietly together, exchanging glances with your new found friend. In your previous experience with dingoes you have found them to be timid creatures, this one is incredibly inquisitive. You sit quietly together, looking, listening. White Dingo also sits quietly, looking, listening. White Dingo now trots towards you, it comes to a halt on the rail

tracks, then sits. You are no more than twenty metres from each other, you are speechless. You sit some more. You listen to the silence of The Nullarbor. A zephyr wafts gently across the plain. You return to the binoculars, you see a thick white coat, dark eyes, alert ears. You have been admiring this creature for almost forty minutes, darkness is falling, it is time to change the tyre, you assume that the noise will scare off your new friend. You are surprised when it does not, in fact your new friend seems terribly interested in the goings on with your tyre changing and the associated cursing involved with freeing up the seized jack.

You jack up the vehicle, remove the blown tyre, replace it with new and let down the jack. Your new friend only now begins to moves on. You first met almost an hour ago. White Dingo slips over the railway mound like a ghost and is gone from sight. You dash up, twenty metres. You step up onto the mound. You look everywhere for the white dingo. There is not a trace. Vanished as quickly as appeared.

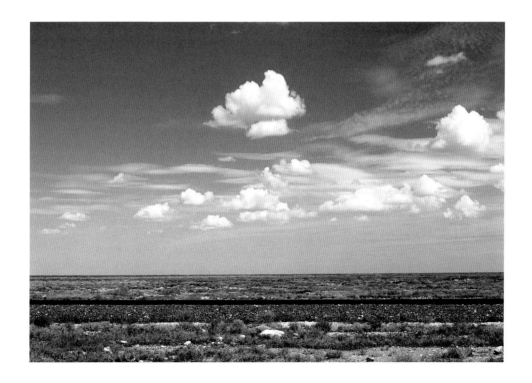

acknowledgements

To my family and friends, thank you for all your love and support, especially my parents Craig and Connie Kimberley and my sister Chloe Podgornik.

To all my friends and new found associates in the wild and crazy world of art and books: Lee Lieberman, Linda Gregoriou, Jack Thompson, John Cann, Nikki Metzner, Sandy Grant, Fiona Schultz, Peter Lothian, Elaine Fell, Adam Crouch, David Longfield, Michael Thomson, Richard Rice, Selwa Anthony, Craig Wood, Natalee Ward, Clare Calvert, Celia Burrel, James Forsyth, Tony Witcher, Paul Johnstone, Mary Coustas, Josh Yeldham, Jo Daniell, Rennie Ellis, Nanette Fox, Terry Serio, Biddy Pirrie, Stephen Grant, Ali Yeldham, Gina Koutroupolos, Nellie Castan, Frank Godby, Emma Cooper, Peter Metzner, Ant Elliott, Kristy Allen, Gary Allen, Peter Monk, Michelle Bugge, Nicole Elliott, Lisa Chivers, Jason Veale, Mark Chew, David Lott, Katrina Sawyer, Andrew Moffat, Michael Lenehan, Peter Houghton, Kit Willow, Mark Podgornik, John Ross, Andrew Podgornik, Bruna Papandrea, Mike Metzner, Anthony Rush, Caroline Nankervis, Jane Newton, Andrew Rettig, Michael Rakusin, Bulla Borghese and Samantha Farrell. Thank you. You have all been very generous with your time and energy.

Finally, my divine wife Caroline, whose patience and encouragement while I was taking these shots and constructing the book has been truly extraordinary. I thank you from the bottom of my heart.

photographer/author

Jason Kimberley is a self-taught photographer with a passion for travel, adventure and capturing all that is wonderful and unique about Australian landscapes and life, particularly life in the bush. His self published book, 'Australia Exposed,' is the result of a year long 4WD trip around Australia in 2000 with his wife Caroline. All the photographs were taken with his beloved 25 year-old SLR 35mm camera which has been on loan from his mother since 1982.

Prior to this Jason had a successful career in the retail industry working in sales, product design and manufacturing. He has worked in management for Country Road and most recently, the Just Jeans Group. He also ventured into the highly competitive Melbourne restaurant scene with 'Veludo,' which quickly became one of the city's top-rated eateries.

Jason's love of travel was formed at an early age-after his family embarked on their first outback adventure. Since then he has travelled extensively throughout Australia and subjected himself to a number of demanding challenges including climbing South America's Mt. Aconcagua, (the highest mountain in the world outside the Himalaya) and trekking Denali in Alaska, the highest mountain in North America.

Jason has had photographic works published in Josh Yeldham's 'Solitude's Bride'(2002) and his written works published in 'The Winning Post'(2002).

Australia Exposed is the culmination of two years work. Jason lives with Caroline in St Kilda. This is his first book.